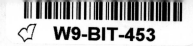
Ensor

JOHN DAVID FARMER

The Art Institute of Chicago

The Solomon R. Guggenheim Museum, New York

*This project is supported by a grant
from The National Endowment for the Arts
in Washington, D.C., a Federal agency.*

George Braziller New York

Photographic Credits

5000 copies of this catalogue
designed by Malcolm Grear Designers
typeset by Dumar Typesetting
have been printed by Mohndruck
in August 1976 for the Trustees of
The Solomon R. Guggenheim Foundation
and The Art Institute of Chicago.

Library of Congress Cataloging in Publication Data
Ensor, James, Baron, 1860-1949.

Ensor.
1. Ensor, James, Baron, 1860-1949.
I. Farmer, John David. II. Title.
ND673.E6F37 759.9493 76-16639
ISBN 0-8076-0836-X

Printed in West Germany

Lenders to the Exhibition

Albright-Knox Art Gallery, Buffalo
The Art Institute of Chicago
Nelson Gallery—Atkins Museum, Kansas City, Missouri
Bayerischen Staatsgemäldesammlungen, Munich
Bibliothèque Royale Albert 1er, Brussels
The Cleveland Museum of Art
Fogg Art Museum, Harvard University,
Cambridge, Massachusetts
Allan Frumkin Gallery, New York
Koninklijk Museum voor Schone Kunsten, Antwerp
The Minneapolis Institute of Arts
Liège-Musée des Beaux-Arts
Musée Hotel Charlier, St. Josse-ten-Noode, Belgium
Musées Nationaux, Paris
Musées Royaux des Beaux-Arts de Belgique, Brussels
The Museum of Modern Art, New York
Museum voor Schone Kunsten, Ghent, Belgium
Philadelphia Museum of Art
Museum Plantin—Moretus, Antwerp
Rijksmuseum Kröller—Müller, Otterloo, The Netherlands
Staatsgalerie Stuttgart
Stedelijk Museum, Ostend
Stedelijk Prentenkabinet, Antwerp
Wallraf—Richartz Museum, Cologne
Yale University Art Gallery, New Haven

Joachim Jean Aberbach, Old Westbury, New York
Julian J. Aberbach, Paris
Mr. and Mrs. James W. Alsdorf
Mr. and Mrs. Leigh B. Block, Chicago
Crédit Communal de Belgique, Brussels
Georges Daelemans
Georges De Graeve
Mr. and Mrs. Jeff de Lange
Barbara M. Elesh
James N. Elesh
Louis Franck, Esq., C.B.E.
André Joiris, Liège
Collection Leten, Belgium
Dr. J. Maniewski
William R. Murdoch
Collection Nellens, Knokke, Belgium
Louise S. Richards
Ambassador and Mrs. Julien Rossat
Mr. and Mrs. Harry C. Sandhouse
Mr. and Mrs. Herman D. Shickman
Gustave Van Geluwe

Acknowledgments

Five years ago, John David Farmer, then Curator of Earlier Painting at The Art Institute of Chicago, suggested a major exhibition of the works of James Ensor. This proposal was enthusiastically adopted, and he began the work of examining the total production of this painter of baffling, beautiful, and often very moving works. Shortly after it had been decided to hold the exhibition in Chicago, The Solomon R. Guggenheim Museum expressed interest in participating in the exhibition. The resulting joint venture has proved fruitful and rewarding for both institutions.

We wish to thank Mr. Farmer, now Director of the Birmingham Museum of Art, for selecting this first comprehensive Ensor exhibition held in the United States since 1951 and for assessing the Belgian master's contribution in the accompanying catalogue essay. The following staff members of both institutions have also been most helpful during the prolonged and often difficult period of preparation: at the Art Institute: Hélène Dahlstrom, Eva Landesman, Susan Wise, and Jean-Patrice Marandel, all of the Department of Earlier Painting and Sculpture, and Harold Joachim, Anselmo Carini, and Susan Sisk of the Department of Prints and Drawings; at the Guggenheim Museum: Linda Konheim and Carol Fuerstein.

We also wish to express our thanks to the following organizations for financial support: The National Endowment for the Arts in Washington, D.C., a Federal Agency; Société Générale de Banque/Generale Bankmaatschappij; The Solvay American Corporation; International Business Machines of Belgium, N.V.; Esso, Belgium; European-American Bank & Trust Company; BP Belgium N.V./S.A.; Jean Cattier; Banque de Commerce S.A.; Fribourg Foundation, Inc.; Belgian Linen Association; Rudolph W. Knoepfel; Agfa-Gevaert, Inc.; Bekaert Steel Wire Corporation; and Robert M. Gottschalk.

Through the efforts of Paul Delmotte, Director for Art Promotion of the Belgian Ministry of Dutch-Language Culture and Education, that agency has assumed the costs of transatlantic transportation and insurance. We extend our appreciation to him and for this generous financial assistance. We also wish to thank His Excellency, Willy VanCauwenberg, Ambassador of Belgium to the United States, for his official endorsement of the exhibition.

Finally, we gratefully acknowledge the generosity of all the lenders to the exhibition, both named and anonymous, without whose kindness and willingness to deprive themselves temporarily of their treasures, we should have no exhibition.

JOHN MAXON, Vice President for
Collections and Exhibitions
The Art Institute of Chicago

THOMAS M. MESSER, Director
The Solomon R. Guggenheim Museum

James Ensor is a singularly Belgian artist. His roots are deep in the soil of his native country, which he left for no more than a few days during his eighty-nine years. Unlike the paintings of many of his great French contemporaries—Monet or Cézanne, for instance—few of Ensor's works have left the land of his birth. Moreover, despite the international importance of Ensor to the development of modern art, little research and publication have taken place outside of Belgium.

My research on Ensor, therefore, owes a basic debt to many Belgians who have shared their time and expertise. Most important has been Paul Delmotte, head of the Dienst voor Kunstpropaganda, Ministerie van Nationale Opvoeding en Nederlandse Cultur. Thanks to his efforts, that Ministry gave its official sanction to the exhibition and awarded funds to cover the expenses of transatlantic transportation and insurance. His official presence helped assure important loans from Belgian museums, and his personal acquaintance with private collectors opened many doors. His capable staff has coordinated the logistical problems involved in shipping numerous valuable works from Europe.

Jacques Melsens, Consul General of Belgium in Chicago, prepared the way to Belgium from the United States. Mr. Melsens has taken this exhibition on as a personal project and on more than one occasion has cut administrative red tape to eliminate difficulties.

Many individuals and institutions agreed that this was a worthwhile endeavor and have lent precious works to the exhibition. Their names are recorded in the list of lenders to the exhibition, and though I cannot repeat the lengthy list here, I do wish to thank each of them. In addition, a number of scholars have helped me considerably with both information and advice. I would be remiss not to acknowledge the considerable assistance of Frank Patrick Edebau, Director of the Stedelijk Museum, Ostend, who has studied Ensor for many years in the context of the artist's beloved city. Auguste Taevernier, a perceptive connoisseur of Ensor's graphics, gave me many lessons based upon his own collection, probably the finest group of Ensor prints in the world. Marcel De Maeyer willingly shared the results of his own years of research on Ensor. Louis Franck is not only a generous lender but provided advice and aid. Mrs. F.-C. Legrand, Curator of Modern Art at the Musées Royaux des Beaux-Arts de Belgique, has published extensively on Ensor in recent years and gladly imparted considerable help. Jean Warmoes, Curator of the Musée de la Litterature in the Bibliothèque Royale Albert 1er, provided much scholarly information.

John Maxon, Vice President for Collections and Exhibitions at The Art Institute of Chicago, encouraged me to pursue work on this exhibition from its inception. He arranged for me to take a leave of absence from my post at the Art Institute in order to concentrate on research without the diversion of other curatorial duties. Thomas M. Messer, Director of The Solomon R. Guggenheim Museum, and Henry Berg, Deputy Director of that institution, helped at every step in the organization of the exhibition.

Expertise on Ensor is not limited to Belgium, and I acknowledge gratefully the help of James Elesh, whose study of Ensor's prints is yielding interesting observations. Harold Joachim, Curator of Prints and Drawings at The Art Institute of Chicago, has built one of the finest Ensor collections in the United States and shared the results of his patient work enthusiastically. Dennis Adrian provided much useful information and encouragement from the very beginning.

Any publication stands or falls on clarity of thought, and what logic the reader perceives in the following essay can be attributed to my wife, Patricia P. Farmer. She is an art historian of considerable skill and has modestly channeled her own creativity in this work to the end of maintaining order in my discussion. Her questions have acted as challenges to my presumptions, leading me to look at Ensor with what I hope is some degree of perception.

Linda Konheim, Curatorial Administrator at the Guggenheim, coordinated the exhibition for that museum and aided Carol Fuerstein, the Guggenheim's Editor, who organized the catalogue for production. The many tasks at The Art Institute of Chicago were coordinated by Eva Landesman. Jean Elliott, Secretary at the Birmingham Museum of Art, aided in typing the manuscript and checklist.

JOHN DAVID FARMER
Director, Birmingham Museum of Art

Chronology

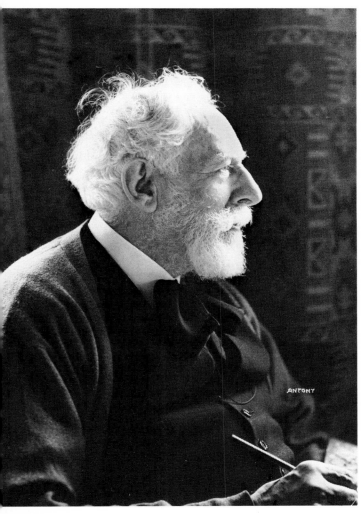

Profile of James Ensor

1860 James Sidney Ensor is born at 44 (now 26) Langestraat, Ostend, on Friday, April 13. His father was James Frédéric Ensor, born in Brussels of English extraction; his mother Maria-Catharina Haegheman, Flemish, from a family of Ostend shopkeepers.

1861 Mariette Ensor, called Mitche, James's sister, born in Ostend on October 29.

1873 James enters the Collège Notre-Dame in Ostend, does poorly.

1875 The family moves to a house at the corner of Vlaanderenstraat and van Iseghemlaan. James leaves school and begins lessons with two local painters. He produces a few sketches that have survived.

1877 James enters the Académie Royale des Beaux-Arts, Brussels.

1879 Still at the Académie, he meets Professor and Mrs. Ernest Rousseau through an artist friend, Théo Hannon, Mrs. Rousseau's brother. Professor Rousseau is Rector of the Université Libre de Bruxelles, Mrs. Rousseau is a scientist. His classmates at the Académie include Fernand Khnopff and Willy Finch.

1880 Leaving the Académie, James returns to Ostend and sets up his studio in the attic of the family house.

1881 Ensor exhibits publicly for the first time at the premier exhibition of *La Chrysalide,* Brussels.

1882 Ensor exhibits works at the *Cercle artistique,* Brussels, but *Woman Eating Oysters* is rejected by the Antwerp Salon. Two interiors are accepted at the Paris Salon.

1883 Shows five works at the group exhibition *L'Essor,* Brussels. Later in the year the important avant-garde organization *Les Vingt* is formed in Brussels, Ensor an original member with Khnopff, Guillaume Vogels, Théo van Rysselberghe, Finch, and others.

1884 Everything Ensor submits to the Brussels Salon is rejected, including *Afternoon at Ostend.* His first article, *Three Weeks at the Academy,* is published in *L'Art moderne.* The initial exhibition of *Les Vingt* includes six works by Ensor.

1885 Six works by Ensor shown at *Les Vingt,* Brussels.

1886 Ensor begins making prints. He reproaches Octave Maus, secretary of *Les Vingt,* for his praise of a painting by Khnopff, *While Listening to Schumann,* which Ensor believes to be a plagiarism of his own *Russian Music.* He opposes inviting Whistler to exhibit with *Les Vingt.*

1887 Death of James's father. Ensor exhibits the series *Les Auréoles* at *Les Vingt*. Georges Pierre Seurat's *Sunday Afternoon on the Grande Jatte* is also shown, converting a number of members of *Les Vingt* to the principles of Neo-Impressionism.

1888 Twenty-one works by Ensor are shown at *Les Vingt*, but his *Tribulations of St. Anthony* is rejected. He meets Augusta Boogaerts, who becomes a lifelong friend. He produces thirty-four prints, his greatest annual output in this medium.

1889 *Les Vingt* rejects *The Entry of Christ into Brussels*, completed the preceding year, but shows eleven other works.

1890 Further works rejected by *Les Vingt*; eighteen shown.

1891 Ensor shows fourteen works at *Les Vingt*.

1892 Ensor may have made a four-day trip to London. Eugène Demolder publishes the first monograph on the artist. Mitche marries Taen Hee Tseu, who leaves her before her child, Alexandra, is born.

1893 The last exhibition of *Les Vingt*, after which it disbands with Ensor the only member voting against dissolution. Ensor attempts to sell the contents of his studio for 8,500 francs, but no offers are made.

1894 The initial exhibition of *La Libre esthétique* in Brussels, the successor to *Les Vingt*, includes seven works by Ensor.

1895 Ensor shows a major group of works at *La Ligue artistique*, Brussels.

1896 In Brussels Demolder organizes the first exhibition devoted exclusively to the works of Ensor. First major purchase of a work by a Belgian museum, *The Lamp Boy*, bought by the Musées Royaux des Beaux Arts de Belgique.

1898 The journal *La Plume* organizes an exhibition in Paris of Ensor's works and devotes a special issue to him.

1899 Fifty-two graphic works by Ensor shown at the *Cercle artistique et littéraire*, Ostend.

1900 Ensor continues to show at *La Libre esthétique* (three works).

1903 The artist is named a Knight of the Order of Leopold.

1904 This year or the preceding, Emma Lambotte meets Ensor and becomes a patron and friend.

1905 *Kunst van Heden* of Antwerp, newly founded by François Franck, who becomes one of Ensor's most important supporters, gives Ensor a major exhibition.

1907 Ensor begins to copy some of his earlier works in bright versions.

1908 Emile Verhaeren writes the first major monograph on Ensor.

1911 Emil Nolde visits Ensor in Ostend. Ensor designs and writes the music for the ballet *Scale of Love*.

1913 Herbert von Garvens-Garvensburg publishes, in Hanover, the first book on Ensor's prints.

1915 His mother dies.

1916 His aunt dies.

1917 Ensor moves to the house owned by his uncle at 27 Vlaanderenstraat. This is his home until his death.

1920 The Galerie Giroux in Brussels has the first major retrospective exhibition of Ensor's works.

1921 *Kunst van Heden* in Antwerp organizes an even larger retrospective (133 works). The first volume of his writings appears in Brussels. Paul Colin publishes an important monograph in German.

1922 Gregoire le Roy's monograph appears.

1925 Loys Delteil publishes a catalogue of Ensor's prints.

1926 Two exhibitions: in Paris at the Galerie Barbezanges-Hodebert and in Venice at the Belgian Pavilion.

1927 Important exhibition (132 works) is held in Hanover at the Kestner-Gesellschaft.

1929 The inaugural exhibition at the Palais des Beaux-Arts in Brussels is devoted to Ensor, named a Baron by King Albert the same year. The exhibition comprises 337 paintings, 135 etchings, and 325 drawings.

1931 Edmond de Valeriola's monument to Ensor is unveiled near the Kursaal, Ostend.

1932 The Jeu de Paume in Paris exhibits 171 works by Ensor.

1933 Ensor is proclaimed "Prince of Painters" in Brussels and awarded the *Cravate de la Legion d'Honneur* by the French Minister, Anatole de Monzie.

1935 Albert Croquez publishes a catalogue of Ensor's prints.

1939 The *Gazette des Beaux-Arts* organizes a major exhibition in Paris (380 works). A number of Ensor's works, including *Haunted Furniture* and *Sick Tramp Warming Himself*, are destroyed in the bombardment of Ostend.

1945 Mitche Ensor dies.

1946 Major retrospective exhibition (88 works) organized by the National Gallery, London.

1947 Second edition of Croquez's print catalogue appears.

1948 Founding of *Les Amis de James Ensor*.

1949 The artist dies on November 19 and is buried in the graveyard of Notre-Dame des Dunes, near Ostend.

James Ensor and Ostend

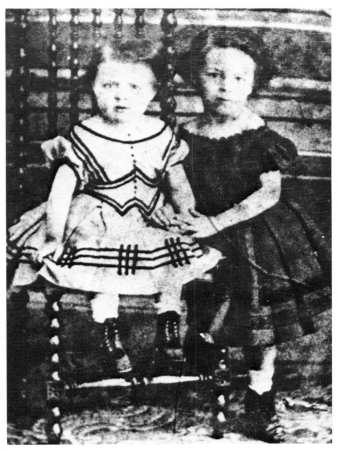

Fig. 1. Ensor and his sister, Marie. 1864. Courtesy Archives, Stedelijk Museum, Ostend.

I was born at Ostend, on April 13, 1860, on a Friday, the day of Venus. At my birth, Venus came toward me, smiling, and we looked long into each other's eyes. She smelt pleasantly of salt water.[1]

To the northwest, behind the house where James Ensor was born, stood the ramparts, which at that time still protected Ostend from the surging North Sea. The rhythm of waves, the frequent mists, and the capricious climate of the land where he grew to manhood strongly influenced Ensor's art, and his sometimes bizarre sensibility may have developed as a reaction to the instability of a moody family and the somewhat unusual nature of the objects that surrounded him daily in his mother's curio shop.

His father, James Frédéric Ensor, was born in Brussels on October 27, 1833, of British origin, the son of James Rainfort and Anna Andrew. His mother, Maria-Catharina-Lodewijka Haegheman, born in Ostend on April 24, 1835, was the daughter of Jean-Louis and Maria Antonia Hauwaert. In the house on Langestraat, Ensor's parents kept a little shop, where one could find stuffed animals, seashells, coral, odd fish, and dried sea plants, together with all sorts of beach articles, such as toy boats, miniature buckets, spades, fish nets, and numerous other exotic things. During Carnival in Ostend masks were also offered for sale in the shop. The collection made a deep and lasting impression on Ensor.

In this context he wrote:

One night, when I was asleep in my cradle, in my illuminated room with windows wide open on the ocean, a big sea bird, attracted by the light, came swooping down in front of me and jostled my cradle. Unforgettable impression, wild fear, I can still see that horrible vision and I still feel the hard shock of that fantastic black bird, greedy seeker of light.[2] *I was also deeply moved by the mysterious stories about fairies, ogres and malevolent giants—marvelous tales these, driveled interminably by a good old Flemish maid who was wrinkled, dappled, pepper-and-salt gray and silver. I was even more fascinated by our dark and frightening attic, full of horrible spiders, curios, seashells, plants and animals from distant seas, beautiful chinaware, rust and blood-colored effects, red and white coral, monkeys, turtles, dried mermaids and stuffed Chinamen.*[3]

After moving several times, the Ensor family settled down in 1874 at the corner of Van Iseghemlaan and Vlaanderenstraat. At the age of sixteen, Ensor attempted

his first little paintings on cardboard and wood, mostly seascapes and beach scenes, or the polders seen from the top of a high dune near the little church of Mariakerke. Those years appear to have been the happiest in his life. His parents, two aunts who cherished him, and a frivolous, volatile younger sister all served as models for his first paintings and drawings.

Later, he spent two years at the Académie Royale des Beaux-Arts in Brussels, but the experience left the twenty-year-old Ensor contemptuous of formal art training:

In 1880 I walked out on that establishment for the near-blind without further ado. I have never been able to understand why my teachers were so upset by my restless explorations. I was guided by a secret instinct, a feeling for the atmosphere of the seacoast, which I had imbibed with the breeze, inhaled with the pearly mists, soaked up in the waves, heard in the wind.

His first studio, which can be considered the birthplace of most of his famous paintings, drawings, and etchings, was in the attic of the family house where, from

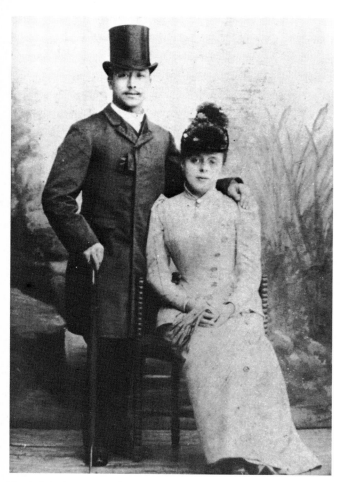

Fig. 2. Marie Ensor and her Chinese husband, Taen Hee Tseu. 1892. Courtesy Archives, Stedelijk Museum, Ostend.

its small windows, he could see the whole city on one side and the North Sea on the other. As Paul Haesaerts has noted, "To some extent the future of modern painting was determined in that attic."[4]

In my parents' shop I had seen the wavy lines, the serpentine forms of beautiful seashells, the iridescent lights of mother-of-pearl, the rich tones of delicate chinoiserie.

In addition to the psychic injuries sustained at the Académie Royale, Ensor soon became aware of trouble within the family circle. Domestic storms were constantly threatening, and they sometimes freshened to gale proportions: His mother, who was continually complaining about her husband, tried to set the son against his father, while his aunt kept harping about the state of her health, and his sister made frequent pleasure trips, deserting the others in their mounting panic. All this created a terribly depressing atmosphere, but some inner reserve of strength, perhaps derived from his father's English pride in being independent and unconventional, kept Ensor going.

It has been alleged that Ensor inherited his artistic sensitivity from his mother, but his father surpassed her in being broad-minded, cultured, well read, and well traveled, as well as creative. Moreover, she was by no means well disposed toward her son's work and could never bring herself to sell it in the shop.

In my opinion, it was his father who, accepting young Ensor's unusual impulses, encouraged the child to come to terms with his own needs, aspirations, capacities, and characteristics, so that he could gradually establish his identity in a self-confident manner. This attitude deviated markedly from accepted educational methods in the 1870's and from the dull, narrow-minded "grocer's mentality" of Ensor's immediate environment. But, as always, a price had to be paid for such unconventionality. Because he was a foreigner, Ensor's father could not find a decent job and he had to depend financially on his wife, a situation so painful to him that he eventually became an alcoholic and died in 1887. His son testified later: "He really was a superior man, finally preferring [quoting Paul Claudel on Verlaine] to be drunk rather than to be like the rest of us." In time, an evident lack of understanding or interest on the part of his fellow citizens, as well as attacks launched against him by the art critics, caused Ensor to withdraw for a time from society, saying, "I have joyously shut myself up in the solitary domain where the mask holds sway, wholly made up of violence, light, and brilliance. To me the mask means freshness of tone, acute expression, sumptuous decor, great unexpected gestures, unplanned movements, exquisite turbulence." This explanation, while charming, refers only to the mask as a pictorial studio object. In

Fig. 3. Ensor on the beach at Ostend. 1920's.

fact, Ensor used the mask to unmask the bourgeois society that had rejected him. What he produced in his attic studio would, some forty years later, shake the world of art.

His mother died in 1915, and in 1917 Ensor moved to Vlaanderenstraat 17 (now 27), which he inherited from his uncle, Leopold Haegheman. It was a house and shop similar to the one his parents had owned. He lived there until his death in 1949.

Ensor did not travel much. Except for three short trips to Paris, London and Holland, he remained in his own city, abiding by Rembrandt's maxim: "Wherever you are born, your birthplace offers more beauty than you will ever be able to paint during your whole life." Ensor himself said:

High-speed traveling becomes more frequent, and before long one will cross countries without seeing or understanding them, but one will always have to build his house, catch his fish, cultivate his fields, plant his cabbages, and therefore one must look with both eyes, and to look is to paint and to paint is to love nature and women and children and the steadfast earth.

Ensor particularly loved Ostend's poor people, the rude tars, the pathetic fishermen's wives—and not only out of pity for their lack of status, although he drew a parallel between their oppression and his own. He admired their integrity, their down-to-earth humor, their way of speaking, their broad gestures, and their acceptance of the tragi-comic in life. He liked to spend time with them, often drawing or painting them and some-

Fig. 4. Ensor on the docks in Ostend. 1920's.

times commenting indignantly in his work on their terrible lives. In 1887 there was a strike against the import of foreign fish which soon gave rise to revolt: Ostend's fishermen boarded English boats and threw their fish overboard. The armed forces intervened, and two fishermen were killed. This event greatly affected Ensor, and in 1888 he drew a poignant caricature entitled *The Strike in Ostend* (Pl. 47), which shows police killing people. In the same year he etched *The Gendarmes*, repeated in 1892 as a painting with the same title (Pl. 37): two corpses in a morgue, guarded by gendarmes, one of whom is wiping the blood off his saber, while the other displays a few pieces of money in his hand.

Ensor once said to Jean Tengels, "When I see soldiers parading on formal occasions, my imagination divests them of their decorations, and I see them in their shirt-tails."[5] This idea applied not only to those in uniform, but also to magistrates, judges, doctors, politicians, bankers and other dignitaries. We can rightly say he took

strong positions against both the establishment and its paternalism. The critics who satirized him during this heroic period did so not only from artistic blindness, but also because most of them were conditioned by the ruling classes. "Who bears the torch of truth among the crowd singes here a beard and there a wig." Is it surprising, then, that Charles De Coster's *Tijl Uilenspiegel* was one of Ensor's favorite books?

During his whole lifetime Ensor was an energetic fighter against those who, for commercial reasons, wanted to rebuild and modernize his beloved city.

> Poor old Ostend, at the mercy of the depredations of lame architects who can see no farther than their noses. Down with those who are ruining our marvelous sites! Unmask the moldy schemes of the improvement-mad! Blast those who are filling in our wonderful docks! Public flogging for those who are leveling the gentle curves of our sand dunes!

His intelligence, his idealism, and his purity made him extremely vulnerable, and this explains why in some of his works, especially the engravings, he gave free rein to his sarcasm, without sparing those who had hurt him. Referring to this facet of his work, the eminent poet and art critic Franz Hellens said:

> The inexhaustible imagination of Ensor shrank from no natural fact and committed to canvas or copperplate images which at first sight often look coarse and even scatological. . . . But to judge Ensor's art sanely one must consider it in itself, beyond the effective phenomenon. From this I conclude that, through his inner nature and inmost thoughts, Ensor was, and remains, an artist enamored of purity. His earliest works, boldest works from the point of view of obscenity, breathe an air relieved of scoria, the bracing air of the sea, innocent, and I would go so far as to say an atmosphere that could be called messianic.[6]

During the last thirty years of his long life, when, finally, in response to his steadily growing fame Ensor was made a baron, his bust was placed in a square in Ostend, and the European intelligentsia came to visit him in the house that has now been converted into a museum. Jean Cassou, the former director of the Musée National d'Art Moderne in Paris, once said:

> I have never ceased to cherish [the man] and to serve [him] as best I can from the day I called upon him in his legendary souvenir shop, on a visit that remains one of the dearest memories of my youth. There he was, the bearer of the message of the marvelous—there he will always be—like some old magician surrounded by his fetishes and amulets, drawing fantastic polkas out of his harmonium. There he was, and my gaze timidly met his clear, sea-blue eyes.[7]

When the title of "Baron" was conferred on him by King Albert I, in 1929, James Ensor chose as his device: *Pro luce nobilis sum*. He meant in fact *Pro luce Ostendae nobilis sum*: the wonderful light of Ostend, unique on

the Belgian coast; the subtle, rarefied effects of light on sky and water, the light that swells up from the sea like a tide across the dike, vibrating on the roofs, the light that slips through the thick curtains into gloomy interiors, like gold powder. Ensor cannot be separated from Ostend, to which he gave the beauty of nobility, and one can wonder whether he would ever have become as famous without Ostend, his one and only love. Ensor was an ascetic who was concerned only with his art. He felt his city and its atmosphere so physically that, in Paul Haesaerts' words, "The spirit of art is embodied in flesh, and the flesh of Ensor's art is that of his city."[8] He certainly never learned to paint at the Académie Royale; rather, he discovered the art of painting in himself and through Ostend. And in his daily contact with the sea and its mirages of ever-changing color nuances, Ensor found great and lasting consolation:

> Pure sea, inspirer of energy and steadfastness. . . .Medicinal sea, worshipped mother, I should like to offer one fresh, simple bouquet celebrating your hundred faces, your surfaces, your facets, your dimples, your rubescent underparts, your diamond-studded crests, your sapphire overlay, your blessings, your delights, your deep charms. . . . Let us be great and deep like the sea.

At the outbreak of the war in 1940, when Ensor was eighty years old, many of his friends tried to convince him of the dangers to which he was exposing himself by refusing to leave Ostend. He replied to their urgings that he leave: "I prefer to throw myself out of the window." And yet he knew his life was at stake in Ostend. In 1940 the Museum—hardly two hundred yards from his house—was completely destroyed, and some time later his studio was damaged by high-explosive shells.

Perhaps he was right to stay. If he had quit Ostend, to live in another, safer town or in the open country or even in the gloomy silence of the woods, his longing for the moving immensity of the murmuring sea would probably have been too much for him.

Once, during the war, while he was clandestinely listening to the BBC, Ensor heard the erroneous announcement of his own death. But he was not at all moved by the news, because he had long known that only those who accept death may live in complete liberty. Those who fear it and attempt to avoid it are self-condemned to a life of frustration and conformity, a degrading death-in-life.

In a letter to his friend Robert Croquez, Ensor once wrote: "The Museum of Antwerp has made me repeated offers for the great canvas The Entry of Christ into Brussels, and I could still keep the picture until the wretched day of my death."

James Ensor died on November 17, 1949. Paul Haesaerts described the funeral:

> He was given a king's funeral. The whole city, the whole of Belgium, accompanied him to the grave. The last procession through the streets of Ostend could not fail to evoke the Carnival-like Entry of Christ into Brussels, which he had painted more than half a century earlier. Around the sacred relic—in the picture it had been the small, haloed figure of the God on a donkey, but now it was the painter's own coffin—swirled just such an absurd tide of humanity as Ensor had painted in his heyday. Among the swarming masses were ministers in full regalia, ambassadors in their cocked hats, church dignitaries in red and lace, mustachioed generals in showy uniforms, critics sharpening their pens, severely frowning magistrates, schoolboys lined up in rows, the fishermen of Ostend in their traditional brown, the gaping curious, fishwives aroused from their melancholia. Brass bands played, church bells rang out, orators delivered high-sounding eulogies, flags flew at half-mast. All that was lacking to make the masquerade complete were delegations of animal musicians and grimacing fishes, summer vacationers in their bathing suits, hilarious devils, fairies in mourning, and skeletons at once victorious and weeping. It was neither the first nor the last time . . . that a subversive artist, a "madman," an undesirable, had become the pride of the very nation that had despised him. "The people" are quick to seize on a new name to worship, totally indifferent to what that name stands for. So the modern state turns its bad boys into demigods, mounting and stuffing them for exhibition.[9]

There will be no "wretched day of death" for Ensor's art.

<div align="right">

FRANK PATRICK EDEBAU
Director, Stedelijk Museum, Ostend

</div>

NOTES

[1]This and all succeeding quotations from Ensor's writings are taken from James Ensor, Mes Ecrits, 5th ed. (Liège, 1974). Translations are by the author.

[2]Was Ensor aware of Leonardo's dream of a similar bird, the subject of a psychoanalytical essay by Freud in 1910?

[3]The "dried mermaids" and "stuffed Chinamen" were composite artifacts made from parts of various sea creatures.

[4]Paul Haesaerts, James Ensor (New York, 1959), p. 50.

[5]Jean Tengels, Variations sur James Ensor (Ostend, 1931), p. 71.

[6]Robert Croquez, Ensor et le Rotary, "Preface" (Ostend, 1973), p. 15.

[7]P. Haesaerts, James Ensor, p. 11.

[8]Ibid., p. 44.

[9]Ibid., p. 230.

James Ensor and the Art of His Time

In 1949, when James Ensor died at the age of eighty-nine, he was respected and beloved by his countrymen and eulogized by critical consensus as the greatest Belgian artist of modern times. During the last two decades of the nineteenth century, the startling originality of his prolific art put him among the least appreciated and most misunderstood artists in Europe. Yet the commercial and critical success garnered in his later years was strangely accompanied by a decline in the quality and power of his art. Such irony is not unique in the history of art, but perhaps no other artist worked on for so long in comparative mediocrity after assuming such a radical and spectacular position in his early career.

As a young man, Ensor was so combative and abrasive that he rejected even the circle of companions who, as fellow artists, shared his distaste for the authority of a moribund art establishment. He worked alone, experimenting ceaselessly and producing what is now accepted as a magnificent and prodigious oeuvre. Within the framework of his isolated activity and irritable disposition, it is not difficult to see why he was disliked, or why few of his contemporaries exerted themselves to understand his motivations when, after a brief academic apprenticeship in the realist school of painting, his palette burst all bonds of respectability and he began to flood his canvases with disturbing imagery conveyed through a rich range of stylistic modes.

The fact that Ensor's work does not look like that of his fellow Belgians and seems light years away from French painting should not lead to the conclusion that he was no more than a lonely eccentric, conditioned by an intangible Flemish nationalism or racial spirit. This is a not uncommon interpretation of his art—especially by Belgian critics—and there is no doubt that the palette, forms, and fantasy of his artistic antecedents in the Low Countries were sources to which he returned frequently. Bosch, Brueghel, Rubens, Rembrandt: all were so intimately familiar to Ensor that their reincarnation under his brush and etching needle seems inevitable, quite natural, and, indeed, almost spiritual. On the other hand, his painting is inexplicable without a consideration of the aesthetic ferment taking place in the Paris and Brussels of his time.

Ensor's maturity coincided with the richest moment in the artistic history of his country since the time of Ru-
bens; he observed, participated in, and then rejected much of what was available to him—a deliberate and clear repudiation that emphasized his self-consciousness and identifies him firmly with the philosophical attitudes of his era. In one sense Ensor exceeded his contemporaries, his acute sensitivity to social and political pressures drawing a reaction from him so unflinchingly direct that other responses, by contrast, seem arty and disdainful. That is certainly another irony, perhaps even a contradiction, in Ensor's character: He was so often aloof, yet ever ready to use his art as a weapon on behalf of social causes.

Despite this apparent disavowal of *l'art pour l'art*, no artist working in the closing years of the nineteenth century can have been more attuned to the expressive potential of style, technique, and iconography. Ensor's facility and intelligence rarely erred during the 1880's and 1890's, when constant experimentation with new methods was carried on not in search of some stylistic perfection or eternal truth but in order to present the idea at hand with the greatest clarity. Ensor's formal solutions are the means to his eloquence.

Viewed in the context of Belgian art in the 1870's, his family situation, and his environment, Ensor's accomplishments are quite extraordinary, for he was, in truth, a provincial in a nation of slight artistic consequence. At the time of Ensor's birth, Belgium, notwithstanding a noble past and a rich patrimony, was artistically insecure, its academies and salons reflecting, somewhat dimly, events and styles originating in Paris. Jacques-Louis David, an exile from France living in Brussels (where he later died), had found willing pupils in Belgium. His formidable and austere neoclassicism was continued in the work of François-Joseph Navez and lesser artists, while Baron Wappers effected a robust romanticism by combining aspects of Rubens and Delacroix.

The most arresting Belgian artist of this period was Antoine Wiertz, whose works are now almost entirely confined to his former atelier in Brussels. His training began at the Academy in Antwerp during the early 1820's, after which he traveled to Paris and Rome, developing a taste for the grand manner. Returning to Brussels he set up a studio in which he constructed huge canvases treat-

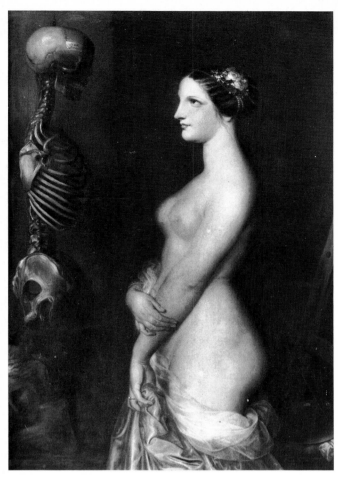

Fig. 5. Antoine Wiertz. *La Belle Rosine*. 1847. Oil on canvas. Collection Musées Royaux des Beaux-Arts de Belgique, Brussels.

erotic works were accepted with relish. The titillation of thrust and counterthrust between courtesan, roué, death, and retribution accorded well with the sophisticated Parisian society of that time and anticipated Toulouse-Lautrec's fascination with this demimonde by several decades (Fig. 6).

Rops' fashionable Belgian contemporary was Alfred Stevens, and the contrast between their works is most instructive. Superficially, they are alike in style and technique—although Rops was principally a graphic artist and Stevens a painter—but their perception of similar subject matter was totally different. For, while Stevens chose to enter the uneventful world of bourgeois society at home, where eroticism was implicit in the act of a young woman receiving a male caller or simply reading a love letter (Fig. 7), Rops preferred to stand outside,

ing great themes. His paintings often dwelt on morbidity, as in *La Belle Rosine* (Fig. 5), probably his most famous work; but many other works are even more bizarre and idiosyncratic in their iconography and style. Even though his works may be unknown outside Belgium today, any history of late-nineteenth-century Belgian painting must reckon on his influence, for he was an acknowledged pioneer in the curious taste for the shadowy and the enigmatic—qualities characteristic of a certain sensibility at the end of the century.

It is doubtful, though, that the average Frenchman knew or cared what went on two hundred kilometers north of Paris. Baudelaire traveled to Brussels in 1864 and confirmed that the apparent lack of art in Belgium was a sad truth: Only painters of lowly themes existed there, all specializing in narrowly prescribed areas of subject matter and content.[1] Furthermore, the most promising and original Belgian artist of that time, Félicien Rops, had moved to Paris, where his wicked and

Fig. 6. Félicien Rops. *The Shame of Sodom*. n.d. Etching and aquatint. Collection The Art Institute of Chicago, Charles Deering Collection.

the better to reveal the tensions and passions masked by these elegant and elaborate games.

What unites the group of artists exemplified by Rops, Stevens, and their contemporaries Leys and de Braekeleer (Fig. 8) (Antwerp artists whose work is not so much Belgian as consciously Flemish) is their common allegiance to the "realism" taught in the academies, an inspirational or nationalistic realism that transcended the problems of a workaday world. Contiguous to the contrivances of this approach, however, there existed a Pleinairism and naturalism comparable to that of the Barbizon School in France, represented by Hippolyte Boulenger (Fig. 9), Louis Artan de St.-Martin (Fig. 10), and Guillaume Vogels (Fig. 11), whose work was char-

Fig. 7. Alfred Stevens. *The Gift.* ca. 1865-70. Oil on canvas. Collection The National Gallery, London.

Fig. 8. Henri de Braekeleer. *The Dining Room in Henry Leys' Town House.* 1869. Oil on canvas. Collection Koninklijk Museum voor Schone Kunsten, Antwerp.

acterized by an impressionistic concern for light and truth to nature, and who placed themselves outside the establishment.

Thus, the state of the arts in Belgium when James Ensor began painting in the late 1870's resembled that of France in several ways: Control was held by the academies, which stressed the carefully taught principles of accurate observation and representation; there was considerable dissatisfaction with existing systems of exhibition and patronage; and a minority of independents among artists were working mostly in a *plein-air* technique. The national consciousness was, however, quite unlike that of France; the basis for its artistic pride resided more in its past—particularly the fifteenth and

Fig. 10. Louis Artan de St.-Martin. *Day.* n.d. Oil on canvas. Collection Musées Royaux des Beaux-Arts de Belgique, Brussels.

Fig. 9. Hippolyte Boulenger. *The Flood.* n.d. Oil on canvas. Collection Musées Royaux des Beaux-Arts de Belgique, Brussels.

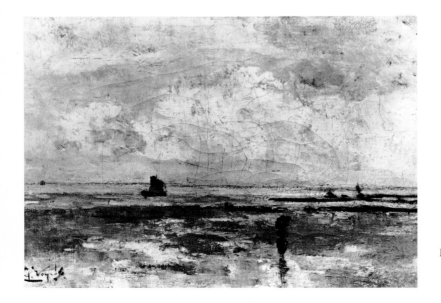

Fig. 11. Guillaume Vogels. *Beach.* n.d. Oil on canvas. Collection Musées Royaux des Beaux-Arts de Belgique, Brussels.

seventeenth centuries—than in its present. Moreover, the country, being very new and very small, displayed an understandable defensiveness in its attitude toward France, the seductive and sophisticated capital of the art world and consequently an omnipotent preventive to the development of a native Belgian art. Ensor was probably not aware of these wider-ranging issues when he first evinced an interest in drawing rather than in academic schooling, but they inevitably helped form him as he matured.

A few paintings survive from as early as 1876, when Ensor was only sixteen years old. By then he had received some instruction from two local Ostend artists: Michel van Guyck and André Dubar. Little remains of their work, but one may assume that van Guyck, having an academic reputation, taught Ensor some technique, and that Dubar, known for his landscapes, coached him in the early sketches of the coast and dunes. These first paintings are very simple representations of the countryside, principally the great dunes that line the coast north and south of Ostend. Strikingly similar to the work of Boulenger and Vogels, the colors are concentrated in the middle range of values, mostly gray-greens to gray-blues flecked with white and some pure colors. People seldom appear in these scenes.

In 1877, Ensor enrolled at the Académie Royale des Beaux-Arts in Brussels, under the tutelage of several now-forgotten painters who failed to appreciate his independent nature. If he had not done much in the way of drawing before attending the Académie, thereafter his production of sketches became prodigious; as much as Ensor hated the Académie, this discipline probably did him no harm.

Beyond academic training was the far more arousing discovery of the world in ferment—artistically, socially, and politically. During these student years Ensor became part of a group of rebellious and reform-minded anti-establishment artists. Among this group at the Académie were Fernand Khnopff, Symbolist painter, and Willy Finch, another Belgian of English ancestry. In Théo Hannon, a dilettante painter and writer, Ensor found another kindred spirit. Hannon gave the young Ostend student access to a circle of intellectuals by introducing him to his sister Mariette Rousseau, who was a respected scientist and the wife of Ernest Rousseau, the rector of the Université Libre de Bruxelles. Their house was often the meeting place of liberal spokesmen and other free thinkers, so it seems reasonable to assume that Ensor either acquired or strengthened many of his radical notions there.

Biographers have made much of this period in the artist's life. He is said to have met Félicien Rops at the Rousseaus', and their son, Ernest, became one of Ensor's closest friends. F.-C. Legrand speculates that the grand diversity of natural scientists, mathematicians, and scholars of all sorts who frequented the Rousseaus' home opened Ensor's mind and eyes to new visual possibilities: "The infinitely great, the infinitely small, the invisible, the subconscious creating new fields of experience."[2] Ensor, who seems never to have forgotten or failed to find visual stimulation in anything, was introduced to the world of the microscope by Mme Rousseau, and images found in his later drawings and paintings are probably directly attributable to this experience.

A number of drawings can be identified with some certainty as belonging to this period, especially some representing biblical and ancient scenes, as well as a few academic studies of the nude (Pl. 51). These last are quite routinely and respectably drawn, although a satire Ensor wrote later about life at the Académie leads the reader to infer that he was not always a willing pupil.[3] In this short piece, Ensor (identified only as a future member of *Les Vingt*) is corrected by three professors for emphasizing color rather than drawing. He did, in fact, win second prize for a drawing after the antique, but it was the only recognition he ever gained during his years there.

He also produced a number of narrative drawings, *all' antica* (for instance, Pl. 52), and a few oil sketches of biblical scenes. The technique of these oil sketches is rather heavy-handed. *Judith and Holofernes* (Pl. 7), for instance, would have remained an undistinguished memento of his years at the Académie without the bizarre and comic touch provided by the artist's having inserted into the biblical scene—probably years later—incongruous biomorphisms, which seem to have come from one of Mme Rousseau's microscope slides. The light palette and assured style of these animal forms contrast with the melancholic weight of the original scene. Furthermore, Ensor's "improvement" indicates a peculiar aspect of his creative sensibility: He had little or no feeling that the work of art was unalterably complete, and he often revised his pictures—almost always in a manner that transformed their meaning or mood.

Self-mockery and irony did not become part of Ensor's art until later. He began to do self-portraits as early as 1878, but the small oil study of 1879 (Pl. 1) shows him still as a serious and conventional artist at his easel: The painter earnestly studying his own callow countenance. The face, moustachioed but as yet lacking a beard, peers closely at its subject, in order to assimilate the formal lessons. And Ensor did learn those lessons. He drew everything he saw around him—family and friends, people on the street, objects—studying structure and analyzing the light that both created and destroyed form. There are also a number of finished subject drawings from

about 1880, one of the most spectacular and informative a sheet he produced at the very end of his tenure at the Académie representing the *Death of Jezebel* (Pl. 53). It is laden with mystery and foreboding, in a style decidedly nonacademic. Its exoticism and expressive use of *chiaroscuro* suggest Ensor's interest in some works of the late 1870's by the French painter Gustave Moreau. Two of these works especially, representing Salome, are closely related to the *Jezebel* in their composition, style, and taste for high drama.[4] It was around this time that Belgians began to discover Moreau, who was to exert a considerable influence on the Symbolist movement in Belgium. Khnopff, for instance, Ensor's fellow academician, had seen Moreau's paintings in Paris as early as 1877 and adopted a similar manner on his return home.

In light of Ensor's further development and his inclination to the eccentric, it seems strange that the possibilities manifest in *Death of Jezebel* did not immediately become the focus of his concentration. Instead, he returned to Ostend in 1880 and set up a studio at the top of his family's house, where his determination to pose and solve problems took the form of a constant scrutiny of his own family, resulting in a vast number of scenes and portraits.

The output of drawings from this period is prodigious. Mainly small in scale, captured in rapid charcoal or pencil strokes, and sometimes augmented with colored chalk, they confirm Ensor's assimilation—reluctant though it may have been—of the academic formulae for rendering mass and texture.[5] There are occasional watercolors, and his first major paintings also date from 1880. In his essay for this work, Frank Edebau has described that Ostend household, where mother, father, sister, and aunts lived in constant tension. In Ensor's paintings the endless ritual of home life is set down over and over again with minor variations, and it appears to have been a domestic situation in which Ensor's father rarely participated. Considering the physical closeness of the situation and Ensor's sensitivity to it, the objectivity with which his sketches are endowed is amazing; they seem as dispassionate as his studies of mere things, devoid of any sentiment on the artist's part. Judging from the numerous representations of his sister, who was a year younger than he and nicknamed Mitche, Ensor must have preferred her as a model. We see her reading, writing, or sitting in silent contemplation (Pls. 55, 59, 62) but still gain little notion of Ensor's real feeling for her.

These family sketches are the basis for Ensor's earliest masterpieces, a group of paintings showing the interior of the house and its inhabitants. His still-dark tonality evokes not only the actual dimness of rooms lit by Ostend's north light but another, less explicit sensation

as well. As in the drawings, there is a lack of animation, a stillness about the subjects, an oppressive gentility cast over the family, who are dressed in their best clothes to entertain guests or perhaps in readiness to attend some event outside.

Ensor prepared extensively for these deceptively off-hand representations of middle-class life, both in the figure sketches and small preliminary oils of the full composition. In the study made in 1880 for the *Bourgeois Salon* of the following year (Pl. 4), it is possible to understand the Académie's impatience with its headstrong student; notwithstanding its low-keyed tones, the work bypasses compositional precision to dwell on color and mood. The qualities of densely filtered sunlight and hushed atmosphere are the subject and the structure of Ensor's endeavor. *Russian Music* of 1881 (Pl. 8) is one of Ensor's first set pieces of this type, but its lack of sentimentality, by contrast with the genre's established code, doomed it to critical failure. More anecdotal than most of his other paintings at the time, this surprisingly intimate and personal work, which shows his friend Willy Finch listening to Mitche playing the piano, still could not satisfy the public's desire for narrative exposition. Furthermore, his painterliness did nothing to appease their appetite, since any detail he had included was lost in a blur of twilight haze—also a transgression to those who demanded compositional clarity in addition to unambiguous content.

One of the most extraordinary pictures from these first years away from the Académie is the puzzling *Woman in Distress* of 1882 (Pl. 10). In a room dappled by patches of golden light and gloom, Ensor's sister lies half hidden in bed, curtains drawn behind her—an enigma only partially explained by the title of the work, first known simply as *Troubled*. Again, the medium of light is prevalent, and the psychological problems of the unstable and unhappy Mitche, whose life was dominated by three older women (and later a failed marriage), are transmitted through its fluctuations.

Many years later Ensor unburdened himself to his patron, Emma Lambotte, describing the strain of his achievements during those years. "Yes, I have worked hard, especially in 1880, 1881, and 1882. But the pain, uncertainty and daily worries were not good for my work."[6] For relief from family anxieties, he turned to other models. Though few of his paintings show life beyond the Ensor household—the monumental *The Rower* of 1883 (Pl. 13) is a major exception—and the sketchbooks are also confined to domesticity, some of his most finished drawings portray the local working class or his friends.

Fellow artists, such as Guillaume Vogels, Willy Finch, and Théo Hannon, appear with such frequency as

Ensor's models that it must be supposed he maintained not only friendship but also a working relationship with them. Finch was his favorite model, often seen posed at his own easel (Fig. 13). The early friendship with Théo Hannon, who, never a very serious artist, later became a critic (thereby cooling off their former rapport), is well documented by affectionately drawn works in which Hannon is the subject (Pl. 60). Vogels seldom appears as an Ensor model, but because he was a pioneer Plein-airist he could easily be associated with the engaging picture of an artist among the dunes entitled *The Painter and His Model* (or *Model in the Dunes*).

A considerable advance over his academic work is evident in the high quality of several of Ensor's drawings from 1880, where outline is suppressed in favor of mass. An insistence on the importance of form in these inaugural portraits is strengthened by the exclusion of competitive environment and by the uncomplicated poses of the sitters.

In keeping with his early development, Ensor's landscapes in the 1880's often appear to be completely ingenuous, composed of nothing more than sea, sky, and dunes. It is a quality of the Belgian coast that no strong contrast exists among these elements, and one perceives a unity rather than the sharp distinctions found farther south. Ensor and Vogels emphasized this in their seascapes, playing down any possible pictorial distractions. Sailboats are mere notations in an overall field of sea and sky entitled *After the Storm*, 1880 (Pl. 2), a painting of such coloristic intangibles that it is nearly impossible to reproduce—but a joy to confront.

Even at this stage of his life, Ensor was mindful of the urban environment, which later replaced his poetic landscapes and sea views. He obviously saw a great deal from his studio window, as there are a number of early studies showing Ostend rooftops, including an impressionistic rendering of the Vlaanderenstraat (Pl. 3). The street is devoid of traffic, and the snow (unusual for Ostend) softens and disguises the angles and edges of the buildings.

It must not be thought that Ensor isolated himself in Ostend, either socially or artistically. He continued to enjoy the exciting environment provided by visits to the Rousseaus in Brussels, and he began to submit his paintings for exhibition quite soon after leaving the Académie. Several new exhibition groups had been formed, declaring themselves independent of the established salons, which were characterized by narrow standards and an intolerance for nonconformists. In 1881, Ensor participated in the first show of the art circle *La Chrysalide* in Brussels, where he was joined by at least two of his comrades from school days, Willy Finch and Théo Hannon, and other Belgian artists including Constantin Meunier, Pericles Pantazis, and Guillaume Vogels. Ensor

chose to enter several of his Ostend interiors, including the final version of the *Bourgeois Salon*. His efforts received a perceptive and nearly cordial review from the critic of *L'Art moderne*, Jean François Portaels, who, as director of the Académie during Ensor's stay there, was beguiled by one of the young artist's drawings and hung it in his studio. He wrote:

Among new arrivals, James Ensor seems full of promise and has attracted attention. His sketches reveal an attentive observation to the effects of light and air, a finesse in producing certain tonalities, and an extraordinary lack of banality for a beginner. There are the makings of a painter here, but there is also scorn for drawing, modeling, and perspective. M. Ensor should not fool himself: Talent is not complete without the science of form.[7]

Portaels, in what may be surmised was Ensor's first mention in print, thus laid down the foundation for future criticism of his work: favoring the emphasis on atmosphere and sensitivity to the effects of light, but deploring the lack of strength in formal design.

Ensor exhibited or submitted his work both within and without the establishment during these early years. There is no evidence that he scorned attention from the conservative art world. He sent a painting titled *Chez Miss*, probably to be identified with *Russian Music* (Pl. 8), to the 1881 *Exposition Générale des Beaux-Arts*; two canvases went to the Paris Salon in 1882; and, more significantly, he allied himself with an organized group of artists exhibiting under the name *L'Essor* in Brussels. Seven of Ensor's paintings were hung in the group's sixth exhibition in 1882, and five were exhibited with them the following year. He was again praised by the critic of *L'Art moderne*: ". . . we will see him among the top positions in the next years."[8] In the same year Ensor showed in the Ghent Salon, and Emile Verhaeren, the influential and intellectual Belgian critic and poet, wrote: "His works are hung sky-high. Patience, the day will come when he will be judged worthy of a better place."[9] In fact, 1883 was the final year for *L'Essor*, and in October the formation of *Le Groupe des Vingt* in Brussels was announced. This organization, under the guidance of Octave Maus, lawyer, amateur musician, and enthusiast for modern art (Fig. 12), achieved the culmination of the avant-garde movement in Belgium in the late nineteenth century. It was as much a literary movement as a visual one, exciting a great efflorescence of belles lettres from Belgians like Maurice Maeterlinck, Georges Rodenbach, Eugène Demolder, and Emile Verhaeren.

In 1880 some of these artists, seeking an outlet for their mature talents, had founded *La Jeune Belgique*, the voice of an incipient Symbolist movement in literature. The following year *L'Art moderne*, its counterpart in

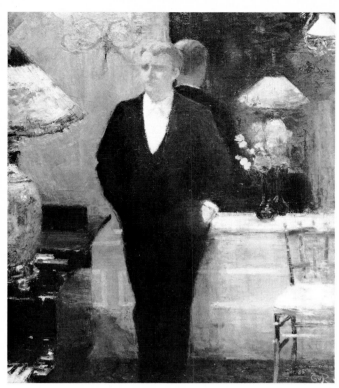

Fig. 12. Théo Van Rysselberghe. *Portrait of Octave Maus.* 1885. Oil on canvas. Collection Musées Royaux des Beaux-Arts de Belgique, Brussels.

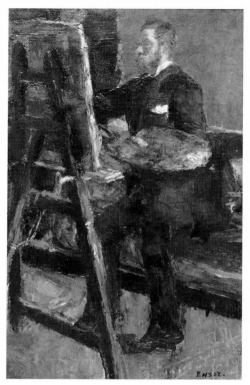

Fig. 13. James Ensor. *Portrait of Willy Finch.* ca. 1882. Oil on canvas. Collection Koninklijk Museum voor Schone Kunsten, Antwerp.

artistic criticism, appeared for the first time, later becoming the semi-official organ of *Les Vingt.*

Les Vingt's members were egocentric, and the group's history was stormy. The initial members included Vogels, Ensor, Khnopff, Pantazis, Théo Van Rysselberghe, Willy Finch (Fig. 13), Willy Schlobach, and others, making up the number twenty. The artists themselves set policy, with Maus acting as secretary. There was no manifesto, except assurance of freedom of expression for the members, a privilege difficult to obtain in the more official exhibitions and competitions.

For Ensor *Les Vingt* came into being just in time. His works were becoming increasingly ambitious as his palette cleared and brightened. In 1882 his most vibrant work to date, the stunning *Woman Eating Oysters,* was executed. Today, it is one of the treasures of the Koninklijk Museum in Antwerp, but it was flatly refused at the Antwerp Salon of 1882 and even by *L'Essor* in 1883. In 1884, Ensor's entire submission to the Brussels Salon was rejected, *Woman Eating Oysters* being refused because of its "lack of form"—the judges were maddeningly insensitive to the vital brilliance of reflected and filtered light throughout the exquisite still life on the table. Only Verhaeren perceived its true qualities: "The jurors must know that in closing the door to a talent and a colorist like James Ensor they are making themselves look ridiculous."[10] This picture has been termed the first of Ensor's

works in the luminous, coloristic mode characteristic of his maturity. Although these changes alone may account for its initial rejection, the subjects of his paintings were becoming far more personal, unconventional, and consequently too discomforting for acceptance.

In 1883 he painted his last great canvases in an essentially realist manner, stretching this technique to its limits of expressiveness. One feels in him, at this point, an impatience with the old forms. *The Rower,* a monumental figure conceived with bold breadth and painted with a palette knife, remains close to earlier works, but two other paintings of that year show Ensor moving in a new direction. *The Drunkards* (Pl. 12), two besotted Flemish farmers in a tavern, creates a shocking impact, baffling in its power because the scene is nearly static. Van Gogh's early works share this characteristic, but *The Drunkards* is a far more sophisticated and competent excursion into psychology and social commentary. In its sensitivity to the degradation of the subjects, the painting is actually closer to the work of Degas, although his work was probably not exhibited in Belgium earlier than 1885.

Ensor's second significant work of this year is less easy to grasp. It carries the title *Scandalized Masks* (Pl. 14), apparently Ensor's own invention, since he reused it *(Les Masques scandalisés)* on the plate of his etching from this composition twelve years later, but the title does not

satisfactorily explain the situation. In a drab room, furnished only with a table and chair, dimly lit by a hanging lamp, two figures in Carnival masks confront each other, one sitting at the table on which a bottle stands and another entering the doorway. There is no action, each figure seeming spellbound by the presence of the other, but the effect is dramatic and frightening. The place of this strange scenario within the iconography of Ensor's art has been misunderstood; it is almost certainly the first appearance of the mask in his work, a motif inextricably associated with his later artistic idiosyncracies. But the riddle of this baffling composition cannot be unraveled unless it is compared with other paintings from 1883. In that ambience it becomes quite simply another genre scene as bleakly realistic as *The Drunkards,* with the same negative social implications. Ensor's vision had not yet transcended the face value of his native city's customs, among which Carnival was a major event —both historically and practically, in its relation to the family shop, where Carnival masks were sold. Perhaps, as Libby Tannenbaum has intimated, the two pictures represent a symbolic reaction to his father's alcoholism.[11]

Critical perception of Ensor depends to a great extent on how the works of this period are interpreted. Traditional opinion has held that his macabre inventions date from as early as 1883, when he was working in relative isolation in Ostend. But it has recently been shown that the elements of fantasy and caprice for which Ensor is famous were not indigenous to compositions from the early 1880's and, indeed, were added to them years later by the artist, totally changing their original character.[12]

One example is the famous *Self-Portrait in a Flowered Hat* of 1883 (Pl. 15), in which Ensor represents himself in a wonderful hat festooned with flowers and feathers. It is amusing, full of the self-mocking whimsy with which Ensor endowed his mature works—stylistically adroit and sophisticated in its obvious derivation from the artist's great predecessor, Rubens. Marcel De Maeyer examined the portrait very carefully, however, and found the original painting of 1883 quite conventional and not unlike the earlier likeness of 1879 in its general appearance.[13] Sometime later—De Maeyer suggests no earlier than 1887 or 1888—Ensor added the gay hat in this work and began to work over many other paintings and drawings, adding skeleton and mask motifs and the strange creatures he may have observed in Mme Rousseau's microscope.

De Maeyer has noted this same treatment in *Skeleton Studying Chinoiseries* of 1885 (Pl. 21), apparently begun as an intimate interior, perhaps like the *Bourgeois Salon* (Pl. 4) with a single figure, reading.[14] A careful investigation of the painted surface shows that the skull has been superimposed on a normal head.

Changes can also be distinguished in *Girl with Doll* (Pl. 18), dated 1884. Undoubtedly begun in the manner of his first style, the addition of an orientalized and embryonic creature resembling the ectoplasm of seances and a gaudy splatter of peculiar floral patterns on the wall invests the picture with intentionally uneasy overtones. The original space is choked by a new insistence on patternistic effect, and both the little girl and the doll she holds have been altered by some vague but disquieting obliteration of contour.

Two radiant landscapes of 1885, *Rooftops of Ostend* (Pl. 20) and *Hôtel de Ville, Brussels* (Pl. 19), herald the significant changes initiated in the next two years. Familiar silhouettes of the city become indistinct, crumbling under the force of a cosmic gilding which penetrates their structure. Ensor never comes quite as close to French Impressionism again as in these paintings. Turner's influence has also been suggested, but Ensor's only probable contact with the English artist's experiments in colorism, apart from reproductions, would have been a trip to London in 1892.[15] So the question remains: What catalyst triggered such a radical change in Ensor's artistic vocabulary? It seems likely that the answer lies in contacts made through *Les Vingt* and within the increasing cosmopolitanism of Brussels. At the first exhibition of *Les Vingt,* James McNeill Whistler showed his "color arrangements," which were both scorned and influential. Verhaeren, perceptive as always, found them contrived and antirealist, but the products of a remarkably talented vision.[16] Ensor must not have approved, since he later tried to prevent Whistler from exhibiting with the group, but this does nothing to deny the possibility that he responded subconsciously to these explorations. He was also exposed to French painting when Durand-Ruel exhibited Degas, Renoir, and Monet in 1885 at a hotel in Brussels and again the following year when Monet, Renoir and Rodin were invited to participate with *Les Vingt.*

Ensor's own powers of invention were so great that his development must not be seen as merely a chronology of reactions to challenges from other artists, but it is true that he frequently found incentive in a multiplicity of styles and techniques, and the considerable body of drawings he made in 1885 signifies a time of experimentation. *Rooftops of Ostend,* one of the relatively few paintings from that year, announces his interest in the expressive possibilities of light: "Light ought to be the vehicle for all grand aspirations," he said in a letter of 1894 or 1895.[17] The drawings show that he was immersed in a study of other artists' techniques.[18] This was a common practice of academic training which Ensor had followed at school, but it is significant that he made

so many copies in the very years when he was becoming increasingly individual. His intense study of the old masters of the seventeenth through the nineteenth centuries helped to free him from vestigial restraints of the realist school in which he had been nurtured. Even though Ensor may not have seen Turner's paintings, he was acquainted with reproductions of them and copied several. Schoonbaert has discovered the specific sources for many of these, including *Polyphemus Ridiculing Odysseus (Copy after Turner: Sunrise)* (Pl. 79), which is cited on the reverse of Ensor's drawing, in his own handwriting, as coming from a book by Ernest Chesreau.[19]

Above all, Ensor looked carefully at the works of Rembrandt, especially the prints, adapting their mystical chiaroscuro in drawings like *Copy After Rembrandt: Death of Mary Magdalen* (Pl. 66). Rembrandt's power to create drama through light, exploiting the white of his paper overlaid with a few deft strokes, obviously helped Ensor develop an effective graphic technique. Rembrandt's influence upon Ensor's choice of subject matter is paramount, for religious themes play an increasing role in his art after 1885 and surpass the academic treatment which they had received in his earlier works.

Another aspect of Rembrandt's character that must have struck a responsive note in Ensor was the artist's

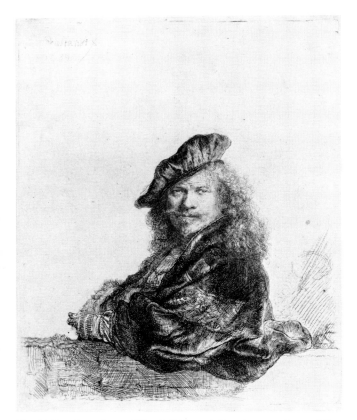

Fig. 14. Rembrandt van Rijn. *Self-Portrait Leaning on a Stone Sill.* 1639. Etching and drypoint. Collection The Art Institute of Chicago, Clarence Buckingham Collection (1938.1791).

preoccupation with himself as a subject. Ensor's self-portrait in charcoal (Pl. 86) is far more interesting than any of those he had previously executed, and may owe its greater appeal to a study of similar works by Rembrandt. Several copies of Rembrandt's self-portraits, including one dated 1886 (Pl. 76 and Fig. 14), show an absorbing personal introspection and reveal a tendency to pose.

Ensor's copies after Thomas Rowlandson seem a surprising idea at first, since Rowlandson was not well known outside England and demonstrated a peculiarly eighteenth-century taste. The satirical mode suited Ensor, however, and reflections of Rowlandson's coarse caricatures (Pl. 73) as well as the more sophisticated burlesques of Daumier (Pl. 64) and Goya (Pl. 69) are unmistakable in the development of his socially conscious art.

Other, less political artists also fascinated him, and he copied Puvis de Chavannes, Dürer, and Delacroix in order to build his technical resources. His *Lion* after Delacroix (Pl. 65) is almost pure calligraphy, in a style he never essayed before, and must have been an important lesson; no original subjects in Delacroix's style appear in Ensor's work, but the impact of theatrical linearism was not forgotten.

The fruits of this unflagging study were soon realized. The next few years were crammed with active production, incorporating his most astonishing innovations; the "sources" transformed into a unique and devastating iconography realized in a variety of dazzling styles. Until this time his career could be summed up as that of a moderately independent artist with a conservative background, who had offended a few dogmatic academicians, but from 1885 on he offended nearly everyone, even some of his closest associates. For an increasing number of satirical compositions, Ensor used explicitly scatological devices which are still shocking today. Obscenity, socialism, and dream imagery mingled on his fantastic picture surfaces—sumptuous and painterly, or linear and graphic. His penchant for light and coloristic values never waned, in fact was pressed to greater heights, but his work became truly modern in its arbitrary manipulation of space, form, and color.

The diversity of his work after 1885 is so immense that no general description fits the period, but one common trait is the integration of form and content. *Girl with Doll,* for instance, as reworked (Pl. 18), is divested of sentiment by the intentional crudeness of its brushwork. But it was the adaptation of his environment in tandem with his artistic heritage that occupied Ensor's most intense efforts. A drawing of 1885, which he titled on the sheet *Masques et marmousets (Masks and Grotesque Figures)* (Pl. 68), transforms the Belgian Carnival holiday into an ominous event reminiscent of Goya's hor-

rors. Such a setting gave Ensor license to enter the world of fantasy while simultaneously recognizing reality.

Religion, too, underwent an audacious metamorphosis at Ensor's hands. Sometime before the 1887 exhibition of *Les Vingt* he wrote Maus saying that he wished to enter a painting, *Christ Walking on the Water*, and a series of drawings that he called *Visions* and which he subtitled *Les Auréoles du Christ ou les sensibilités de la lumière*.[20] His mission as stated in the title, to explore the mystical properties of light, perpetuated itself in his work for the next decade. The composition of the first drawing from 1886, *The Gay: Adoration of the Shepherds* (Pl. 70), is crowded with anecdotal detail. Rustic spectators press forward to catch a glimpse of the Holy Child lying in luminescent glory at the center, a mangy dog scratches himself, and a farmer is shown in the act of killing the goose that will be his offering. While the prevailing mood is not actually gay in accordance with the title, it is at least serene, bathed in a joyful light suggesting the chiaroscuro technique of Rembrandt's *Hundred Guilder Print*, and the homely worshippers are gently dealt with.

Not so in the remainder of the drawings. *The Alive and Radiant: The Entry into Jerusalem* (Pl. 77), one of two in the series datable to ca. 1886, borders closely on profanity: Christ, riding an ass, is nearly lost in the midst of a grim crowd that welcomes him with sarcasm, spelled out on banners reading, "Les Charcutiers de Jerusalem," "Les XX," "Colman's Mustard," "Vive la Sociale."

The Sad and Broken: Satan and His Fantastic Legions Tormenting the Crucified Christ (Pl. 72) is a powerful heresy: a skeleton climbs the cross to feed on Christ's body while wraiths and monsters whirl about below. Now the source of light emanates not from Christ but from a host of angels in the sky. The face of Christ is totally obscured by the lack of light and the hands of a molesting demon. It may be that Ensor alludes here to his own persecution in a dark analogy with that of the Savior, for in an 1895 etching of the same scene the face of Jesus bears Ensor's own features (Pl. 50). There seems to be no precedent for the manner in which these themes were attacked; in art, the Passion had never before been so closely correlated with outrage. An unorthodox spirit of deep pessimism is transmitted through the powerful techniques that Ensor had to invent for his purpose. Since he never expressed any allegiance to organized religion, it seems likely that his Christ was intended to represent the nobler side of man's nature, that very quality that Ensor saw society destroying.

Biblical origins can be cited for other drawings from this time. *The Devils Dzittzs and Hihahox* (Pl. 74) is, in addition, one of Ensor's most orientalized ensembles. A skeletonized Satan, seated Buddha-like, and a curious

figure with a halo, waving a sword and riding mounted on a tiger, are certainly extreme examples of nineteenth-century *japonisme*; a complement of bizarre biology—a duck-headed snail and many mutants from the sea—eddies through the murky air. *Christ Driving the Money Changers from the Temple* is remarkably different in style, forbearing to use any contrast of deep shadows with areas of brilliance and achieving its effect instead with a staccato line solidified in a few isolated patches.

Ensor's reliance on pure black and white in this drawing is related to his first known print from the same year, 1886, *Christ Mocked*, based, in turn, on another of *Les Auréoles: The Crude: Jesus Shown to the People*. The etching is precocious for a beginner; as Auguste Taevernier states, "He created a masterpiece at his first attempt."[21] It is not at all clear why Ensor turned so enthusiastically to printmaking when he did. Goya, Rembrandt, and Jacques Callot were acknowledged inspirations and perhaps they challenged him as well. It is probable that after years of conscientious labor to improve and expand his drawing skills, he felt satisfied that the level of artistic maturity he had gained was worthy of this new medium.

In 1886, he produced only seven etchings, but at least one of them, *The Cathedral* (Pl. 96), may be ranked with his greatest accomplishments. In it he makes a typically Ensorian statement on the impoverished moral condition of humanity, playing off the noble structure of the church —an exalted but rare achievement by mankind—against a group of tiny masked faces. His needle is as meticulously applied to the delineation of the impassive crowd as it is to the skeletal gothicism of the cathedral.

Iston, Pouffamatus, Cracazoie and Transmouffe, Famous Persian Physicians, Examining the Stool of King Darius After the Battle of Arbela (the print's full title) raises ridicule to a new level of pungency. From the onomatopoeic names of its ludicrous subjects (recalling Ensor's literary bent for wicked and biting prose) to the parody of Rembrandt's intense early style in etching, it is formidable proof of Ensor's wit and indefatigability. Another print from the same year indicates yet one more aspect of his constant experimentation and proficiency in graphics: the etching and drypoint, *Christ Calming the Tempest* (Pl. 95), in which, with a minimum of strokes, space becomes replete with shimmering light and forms are filled with joy.

At the same time that he was working on nearly abstract canvases, such as *Adam and Eve Expelled from Paradise* (Pl. 22), *Masks in the City*, and *Fireworks* (Pl. 23), Ensor began depicting a world of death and enigma, represented by their symbols the skeleton and the mask. In 1887 Ensor's father died, an event Piron considers critical in the developing obsession with these motifs.[22]

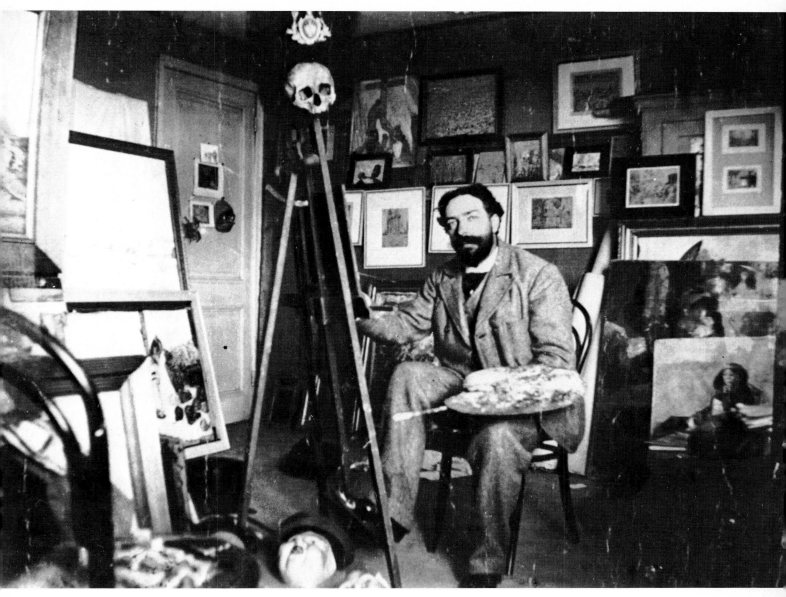

Fig. 15. Ensor in his attic studio. ca. 1900. Courtesy Archives, Stedelijk Museum, Ostend.

Sensitive drawings of his dying father (Pl. 78) break the self-imposed taboo that had denied sentiment in former family portraits. One is also struck by the close physical resemblance between the two men, which Ensor, who had already studied his own face so often, must have been acutely aware of. It is difficult not to interpret his subsequent self-portraits in terms of this identification. For example, in 1886 he drew himself standing before a mirror in the house, sharing the composition with the now familiar Chinese vase (Pl. 71). Sometime later, however, he drew over his own visage, turning it into a skull. A second skull peering over the vase may have been added later. A related print, *My Portrait as a Skeleton* (Pl. 106), is an elegant but not unusual self-portrait in the rare and undated first state, but in later states, dated 1889, the face has been skeletonized. Around 1896, En-

sor made a small painting (Pl. 41) based on a photograph taken in his studio (Fig. 15), where he is seen at his easel surrounded not only by identifiable (and presumably unsold) works but also by skulls and masks; the painting replaces his somewhat arrogant facial features with a grimacing skull.

Skeletons abound in his pictures from this time on. They play billiards and musical instruments (Pls. 83, 91), join the Carnival festivities and—most frequently—perform their anticipated function as the herald of death. One of the most grisly paintings of this period is *Skeletons Fighting for the Body of a Hanged Man* (Pl. 35), made the more ghoulish by the garb of the skeletons, which seems to recall the childhood activity of dressing up in discarded finery, and by the make-believe weapons, a broom and mop, that they wield in battle. A photograph

25

of Ensor and his friend Ernest Rousseau, Jr., engaged in spirited horseplay on the dunes (Fig. 16), reproduces the composition of the central figures. Haesaerts believed that the photograph was posed after the painting,[23] but common sense suggests that the reverse is true.

To attribute this preoccupation with man's mortality solely to the trauma of his father's death, however, would overlook Ensor's deep commitment to art itself and to his own place within the Brussels avant-garde. No later than 1886 morbidity became a recognized factor in Belgian art, combined with a fascination for dreams and the bizarre. Wiertz (Fig. 5) and Rops (Fig. 6) were pioneers in this strange world, but the influence of the French artists Moreau and Odilon Redon, as well as the Belgian literary movement and the presence of young, impressionable artists like Ensor and Khnopff, produced an even more widely expressed and radical change. Redon was well known in Belgium, through exhibition with Les Vingt in 1886 and 1887 and the publication of three albums of prints: Dans le rêve (1879), À Edgar Poe (1882), and Hommage à Goya (1885). The titles of these singular works indicate their fantastic content, which united his exquisite antirealist technique to the most fashionable literature of the time.

Ensor seems not to have been very deeply affected by other precursors of the Symbolist movement, the Pre-Raphaelites or Puvis de Chavannes, for example. In fact he cannot really be called a Symbolist, although he assimilated the fundamentals of an artistic vocabulary from Redon, Rops, and Moreau, who also introduced him to new iconographical sources in Poe and Flaubert. The synthesis is, however, uniquely Ensor's and he experimented in a manner far more inventive than any of his contemporaries.

Though the symbolic meaning of the skeleton, beginning with its appearance in 1886, is conclusively and literally that of death, the meaning of the mask is more complex. The mask was equated with death in one of two paintings by Redon exhibited in Brussels in 1886: The Mask of the Red Death, with a title taken from Poe; in general, however, the Symbolist mask represented a false façade of insincere facial expression. If the Renaissance had postulated that the face expressed a state of mind, then the age of Freud countered with the proposal that the darkest and deepest truths lie buried behind a countenance programmed to conceal. For Ensor the mask carried meaning beyond the literary associations of Redon; he understood its symbolism but related it directly to his own experience, always depicting the type of mask indigenous to the Flemish Carnival, which had been sold on the ground floor of his own house and was worn annually by millions in Belgium's most frenetic festival.

Until about 1883, he had treated such objects as genre details, as I believe he did in Scandalized Masks. Then, for a period of one or two years, he embellished his older works with strange and hideous transformations derived both from his observations and from literary themes. By 1886 he had developed his mature style, involving a confusing and contradictory attitude toward reality that put familiar objects at the service of fantasy. This approach became a means of venting his feelings through the abstraction and distortion of events in his own life.

The juxtaposition of realistic materials in a way that actually undermines naturalism is found in the delightful but cruel Portrait of Old Woman with Masks (Pl. 29). The painting began genuinely enough—one of Ensor's few documented commissions—as a portrait of his Ostend hairdresser's mother. After it was finished—and rejected—Ensor consoled himself with amusing additions to the face: moles, new eyelashes, extra wrinkles, hair sprouting from her chin, and a tangle of faded flowers on her head. Doodling and levity cease where Ensor's insertion of many freakish masks begins; they stare in every direction, unattached to bodies yet most surely imbued with their own ghoulish existence. This is scarcely a Symbolist use of the mask, and the very freedom of its technique and the iridescence of its colors announce an incomparably personal meaning behind the metamorphosis: "O the animal masks of the Ostend Carnival: bloated vicuna faces, misshapen birds with the tails of birds of paradise, cranes with sky-blue bills gabbling nonsense, clay-footed architects, obtuse sciolists with moldy skulls, hairless vivisectionists, odd insects, hard shells giving shelter to soft beasts."[24]

Color and caprice, turbulence and demonology: These were the aspects of Carnival and many other subjects that Ensor favored in the next decade. In 1887 he painted Tribulations of St. Anthony (Pl. 24), a sweeping statement in which the beleaguered St. Anthony is discovered in a world whose viscous atmosphere is filled with loathsome little creatures and a furious scribbling of hell fire. Surrounded by distractions of the flesh and mind—a monstrosity impaled on a lyre is one of the many legacies from Bosch—he tries to shut them out by concentrating on a large book, but many of the vile bodies slither along the ground and attach themselves to his robe, and a tiny man approaches, hypodermic needle at the ready. Incandescent reds vibrate next to chalky surfaces, and sour yellow accents meet small but strident areas of green and pink, all overlaid randomly with scrawls or dainty descriptive drawing. The Infernal Cortege of 1886 or 1887 and Combat of the Rascals Désir and Rissolé, 1888, are variants of like themes found among his increasing number of etchings (ten in 1887 alone).

Fig. 16. Ensor and Ernest Rousseau, Jr., in the dunes near Ostend. 1892. Courtesy Archives, Stedelijk Museum, Ostend.

Much of the turbulence in Ensor's paintings of that time probably derived from disturbing events in his own life. Never a man of notable tact, Ensor seems in these years to have provoked confrontation deliberately. In 1886, against the majority, he opposed inviting Whistler to exhibit a second time with *Les Vingt*. He wrote, "To admit Whistler to *Les Vingt* is to walk toward death...."[25]

A matter of greater gravity occurred in the same year. Maus published an article in *L'Art moderne* on Fernand Khnopff that praised his painting of 1883, *Listening to Schumann* (Fig. 17). Ensor felt that Khnopff's work plagiarized his own *Russian Music* of 1881 and wrote

an injured letter to Maus drawing an analogy with Zola's story, *L'Oeuvre*, in which the hero, Claude Lantier, commits suicide after losing his rightful success to Fagarolles, a craven imitator who has popularized Lantier's more profound ideas. Ensor's comment to Maus is terse: "The portrait of Fagarolles is very good. Only Claude isn't dead."[26] His general mood of antagonism is graphically summed up in an etching, *The Pisser* (Pl. 98), where he aims a wordless answer at the wall upon which his critics have scratched "Ensor is crazy."

Although Ensor may have identified himself with the embattled hermit in *Tribulations of St. Anthony*, he ex-

Fig. 17. Fernand Khnopff. *Listening to Schumann*. 1883. Oil on canvas. Musées Royaux des Beaux-Arts de Belgique, Brussels.

cluded any pictorial reference to his feelings in that work. But a composition of 1888, *Demons Teasing Me* (Pl. 82), leaves no doubt that his sense of harassment was the product of a man menaced as much by his own psyche as by external forces. It was a strong personal statement and he repeated the composition in an etching (Pl. 49) and again in a lithograph, both in 1895.[27]

His creativity reached a summit of production in 1888, with a previously unequaled amount of superior work. In that year alone, he etched forty-three prints of the most diverse and complicated sort, full of technical discovery and modal freshness. His energy seemed to beget energy, and in the same overflowing year he painted the immense canvas that is the most ambitious and important picture of his entire career, *The Entry of Christ into Brussels* (Pl. 25). Conceptually, this work dates from 1885 with the drawing from the series *Les Auréoles du Christ*.[28] He explored the theme in two subsequent drawings, both smaller and less finished. Three is an unusually high number of studies for one of Ensor's paintings, but the viewer is, nevertheless, left unprepared for the richness and fervor of his controversial masterpiece. Its enormous size alone—approximately 8½ by 14 feet—demands careful consideration for this lavish painting, which synthesized the experimentation and dialectic of Ensor's preceding years. The central figure is Christ, to whom Ensor turned so often as the allegory of human dignity, but the scene is Carnival, uproarious, harsh, and encyclopedic. It is a panorama posing more questions than answers. References to contemporary politics appear in the banners greeting Christ—"Vive la Sociale," "Vive Jésus, Roi de Bruxelles"—but do nothing to clarify Ensor's political position, his attitude toward most social institutions being obscure. A possible shift in his sentiments is documented by the deletion of a banner bearing the inscription "Vive Anseele et Jésus," equating a known radical with the Savior (ironically or sincerely?), which Ensor painted out in 1929, before the picture went on public exhibition for the first time. Other slogans appear in the 1898 engraving of the subject (Pl. 109) that are not in the painting. Walther Vanbeselaere in his monograph on *The Entry of Christ* states frankly that no positive response can be found for the problems raised by this puzzling work.[29] Haesaerts also observes that the painting demonstrates no single or consistent point of view in the tradition of "iconographical meaning."

While Ensor's feelings are bitterly and abundantly clear in his brilliant drawing *The Strike in Ostend* (Pl. 47) of the same year (striking fishermen had been fired on and killed by police in Ostend), none of this urgency to react consumes *The Entry of Christ into Brussels*.[30] Its power proceeds from the weight of ideas accumulated over years of introspection, particularly Ensor's self-identification with Christ. The personal nature of the painting is continued in its bold orchestration and application of pigment. Colors are vivid dollops and swipes, even details are treated as broad gestures—the masks lending themselves readily to such directness—and the modeling he studied so painstakingly at the Académie and with such devotion in his studio has been forsaken for crude and angular silhouettes. The effect is one of bizarre puppetry, even those unmasked faces in the mob, especially the marching band, being concealed by impassivity.

Ensor must have felt that in many ways he had made his quintessential artistic statement in the huge canvas. For years he kept it close to him, hanging it on a wall scarcely large enough to hold it, over his beloved harmonium (Fig. 18). With incredible dexterity he had brought together his sense of persecution, his inimitable symbolism, and his implied concern for social conditions. The linear force of his graphic experiments is shared with the freedom of his brush and the bite of pure color applied directly to the picture surface. It is astonishing that such a unified work resulted from so much diversification, but it may explain why most of what followed is concentrated in one stylistic mode.

Still life, which continued to interest Ensor in addition to his more notorious fantasy works, appears in both *Pierrot and Skeleton in Yellow Robe* (Pl. 39) and *Attributes of the Studio*, 1889 (Pl. 28), where it evokes a microcosm of his physical world, including an *écorché* cast, painting materials, plates, and other household paraphernalia against a wall hung with masks. The devotion to texture and shape here recalls his earliest studies, but the play of green against yellow in the background and the disdain for rational space is jarring, and the floating masks are ghoulishly alive. As Tannenbaum has commented, "Ensor had broken still-life tradition in that the masks become actual presences."[31]

Shiny, hard, iridescent objects take on a special significance for Ensor now: Shells and remnants of other sea creatures enter his still-life paintings, and nacreous hues inform the color range of other subject matter as well. *Still Life with Blue Pitcher* (Pl. 31) is as pearly and iridescent as two arrangements with fish and shells from 1888 and 1895 (Pls. 26, 40) and the monumental *Still Life With Ray*, 1892 (Pl. 38).

The landscapes of the 1880's and 1890's—*The Tower of Lisseweghe* (Pl. 27) is representative—are characterized by an unnaturalistic luxury of color related to the *Adam and Eve Expelled from Paradise* (Pl. 22) and *Tribulations of St. Anthony* (Pl. 24). But in prints of the same period, landscape is more explicitly treated, often with representations of Ostend harbor scenes. Dutch and Flemish paintings of the seventeenth century sometimes become

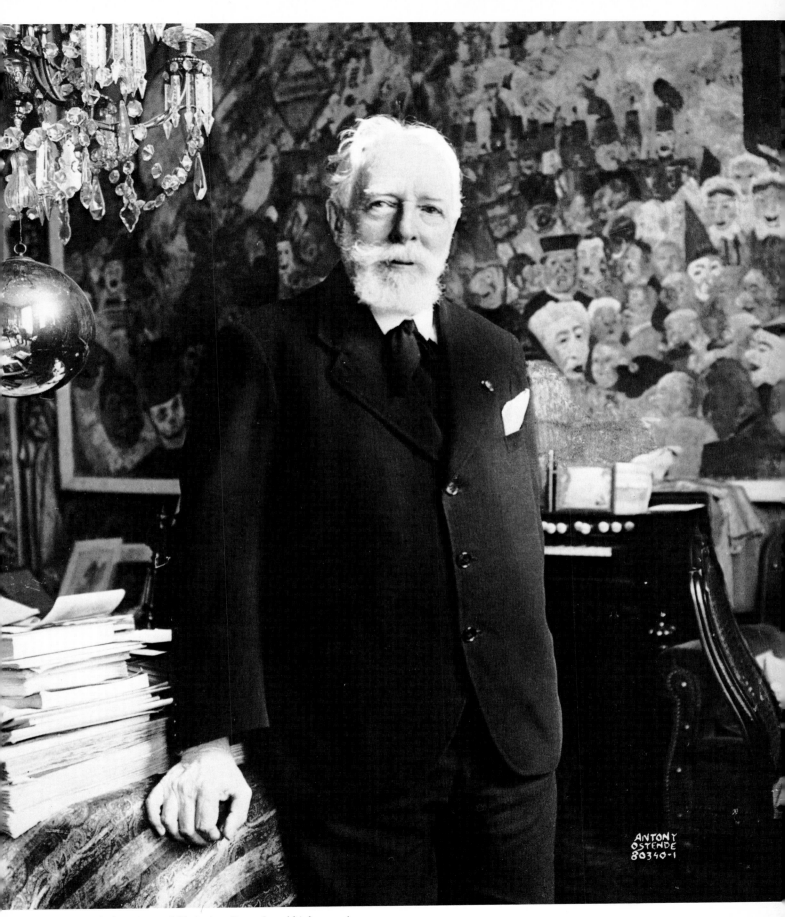

Fig. 18. Ensor before *Entry of Christ into Brussels* and his harmonium. 1940.

sources for his representations of the countryside in Flanders. *Village Fair at the Windmill* of 1889 seems a direct descendant of works by the Flemish-Dutch artist David Vinckeboons, a specialist in the *kermis*. The humor of *The Skaters* (Pl. 105) resembles but exaggerates that of genre artists like Aert van der Neer or Esaias van de Velde, who often painted winter scenes. Ensor also turned once more to Rembrandt, copying the beautiful etching of 1652, *Street near Canal* (Pl. 67).

That Ensor worked diligently on his prints and took the medium very seriously is evident. Light and shadow interact with great intensity in the nearly unequaled *Storm at the Edge of the Wood* (Pl. 102) and particularly in his most famous etched landscape, the intensely lighted *Boats Aground* (Pl. 103). Numerous states exist for many of the etchings. Taevernier says that *The Gendarmes*, 1888, from the heavily sulphured surface of its first appearance to its sixth and final state in which many additions have been made, "was subjected to the greatest number of successive alterations. This allows us to follow Ensor in the arduous pursuit of the work he seeks to achieve."[32] *The Gendarmes*, which is related thematically to *The Strike in Ostend* (Pl. 47) described by Edebau above (p. 12), was also repeated as a painting in 1892 (Pl. 37).

In some instances Ensor worked over his plates simply to reinforce the fragile drypoint with engraving or etching; but compositional corrections and subtle but significant additions embellish successive states of several prints. The rare first state of *The Entry of Christ into Brussels* is corrected in ink, with changes eventually made in the third state of the work. In *Haunted Furniture* (1888) the last of three states shows two more ghostly heads than earlier impressions. *Peculiar Insects* (Pl. 101) includes an extra figure, a third insect, and the dragonfly's tail in the second and all subsequent stages of its development.

With a sense peculiar to graphic artists of genius, Ensor was able to elicit a coloristic impression from his deft handling of pure black and white, but he also hand-colored a number of prints, many of them selections from the less brilliant, later states. As always, Ensor experimented: Light watercolor washes subtly enhance *Christ Tormented by Demons* (Pl. 50), but *Demons Teasing Me* (Pl. 49) and *Hop-Frog's Revenge* (Pl. 108) are actually converted into small paintings. Comparisons between colored and untouched impressions, as with the series of the *Deadly Sins* (Pls. 104, 111), show that the works have undergone a total transformation with the addition of color.

Ensor maintained a battery of styles to accommodate the breadth of his subject matter, and he found the thrust of pure linearism most useful for his satirical prints and drawings. At its most extreme—as in *The Elephant's Joke*, 1888 (Pl. 80)—this linearism results in caricature of appalling artlessness. Ensor carried this directness and simplicity into painting as well, especially during the years around 1890, when his drive to bombard real and imagined adversaries seemed to have no limit. *At the Conservatory* of about 1890 (Pl. 32) speaks to the ineptitude displayed in contemporary performances of Wagner, whose music had captured Ensor's enthusiasm.[33]

Dangerous Cooks, 1896 (Pl. 88), is the most specific polemic against the critical establishment, an unexplained mélange of Ensor's friends and supporters (some of whom had severely criticized his use of the caricatural mode) and his cruelest enemies. The cooks are, of course, the critics who prepare a selection of artists' heads for more critics, the waiting dinner guests: Eduard Fétis, Eugène Demolder, Camille Lemonnier, Max Sulzberger, and Emile Verhaeren, who once owned the drawing. Maus carries Ensor's head on a platter (evoking John the Baptist rather than Christ in this unique instance), identified by an accompanying *hareng saur* (sour herring, which sounds in French like *art Ensor*, his favorite pun and occasional signature). Behind Maus the second cook, Edmond Picard, fries Vogels' head and looks with greedy anticipation at those of Georges Lemmen, Théo van Rysselberghe, and Anna Boch, who has a scraggly chicken's body. An attempted exit up the back stairs by Théo Hannon is foiled, and fouled, by the contents of a chamber pot.

Vilification, unspeakably coarse and directly aimed at the Belgian government, is the content of *Doctrinal Nourishment (Alimentation Doctrinaire)*, Ensor's most unabashed citation of stupidity and baseness. The chief figures of church, state, and military feed the populace in an odious manner, yet the people seem eager for what they receive. In *Belgium in the XIX Century*, c. 1889 (Pl. 84), the mob is less quiescent, and soldiers forcibly quell their unruly actions, while the king seated in a mandorla above them asks, "What do you want? Aren't you content? A little patience. No violence." Ensor sent these repugnant works to the exhibition of 1891 along with *Roman Triumph* (Pl. 85), which pokes fun in a much more good-natured way at the imperial disdain he felt characteristic of the Belgian rulers. Maus was shocked. "Impossible to exhibit," he said later. "The prosecutor would swoop down on us. The government would close the exhibition."[34]

These wide-ranging denunciations suggest an extremely anxious state of mind, which neither of his two great asylums from the threats of the outside world—his relationship with Augusta Boogaerts, whom he had met in 1885, and the comfort and intellectual honesty of the Rousseau home—could assuage.[35] Late in the pre-

Fig. 19. Fernand Khnopff. *Art*. 1896. Oil on canvas. Musées
Royaux des Beaux-Arts de Belgique, Brussels.

vious year he had written to Maus requesting informa-
tion concerning the forthcoming exhibition: "I know
nothing and I wait nervous and uncertain, ruffled and
wary, as when the dragon Fessine hunts in the forest of
Micommence; his foot cloven, rent heart nourished by
the venom of others, pushing, belching, farting, swelling,
pissing, sweating from the frightful cries. Cries which
which which which frighten the brave Attrides crouching
in the mountains of Phnosie. Waiting anxious and tor-
mented, please answer promptly."[36]

By 1890, Ensor was already odd man out among his
colleagues. Georges Pierre Seurat, invited by *Les Vingt*
to exhibit in 1887, had sent his chef d'oeuvre, *Sunday
Afternoon on the Grande Jatte,* a painting that ravished
the sensibilities and influenced the style of a broad rep-
resentation in the group. As early as 1890 many members
of *Les Vingt* were committed Neo-Impressionists, espe-
cially van Rysselberghe, Georges Lemmen, Willy Finch,
and Henri van de Velde. Khnopff, on the other hand, led
another group of *Vingtistes* in the direction of Symbol-
ism (Fig. 19).

Yet those critics who believed in Ensor had already
begun putting their opinions in print, though rarely with-
out qualification. Emile Verhaeren, speaking of the first
large drawing of the *Entry into Jerusalem,* 1885, wrote,
"These mad sketches stupefy at first, then affect deeply.
They carry one off toward chaos, but grandly and in full
flight."[37] In 1892, Demolder published a modest but re-
vealing monograph, the first devoted to the artist. In it
he stressed Ensor's concern with light—as, for that mat-
ter, did most critics—a force that "devours objects" but
is "also rich, for it multiplies, like a treasure trove, the
reflection of a reflection and the nuance of a nuance."[38]

Ensor also began to sell pictures. In 1896, the Musées
Royaux in Brussels purchased the *Lamp Boy,* one of

Ensor's earliest oils, and the Cabinet des Estampes
bought a group of etchings. That same year, Demolder
organized an exhibition in Brussels devoted entirely to
works by Ensor, and in 1898 the avant-garde *Salon des
cent* brought together fifty-five of Ensor's pictures in
Paris, accompanied by a catalogue and a special issue of
La Plume. Ensor had unquestionably achieved recog-
nition both within and outside his country.

The intensity of his invention began to deteriorate in
the 1890's, however. The flood of satirical works re-
ceded, and, even as he was painting *Dangerous Cooks*
and *The Gendarmes,* Ensor began a new cycle; *The Con-
soling Virgin,* 1892 (Pl. 36), his most classical painting,
has only a few touches that remind us of the satirical
artist—the mask at the upper right and his pictographic
signature, a *hareng saur,* at the lower right.

By 1900, with his critical reputation ascending and his
financial situation apparently assured, the man of sar-
casm had become *un grand homme,* a raconteur, and
familiar presence in his native city of Ostend. As early
as 1886 a few works had revealed a taste for the tonality
and delicacy of the Rococo. After 1900 there are numer-
ous works in this manner. In 1907 he designed the cos-
tumes for a ballet, *The Scale of Love,* the music of which
he had also composed, and painted a series of works
after Watteau in a delicately erotic mood. He was created
a Chevalier of the Order of Leopold in 1903, and the
title of Baron was bestowed on him by King Albert I in
1929, exactly forty years after Ensor had produced a
print representing an earlier king of Belgium defecating
on his subjects—the scandalous *Doctrinal Nourishment.*
In 1905 he was invited to show his works at the third
exhibition of *Kunst van Heden* in Antwerp, a contem-
porary art circle led by the connoisseur and influential
collector François Franck. Franck became one of Ensor's

greatest patrons, and by the time of his death in 1933,[39] Antwerp was unmatched for the wealth of its Ensor collections.[40]

Ensor's reputation spread. He was the subject of an interesting article in 1905, which grouped him with Aubrey Beardsley and Edvard Munch.[41] In 1907, Verhaeren wrote the second monograph to be published on Ensor, and articles in German and Dutch periodicals began to appear, leading to his inclusion in an exhibition of 1912 sponsored by the pioneer German Expressionist journal, *Der Sturm*. As his renown expanded, however, due in part to the acceptance of those paintings and prints less calculated to offend, the quantity and quality of his current work shrank. A few paintings and numerous drawings of superior quality reveal a continuity with previous performances, but the will to create and confront had quite decisively departed. A comparison of output between two years shows the contrast: In 1888 Ensor produced forty-five etchings and completed the mammoth *Entry of Christ into Brussels*, at least four other major paintings, and many drawings, some of them highly finished. In a typical later year, 1908, his work yielded only a few paintings, at least one of which merely reproduced an earlier canvas *(Skeleton Musicians)*. He etched only a handful of compositions after 1900, and only three others are known after 1904.

Ostend remained his home and he continued to live with his family. Although Mitche married a Chinese businessman in 1892, her groom departed before the birth of their child, a little girl who became the enchanting subject of Ensor's fine watercolor of 1899 (Pl. 48). It is one of his last notable achievements. After 1900 there are only a few original compositions, like the superb and poignant painting, *The Artist's Mother in Death* of 1915 (Pl. 45). When his aunt died the year after his mother, Ensor moved to 17 (now 27) Vlaanderenstraat with his sister, his niece, and two servants. There he made some paintings—a few very good ones, like the *Finding of Moses*, 1924 (Pl. 46)—and a handful of competent drawings, but on the whole he concentrated on his music and led a quiet life.

The cause of his sad decline has been the subject of much speculation, even posthumous psychoanalysis.[42] The artist's guarded comments about himself have not aided historians in their quest to explain his reversal. The ambience of the final Ensor ménage—carefully restored to its state at the time that Ensor lived and worked there —is suggestive in this respect, communicating as it does an extreme feeling of claustrophobia and oppression.

Another possible reason for his decline—although this admittedly depends on the omniscience of hindsight— is that Ensor's early development demanded so vast an expenditure of energy that it simply exhausted his re-

sources, psychic and artistic. He produced a lifetime of work in two decades of brilliant stylistic experimentation and personal commitment to his art; for Ensor, it was not merely a romantic cliché that each object he made included a part of himself. Those years of effort were certainly not comfortable, and he may have wearied of accepting their personal and psychological risks.

More significant than the departure of his muse, however, is what its presence helped him to achieve during his most vital working years. Modern aesthetic intelligence accepts Ensor without question, acknowledging what was once considered aberrational and repugnant as part of a general revolution to free form and color from unthinking convention. His specific influence is difficult to assess because he had no students, but he certainly gave impetus to the Surrealists in Belgium without ever incorporating their theoretical premises among his more personal fantasies. German Expressionism found in him a means for heightened psychological excursions in art. Their strong interest in Ensor is documented by the *Der Sturm* exhibition of 1912 and the visits of Emil Nolde and Erich Heckel to Ostend. Until a thorough analysis of his iconography has been made it would seem that very little more can be deduced about the meaning of his work that is not merely speculative. Ensor is baffling because he wanted to be, both in his lifetime and for posterity: He left few clues, and some were red herrings, such as his habit of backdating and reworking paintings. The presence of any outside influence, especially that attributed to the work of his contemporaries, was nearly inadmissible for Ensor; so much so that when his friend André de Ridder asked him to reveal the genesis of his art, Ensor took refuge behind a veil of charm and poetic indirection, elucidating nothing:

I see a great unity in my art. Humility of the painter before nature; imagination peopled with dreams; works presenting palpable figures or forms, nourished and bathed in atmosphere; bodies broadly conceived; a line which is breathed, formed and drawn by the wind; broken color; gestures magnified and deformed by mirage and I love the sirens and I love blond Venus and the sea shells left on the luminous coasts of the sea.[43]

NOTES

[1]Charles P. Baudelaire, *Beaux-Arts, Oeuvres complètes*, vol. XXIV (Paris, 1961), p. 1427.

[2]F.-C. Legrand, *Ensor, cet inconnu* (Brussels, 1971), pp. 18-19.

[3]James Ensor, "Three Weeks at the Academy: Episodic Monologue," from *James Ensor*, by P. Haesaerts, pp. 355-356.

[4]Both are in the Musée Gustave Moreau: *Salome Dancing* and *The Apparition*.

[5]These have not been catalogued, but L. Schoonbaert has published the fine collection· "Addendum beschrijvende catalogus 1948. Een verzameling tekeningen van Ensor (deel III). Schetsen naar levend model uit de periode 1879-1885" *Jaarboek van het Koninklijk Museum voor Schone Kunsten Antwerpen* (Antwerp, 1970), pp. 305-322.

[6]F.-C. Legrand, *Ensor*, p. 22. Quoted from a letter dated March 1, 1909, in the Musées Royaux des Beaux-Arts, Brussels, inv. no. 10465.

[7]Jean François Portaels, *L'Art moderne*, June 5, 1881, p. 107. From *James Ensor: Proeve van gecommentariëerde bibliografie* by H. de France (Brussels, 1960), pp. 26-27.

[8]J. F. Portaels in an unsigned review in *L'Art moderne*, January 14, 1883, p. 10. Quoted in *Ensor* by H. de France, p. 28.

[9]Emile Verhaeren, *La Jeune Belgique*, October 1, 1883, p. 435. Quoted in *Ensor* by H. de France, p. 29.

[10]E. Verhaeren, *La Jeune Belgique*, 1883-1884, p. 473. Quoted in *Ensor* by F.-C. Legrand, p. 37, n. 13.

[11]Libby Tannenbaum, *James Ensor* (New York, 1951), p. 50.

[12]Paul Haesaerts and others have traditionally held that Ensor began painting masks in works as early as 1879, the date of *Masks Gazing at a Negro* (see P. Haesaerts, *Ensor*, p. 163). Even a superficial study of fantastic works dated before about 1885 or 1886, however, indicates that they have been painted in two distinct and chronologically separate styles.

[13]Marcel De Maeyer, "De Genese van masker, travestie en skeletmotieven in het oeuvre van James Ensor," *Bulletin des Musées Royaux des Beaux-Arts de Belgique* (1963), pp. 69-88, and "Ensor au chapeau fleuri," *L'Art belge* (December, 1965), pp. 41-45.

[14]*L'Art belge* (December, 1965), pp. 17-29.

[15]Suggested but not proven by a letter to Octave Maus dated November 14, 1892, published by F.-C. Legrand, *Bulletin des Musées Royaux des Beaux-Arts*, vol. 15 (1966), p. 40. See also G. LeRoy, *James Ensor* (Brussels, 1922), p. 38.

[16]E. Verhaeren, *La Jeune Belgique*, February 15, 1884, pp. 197 ff.

[17]Written to the art historian and museum director Pol de Mont and published in the exhibition catalogue, *Ensor: ein Maler aus dem späten 19. Jahrhundert* (Stuttgart, 1972), p. 37.

[18]The largest group of these copies, over 160, are in Antwerp and have been catalogued by L. Schoonbaert, "Addendum beschrijvende catalogus 1948, Een verzameling tekeningen van Ensor (deel I)," *Jaarboek van het Koninklijk Museum voor Schone Kunsten Antwerpen* (Antwerp, 1968), pp. 311-342.

[19]*Ibid.*, p. 333, no. 2711/128.

[20]For the letter, which predates February 6, the opening of the exhibition, see F.-C. Legrand, *Bulletin des Musées Royaux des Beaux-Arts de Belgique*, vol. 17 (1969), pp. 191-202.

[21]Auguste Taevernier, *James Ensor, Illustrated Catalogue of his Engravings, their Critical Description and Inventory of the Plates* (Brussels, 1973), p. 9.

[22]H. Piron, *Ensor—een psychoanalytische studie* (Antwerp, 1968).

[23]P. Haesaerts, *James Ensor*, p. 348.

[24]From a speech delivered by Ensor at the opening of his exhibition in the Jeu de Paume, Paris, June 1932. Published in *Les Ecrits de James Ensor, 1928-1934* (Antwerp, 1934), p. 70. Translated by P. Haesaerts, *Ensor*, p. 357.

[25]F.-C. Legrand in *Bulletin des Musées Royaux des Beaux-Arts de Belgique,* vol. 15 (1966), p. 25. From a letter dated November 1886, in the archives of the Musées Royaux des Beaux-Arts de Belgique, inv. 4784.

[26]*Ibid.*, p. 24. From a letter dated September 6, 1886, in the archives of the Musées Royaux des Beaux-Arts, inv. 6367.

[27]Revised to a vertical format, the same composition served as the poster for his exhibition in 1898 at the *Salon des cent* in Paris (Pl. 112), and as the cover for a special issue of *La Plume* devoted to him the following year.

[28]Dated 1885 and exhibited in 1887 with *Les Vingt*.

[29]Vanbeselaere, *L'Entrée du Christ* (Brussels, 1957), p. 37.

[30]See F. Edebau's discussion in his essay, p. 12 of this work.

[31]L. Tannenbaum, *James Ensor*, p. 104.

[32]A. Taevernier, *James Ensor*, p. 143.

[33]"It is at about that time [1880] that Richard Wagner excited me very much. This extraordinary genius influenced and sustained me." From a letter written to Pol de Mont, 1894-1895, in the exhibition catalogue *Ensor: ein Maler aus dem späten 19. Jahrhundert* (Stuttgart, 1972), p. 37.

[34]Octave Maus, "Lorsqu'en 1884," *La Plume*, 1899, p. 31.

[35]He gave Augusta the whimsical endearment *"La Sirène"*; for the rest of his life she remained his friend and a dependable source of support. She was a witty, satisfactory companion for the man and the artist, comprehending his clownishness as well as his acidity, and his portraits of her are affectionate and amusing in tone. Haesaerts reports that their early association was high-spirited and that in later, less lively years she was the arranger of still lifes, supervisor of Ensor's artistic production, and responsible for keeping an inventory of his sales: P. Haesaerts, *James Ensor*, pp. 211, 220.

[36]Letter dated October 28, 1890, in the archives of the Musées Royaux des Beaux-Arts, inv. 5730. Published in the *Bulletin des Musées Royaux des Beaux-Arts de Belgique*, vol. 15 (1966), pp. 34-35. It is reproduced in the exhibition catalogue *Le Groupe des XX et son temps*, 1962, pl. VIII.

[37]E. Verhaeren, *La Vie moderne*, February 26, 1887, p. 138.

[38]E. Demolder, *James Ensor* (Brussels, 1892), pp. 6-7.

[39]See W. Vanbeselaere in the exhibition catalogue, *James Ensor* (Antwerp, 1951), pp. 3ff., and *In Memoriam Frans Franck* (Antwerp, 1933).

[40]The Franck family shared an interest in Ensor. It was their support, as well as that of Emma Lambotte, that was largely responsible for the glorious representation of Ensor's paintings in the Koninklijk Museum in Antwerp. The magnificent *Woman Eating Oysters,* for instance, became available in 1907 after the Liège Museum declined to purchase it, and Mrs. Lambotte, with great insight, bought it for herself, later donating it to the museum in Antwerp. A journal of her letters to Ensor during the first years of their friendship, 1904-1906, has been published by Georges Hermans, "Un 'Cahier Ensor' d'Emma Lambotte," *Bulletin des Musées Royaux des Beaux-Arts de Belgique*, vol. 20 (1971), pp. 85-119.

[41]Vittorio Pica, "Trois artistes d'exception," *Mercure de France*, August 15, 1905, pp. 517-530.

[42]H. Piron, *Ensor*.

[43]From a letter dated September 30, 1928, in *Lettres à André de Ridder*, p. 61.

Bibliographical Note

The literature on James Ensor is now quite extensive, although there are as yet few serious studies in English. For a thorough compilation of the bibliography before 1960 the reader should consult Hubert de France, *James Ensor: Proeve van gecommentariëerde bibliografie* [Bibliographia Belgica 53] (Brussels, 1960). This author lists and annotates 1,040 entries, including exhibition catalogues, general surveys in which Ensor is discussed, and reviews in the press and periodicals. More up-to-date bibliographies can be found in two monographs: Roger van Gindertael, *James Ensor* (New York, 1975) and Paul Haesaerts, *James Ensor* (Brussels, 1973).

Among the general monographs, the last two cited are the most recent. The most thoughtful study of Ensor's life and art is by Francine-Claire Legrand, *Ensor, cet inconnu* (Brussels, 1971); the author is a scholar who has had access to much unpublished source material. Some of this material has been published by her in the *Bulletin des Musées Royaux des Beaux-Arts de Belgique*, 15 (1966) and by Georges Hermans, "Un 'Cahier Ensor' d'Emma Lambotte," *ibid.*, 20 (1971), pp. 85-119. Paul Haesaerts, *James Ensor* (New York, 1959) is richly illustrated, and he includes an extensive catalogue of Ensor's known work.

Some older monographs are extremely perceptive and include interesting material. Among these should be included the very first by Eugène Demolder, *James Ensor* (Brussels, 1892); Emile Verhaeren, *James Ensor* (Brussels, 1908); and Grégoire Le Roy, *James Ensor* (Brussels and Paris, 1922). The 1899 issue of *La Plume*, published in Paris, is devoted entirely to Ensor, and includes articles and poems by a wide range of his contemporaries, including Max Elskamp, Verhaeren, Théo Hannon, Georges Lemmen, Constantin Meunier, and Camille Lemonnier.

Ensor had his first one-man exhibition in Brussels in 1894, and many subsequent exhibitions have been accompanied by useful and informative catalogues. Major exhibitions have since been held in Brussels (1929), Paris (1932 and 1954), Antwerp (1951), Basel (1963), Stockholm (1970), and Tokyo (1972). In 1951 the Museum of Modern Art in New York organized the most significant exhibition in the United States and published a fine catalogue by Libby Tannenbaum. Special attention should be called to the ambitious and informative catalogue for an exhibition at the Staatsgalerie Stuttgart, *Ensor: ein Maler aus dem späten 19. Jahrhundert* (1972).

Ensor's works were part of major exhibitions in Paris, 1970 (*L'Art flamand d'Ensor à Permeke*), and London, 1971 (*Ensor to Permeke, Nine Flemish Painters*). His relations with the avant-garde group *Les Vingt* have been discussed in the exhibition catalogue *La Groupe des Vingt et son temps* (Brussels and Otterloo, 1962), and by Mrs. Legrand in the article cited above.

A few specialized studies are important for their wider significance. Marcel De Maeyer, "De genese van masker, travestie en skeletmotieven in het oeuvre van James Ensor," *Bulletin des Musées Royaux des Beaux-Arts de Belgique*, 10 (1963), pp. 69-88, sheds new light on the chronology of Ensor's development. Herman Théo Piron, *Ensor—een psychoanalytische studie* (Antwerp, 1968), is full of stimulating suggestions, although not accepted by most art historians.

There is no single study of Ensor's drawings, although one should consult the general works cited above and Paul Fierens, *Les Dessins d'Ensor* (Brussels and Paris, 1944). L. Schoonbaert has catalogued the extensive collection in the Koninklijk Museum, Antwerp, and published an illustrated handlist in the *Jaarboek van het Koninklijk Museum voor Schone Kunsten Antwerpen*, (1968), pp. 311-342; (1969), pp. 265-284; (1970), pp. 305-332. A very important group of Ensor drawings were discussed by Gisèle Ollinger-Zinque, "Les auréoles du Christ ou les sensibilités de la lumière de James Ensor," *Bulletin des Musées Royaux des Beaux-Arts de Belgique*, 17 (1968), pp. 191-202.

Ensor's prints have been catalogued several times. The two pioneer efforts at a catalogue raisonné are by Loys Deltiel, *James Ensor [Le Peintre Graveur XIX]* (Paris, 1925), and Albert Croquez, *L'Oeuvre gravé de James Ensor* (Paris, 1935). The standard work now, however, is Auguste Taevernier, *James Ensor: Illustrated Catalogue of His Engravings, Their Critical Description and Inventory of the Plates* (Brussels, 1973). Taevernier published a number of prints unknown or unlisted by either earlier scholar and provided new observations on technique and Ensor's signature. James Elesh, "Ensor's Prints: Some Fundamentals," *Print Collector's Newsletter*, Vol. 6 (1975), pp. 38-40, also makes some new observations.

Ensor's own writings have added to an understanding of his very personal art. Some of his shorter pieces have been collected in *Les Ecrits de James Ensor* (Brussels, 1921); *Les Ecrits de James Ensor de 1921 à 1926* (Ostend and Bruges, 1926); and *Les Ecrits de James Ensor (1928-1934)* (Antwerp, 1934). Letters have been published by André de Ridder, *Lettres à André de Ridder* (Antwerp, 1960).

Checklist

The following is a list of works exhibited. Numbers refer to the Plates, beginning on page 49; works marked by an asterisk () are not illustrated.*

PAINTINGS

1 *Self-Portrait.* 1879
Autoportrait
Oil on panel, 7⅝ x 5¾″ (19.3 x 14.5 cm)
Signed and dated lower left: *Ensor 1879*
Private Collection

* *Artist at His Easel.* 1879
Artiste à son chevalet
Oil on canvas, 15¾ x 12½″ (40 x 31.8 cm)
Signed and dated lower right: *J. ENSOR 1879*
Collection Leten, Belgium

2 *After the Storm.* 1880
Après la tempête
Oil on canvas, 20¾ x 24⅝″ (52.5 x 62.5 cm)
Signed and dated lower right: *Ensor 1880*
Collection Stedelijk Museum, Ostend

3 *Vlaanderenstraat in the Snow.* 1880
La Rue de Flandre en hiver
Oil on canvas, 18⅞ x 11⅞″ (47.9 x 28.4 cm)
Signed and dated lower left: *ENSOR 1880*
Collection Louis Franck, Esq., C.B.E.

4 *Sketch for Bourgeois Salon.* 1880
Esquisse pour le salon bourgeois
Oil on canvas, 26 x 21⅜″ (66 x 57 cm)
Signed and dated lower left: *ENSOR 1880*
Collection Gustave Van Geluwe

5 *Still Life with Blue Bottle.* 1880
Nature morte au flacon bleu
Oil on canvas, 17¾ x 19⅝″ (45 x 50 cm)
Signed and dated lower right: *ENSOR 80*
Collection Georges Daelemans

6 *Woman on a Breakwater.* 1880
La Femme au brise-lames
Oil on canvas, 12⅜ x 9½″ (32 x 24 cm)
Signed and dated upper right: *Ensor 80*
Collection Ambassador and Mrs. Julien Rossat

* *The Cab.* ca. 1880
Le Fiacre
Oil on canvas, 16⅜ x 22″ (41 x 54 cm)
Not signed or dated
Private Collection

* *Dune Landscape.* ca. 1880
Paysage avec dunes
Oil on canvas, 12½ x 15¾″ (31.8 x 40 cm)
Signed lower right: *ENSOR*
Collection Mr. and Mrs. Jeff de Lange

7 *Judith and Holofernes.* ca. 1880 with later additions
Judith et Holopherne
Oil on canvas, 22 x 26″ (55.9 x 66 cm)
Signed lower left: *ENSOR*
Collection Mr. and Mrs. Harry C. Sandhouse

8 *Russian Music.* 1881
Musique russe
Oil on canvas, 52¼ x 43″ (133 x 110 cm)
Signed and dated lower left: *JAMES ENSOR 81*
Collection Musées Royaux des Beaux-Arts de Belgique, Brussels

9 *The Breakwater.* 1882
Le Brise-lames
Oil on canvas, 18½ x 21⅝″ (47 x 55 cm)
Signed and dated lower left: *ENSOR 82*
Private Collection, Belgium

* *Model in the Dunes.* 1882
L'Artiste et le modèle
Oil on canvas, 14¼ x 17¾″ (36.1 x 45 cm)
Signed and dated lower left: *ENSOR 82*
Collection William R. Murdoch

10 *Woman in Distress.* 1882
Femme en détresse
Oil on canvas, 39¼ x 31½″ (100 x 80 cm)
Signed and dated lower right: *James Ensor 82*
Collection Musées Nationaux, Paris

* *Portrait of Willy Finch.* ca. 1882
Portrait de Willy Finch
Oil on canvas, 19½ x 11⅝″ (49.5 x 29.5 cm)
Signed lower right: *Ensor*
Collection Koninklijk Museum voor Schone Kunsten, Antwerp

11 *Still Life.* ca. 1882
Nature morte
Oil on canvas, 31½ x 39¼″ (80 x 100 cm)
Signed lower right: *Ensor*
Collection Liège-Musée des Beaux-Arts

12 *The Drunkards.* 1883
Les Pochards
Oil on canvas, 45¼ x 64¾″ (115 x 165 cm)
Signed and dated lower right: *ENSOR 1883*
Collection Georges De Graeve

13 *The Rower.* 1883
 Le Rameur

 Oil on canvas, 31 x 38⅞″ (79 x 99 cm)
 Signed and dated lower right: *J. ENSOR 83*
 Collection Koninklijk Museum voor Schone Kunsten, Antwerp

14 *Scandalized Masks.* 1883
 Les Masques scandalisés

 Oil on canvas, 53 x 44¾″ (135 x 112 cm)
 Signed and dated lower right: *J. Ensor 1883*
 Collection Musées Royaux des Beaux-Arts de Belgique,
 Brussels

15 *Self-Portrait in a Flowered Hat.* 1883
 Ensor au chapeau fleuri

 Oil on canvas, 29⅝ x 24¼″ (75 x 61.5 cm)
 Signed and dated left below center: *J. ENSOR 1883*
 Collection Stedelijk Museum, Ostend

16 *Ship with Yellow Sail.* 1883
 Bateau à voile jaune

 Oil on canvas, 18¾ x 20¾″ (47.6 x 52.7 cm)
 Signed and dated lower right: *Ensor 1883*
 Collection Mr. and Mrs. Jeff de Lange

17 *Vase of Flowers.* 1883
 Vase et fleurs

 Oil type on fabric, 44½ x 38⅜″ (113 x 97.5 cm)
 Signed and dated lower right: *Ensor 1883*
 The Minneapolis Institute of Arts, purchased through
 funds received by sale of painting given to the museum
 by Mr. and Mrs. William N. Driscoll, Mr. and Mrs.
 Walter F. Gage, and Mr. and Mrs. Winter Dean, Jr., in
 memory of Mrs. Conrad Driscoll

18 *Girl with Doll.* 1884
 Jeune fille et poupée

 Oil on canvas, 59⅛ x 35¾″ (150.5 x 89.9 cm)
 Signed and dated lower right: *Ensor 84*
 Collection Wallraf-Richartz Museum, Cologne

19 *Town Hall, Brussels.* 1885
 Hôtel de ville, Bruxelles

 Oil on canvas, 39¼ x 31½″ (100 x 80 cm)
 Signed lower left: *Ensor*
 Collection Liège-Musée des Beaux-Arts

20 *Rooftops of Ostend.* 1885
 Les Toits d'Ostende

 Oil on canvas, 43 x 52⅝″ (109.2 x 133.7 cm)
 Signed and dated lower right: *Ensor 1885*
 Collection Louis Franck, Esq., C.B.E.

21 *Skeleton Studying Chinoiseries.* 1885
 Squelette regardant les chinoiseries

 Oil on canvas, 39¼ x 25⅜″ (99.7 x 64.5 cm)
 Signed and dated lower left: *Ensor 85*
 Collection Julian J. Aberbach, Paris

22 *Adam and Eve Expelled from Paradise.* 1887
 Adam et Eve chassés du paradis

 Oil on canvas, 80¾ x 96¾″ (205 x 245 cm)
 Signed and dated lower left: *Ensor 1887*
 Collection Koninklijk Museum voor Schone Kunsten, Antwerp

23 *Fireworks.* 1887
 Feu d'artifice

 Oil and encaustic on canvas, 40¼ x 44¼″ (102.2 x
 112.4 cm)
 Signed and dated lower right: *Ensor 87*
 Collection Albright-Knox Art Gallery, Buffalo, New
 York, George B. and Jenny R. Mathews Fund

* *Masks in the City.* 1887
 Les Masques dans la ville

 Oil on panel, 10¼ x 14″ (26 x 35.5 cm)
 Dated: *1887*
 Collection Georges De Graeve

24 *Tribulations of St. Anthony.* 1887
 Les Tribulations de Saint Antoine

 Oil on canvas, 46⅜ x 66″ (117.8 x 167.6 cm)
 Signed and dated lower right: *ENSOR 1887*
 Collection The Museum of Modern Art, New York

25 *The Entry of Christ into Brussels.* 1888
 L'Entrée du Christ à Bruxelles

 Oil on canvas, 101⅜ x 149¼″ (256.8 x 378.4 cm)
 Signed and dated lower right: *J. ENSOR 1888*
 Collection Louis Franck, Esq. C.B.E.

26 *Still Life with Fish and Shells.* 1888
 Nature morte aux poissons et coquillages

 Oil on canvas, 32 x 39½″ (81.2 x 100 cm)
 Signed lower right: *ENSOR*
 Collection Mr. and Mrs. Leigh B. Block, Chicago

27 *Tower of Lisseweghe.* 1888
 La Tour de Lisseweghe

 Oil on canvas, 24 x 28¾″ (61 x 73 cm)
 Signed lower right: *Ensor*
 Collection Louis Franck, Esq., C.B.E.

28 *Attributes of the Studio.* 1889
 Les Attributs de l'atelier

 Oil on canvas, 32⅝ x 44⅜″ (83 x 113 cm)
 Signed and dated lower right: *Ensor 1889*
 Collection Bayerischen Staatsgemäldesammlungen,
 Munich

29 *Portrait of Old Woman with Masks.* 1889
 Portrait d'une vieille aux masques

 Oil on canvas, 21¼ x 18¾″ (54 x 47.5 cm)
 Signed and dated lower center: *Ensor 1889*
 Collection Museum voor Schone Kunsten, Ghent

30 *Still Life with Flowers and Butterflies.* 1889
 Nature morte aux fleurs et papillons

 Oil on canvas, 23⅝ x 19¾″ (60 x 50 cm)
 Signed lower right: *ENSOR*
 Collection Musée Hôtel Charlier, St. Josse-ten-Noode,
 Belgium

* *Still Life with Blue Pitcher.* 1890
 Nature morte à la cruche bleue

 Oil on canvas, 15 x 18″ (38 x 46 cm)
 Signed and dated lower right: *ENSOR 90*
 Collection Rijksmuseum Kröller-Müller, Otterloo,
 The Netherlands

31 *Still Life with Blue Pitcher.* 1890-91
 Nature morte à la cruche bleue
 Oil on panel, 14¾ x 18″ (37.5 x 45.6 cm)
 Signed lower left: *ENSOR*
 Collection Staatsgalerie Stuttgart

32 *At the Conservatory*
 Au conservatoire
 Oil on canvas on panel, 22⅛ x 28¼″ (56 x 71.5 cm)
 Signed lower right: *Ensor*
 Collection André Joiris, Liège

33 *The Good Judges.* 1891
 Les bons juges
 Oil on panel, 15 x 18⅛″ (38 x 46 cm)
 Signed and inscribed lower right:
 ENSOR MORT AUX VACHES
 Private Collection, Brussels

34 *Man of Sorrows.* 1891
 L'Homme des douleurs
 Oil on panel, 8½ x 6¼″ (21.5 x 15.9 cm)
 Signed and dated lower right: *Ensor 1891*
 Collection Leten, Belgium

35 *Skeletons Fighting for the Body of a Hanged Man.*
 1891
 Squelettes se disputant un pendu
 Oil on canvas, 23¼ x 29⅛″ (59 x 74 cm)
 Signed and dated lower right: *ENSOR 1891*
 Collection Koninklijk Museum voor Schone Kunsten,
 Antwerp

36 *The Consoling Virgin.* 1892
 La Vièrge consolatrice
 Oil on panel, 19 x 15″ (48 x 38 cm)
 Signed and dated upper right: *ENSOR 92*
 Private Collection

37 *The Gendarmes.* 1892
 Les Gendarmes
 Oil on panel, 7½ x 21¾″ (45 x 55 cm)
 Signed and dated lower right: *Ensor 1892*
 Collection Stedelijk Museum, Ostend

38 *Still Life with Ray.* 1892
 La Raie
 Oil on canvas, 31½ x 39¼″ (80 x 100 cm)
 Signed and dated lower left: *Ensor 92*, signed lower
 right: *Ensor*
 Collection Musées Royaux des Beaux-Arts de Belgique,
 Brussels

39 *Pierrot and Skeleton in Yellow Robe.* 1893
 Pierrot et squelette en jaune
 Oil on panel, 15 x 18⅞″ (38 x 48 cm)
 Signed and dated lower left: *Ensor 1893*
 Collection Mr. and Mrs. Jeff de Lange

40 *Still Life with Fish and Shells.* 1895
 Nature morte aux poissons et coquillages
 Oil on canvas, 28 x 36¼″ (71 x 92 cm)
 Signed and dated lower right: *J. ENSOR 95*
 Collection Nellens, Knokke, Belgium

41 *Skeleton Painter in His Atelier.* 1896 (?)
 Le Peintre squelettisé dans l'atelier
 Oil on canvas, 14⅝ x 17¾″ (37 x 45 cm)
 Signed lower right: *ENSOR*
 Collection Koninklijk Museum voor Schone Kunsten,
 Antwerp

42 *Masks and Death.* 1897
 Les Masques et la Mort
 Oil on canvas, 31⅛ x 39¼″ (79 x 100 cm)
 Signed and dated lower right: *J. Ensor 97*
 Collection Liège-Musée des Beaux-Arts

43 *The Antiquarian.* 1902
 L'Antiquaire
 Oil on canvas, 33⅝ x 16¾″ (85.5 x 42.5 cm)
 Signed and dated lower left: *J. ENSOR 1902,* inscribed
 lower center: *A. PAUL BUESO SON AMI ENSOR*
 Collection of the Crédit Communal de Belgique,
 Brussels

44 *Flowers in the Sunlight.* 1905
 Fleurs à la lumière du soleil
 Oil on canvas, 24 x 19⅝″ (61 x 49.7 cm)
 Signed lower left: *Ensor*
 Collection Mr. and Mrs. Leigh B. Block, Chicago

* *Theater of Masks.* 1908
 Le Théatre des masques
 Oil on canvas, 32¾ x 34¼″ (83 x 87 cm)
 Signed and dated lower right: *Ensor 1908*
 Collection Ambassador and Mrs. Julien Rossat

45 *The Artist's Mother in Death.* 1915
 La Mère morte de l'artiste
 Oil on canvas, 19½ x 23⅝″ (75 x 60 cm)
 Signed and dated lower right: *Ensor 1915*
 Collection Stedelijk Museum, Ostend

* *Droll Smokers.* 1920
 Fumeurs drôles
 Oil on canvas, 29½ x 25½″ (75 x 64.7 cm)
 Signed lower right: *ENSOR*
 Private Collection

46 *Finding of Moses.* 1924
 La Découverte de Moïse
 Oil on canvas, 47 x 50½″ (119.4 x 128.3 cm)
 Signed and dated lower right: *Ensor 1924*
 From the Collection of Joachim Jean Aberbach,
 Old Westbury, New York

DRAWINGS AND WATERCOLORS

*All drawings and watercolors are on paper unless otherwise
noted.*

51 *Academic Study of a Male Nude.* 1878
 Etude d'académie
 Pencil, 26½ x 19″ (67.3 x 48.3 cm)
 Signed and dated right of center: *J. Ensor 78*
 Collection Mr. and Mrs. Harry C. Sandhouse

52 *Biblical Scene.* 1878
 Scène biblique
 Charcoal, 18½ x 22½″ (47 x 57 cm)
 Signed and dated lower right: *J. Ensor 1878*
 Collection Mr. and Mrs. Harry C. Sandhouse

53 *Death of Jezebel.* 1880
 La Mort de Jézabel
 Charcoal, 27¼ x 20½″ (70.2 x 52 cm)
 Signed and dated lower right: *Ensor 1880*
 Collection The Art Institute of Chicago, Gift of
 Mrs. Tiffany Blake (1960.156)

* *Ostend Fisherman.* 1880
 Pecheur ostendais
 Sanguine, 28⅜ x 22″ (72 x 56 cm)
 Signed and dated lower left: *ENSOR 1880*
 Collection Georges De Graeve

* *Silhouettes.* 1880
 Silhoüettes
 Pencil and watercolor, 9½ x 12⅝″ (24 x 32 cm)
 Signed lower left: *Ensor;* lower right: *Ensor*
 Private Collection

* *Young Fisherman.* 1880
 Jeune pecheur
 Charcoal, 29½ x 24″ (75 x 61 cm)
 Signed and dated lower right: *Ensor 80;* inscribed
 above signature: *jeune pecheur*
 Collection Nelson Gallery—Atkins Museum,
 Kansas City, Gift of Mrs. George H. Bunting, Jr.

54 *Young Man in a Derby Hat.* 1880
 Jeune homme au chapeau melon (garçon à la barrière)
 Charcoal, 30 x 24″ (76 x 61 cm)
 Signed and dated lower left of center: *Ensor 80;*
 inscribed above signature: *garçon à la barrière*
 Collection Mr. and Mrs. Harry C. Sandhouse

* *Piano.* ca. 1880 with later additions
 Piano
 Pencil, 9⅛ x 6½″ (23 x 16.5 cm)
 Not signed or dated
 Private Collection

* *The Artist's Sister.* 1880-82
 La Soeur de l'artiste
 Pencil, 8½ x 6¼″ (21.5 x 16 cm)
 Signed right below center: *Ensor*
 Collection Stedelijk Museum, Ostend

55 *The Artist's Sister and Stove.* 1880-82
 La Soeur de l'artiste et un poêle
 Black chalk and pencil, 5⅞ x 6⅞″ (15 x 17.5 cm)
 Signed lower right of center: *Ensor;* inscribed below
 signature: *Le poêle noir frémit et mord*
 Collection Stedelijk Museum, Ostend

* *Chinese Vase and Figures.* 1880-82
 Vase chinois et personnages
 Black chalk and pencil, 8⅞ x 10⅞″ (22.5 x 27.5 cm)
 Not signed or dated
 Collection Stedelijk Museum, Ostend

* *Vase and Woman.* 1880-82
 Vase et femme
 Black chalk and pencil, 8½ x 6¼″ (21.5 x 16 cm)
 Signed lower right: *Ensor*
 Collection Stedelijk Museum, Ostend

56 *White Horse and Figures.* 1880-82
 Cheval blanc et personnages
 Black chalk and pencil, 8½ x 10⅝″ (22 x 27 cm)
 Signed lower left: *Ensor;* signed center right edge: *Ensor*
 Collection Stedelijk Museum, Ostend

57 *Still Life with Clock.* ca. 1880-82
 Cheminée et pendule
 Pencil and black chalk, 6¾ x 9″ (17 x 22.4 cm)
 Signed upper center: *Ensor*
 Collection The Art Institute of Chicago, Acquired through
 the Grant J. Pick Fund and Charles C. Cunningham (1969.23)

* *Sleeping Woman*
 Femme en repos
 Pencil, 9 x 6¾″ (22.7 x 17 cm)
 Signed lower center: *Ensor*
 Collection Stedelijk Prentenkabinet, Antwerp

58 *Vase with Flowers*
 Vase et fleurs
 Pencil, 9 x 6⅝″ (22.6 x 16.8 cm)
 Signed lower right of center: *Ensor*
 Collection Stedelijk Prentenkabinet, Antwerp

* *Derby Hat and Boot.* 1880-85
 Chapeau melon et chaussure
 Black chalk and pencil, 8⅝ x 10⅞″ (22 x 27.5 cm)
 Signed lower right: *Ensor*
 Collection Stedelijk Museum, Ostend

59 *Portrait of His Sister.* 1881.
 La Soeur de l'artiste
 Charcoal, 29⅛ x 22⅞″ (74 x 58 cm)
 Signed and dated lower left: *Ensor 1881;* inscribed
 above signature: *Portrait de Mlle. Marie Ensor*
 Collection The Art Institute of Chicago, The Margaret
 Day Blake Collection (1970.42)

60 *Théo Hannon.* 1882
 Théo Hannon
 Black chalk and charcoal, 8¾ x 6⅝″ (21.2 x 16.8 cm)
 Signed, dated and inscribed left of center: *James Ensor
 1882 Portrait de Théo Hannon*
 Collection Yale University Art Gallery, New Haven,
 Henry Sage Goodwin, B.A. 1927, Fund

61 *Scaffolding.* ca. 1882
 Echafaudage
 Conté crayon, 8⅞ x 3¼″ (22.5 x 8.3 cm)
 Signed upper left: *Ensor*
 Collection Koninklijk Museum voor Schone Kunsten, Antwerp

62 *Artist's Sister Writing a Letter.* 1883
 La Soeur de l'artiste écrivant une lettre
 Black chalk and pencil, 8¼ x 11⅞″ (21 x 30 cm)
 Signed and dated lower left: *J. Ensor 1883*
 Collection Stedelijk Museum, Ostend

* *Papers and Books Arranged on a Table.* ca. 1883
Papiers et livres sur une table
Charcoal, 8¾ x 6⅞″ (22.3 x 17.4 cm)
Signed lower right of center: *Ensor*
Collection Yale University Art Gallery, New Haven,
Director's Discretionary Fund

63 *Chinoiserie.* 1885
Chinoiserie
Watercolor and conté crayon, 8⅞ x 6¾″ (22.5 x 17 cm)
Signed and dated lower right: *Ensor 85*
Collection Koninklijk Museum voor Schone Kunsten, Antwerp

64 *Copy after Daumier: Fisherman Falling in the Water.* 1885
Copie d'après Daumier: Pecheur tombant dans l'eau
Conté crayon, 8⅞ x 6¾″ (22.5 x 17 cm)
Not signed or dated
Collection Koninklijk Museum voor Schone Kunsten, Antwerp

65 *Copy after Delacroix: Lion.* 1885
Copie d'après Delacroix: Lion
Pen and ink, 6¾ x 8⅞″ (22 x 17 cm)
Not signed or dated
Collection Koninklijk Museum voor Schone Kunsten, Antwerp

66 *Copy after Rembrandt: Death of Mary Magdalen.* 1885
Copie d'après Rembrandt: Mort de Madeleine
Pen and ink, 8⅞ x 6¾″ (22.5 x 17 cm)
Not signed or dated
Collection Koninklijk Museum voor Schone Kunsten, Antwerp

67 *Copy after Rembrandt: Street near Canal.* 1885
Copie d'après Rembrandt: Rue près d'un canal
Conté crayon, 8¾ x 6¾″ (22 x 17 cm)
Not signed or dated
Collection Koninklijk Museum voor Schone Kunsten, Antwerp

68 *Masks and Grotesque Figures.* 1885
Masques et marmousets
Pencil, 8⅝ x 11¾″ (21.9 x 29.7 cm)
Signed and dated lower right: *Ensor 1885*, faintly
inscribed below signature: *masques et marmousets*
Collection The Art Institute of Chicago, Olivia Shaler
Swan Memorial Collection (1950.1512)

* *Self-Portrait "Pas Fini."* 1885
Autoportrait "pas fini"
Charcoal and pencil, 8⅝ x 6¾″ (22 x 17 cm)
Inscribed lower right: *PAS FINI*
Collection Stedelijk Museum, Ostend

69 *Personnages of Goya after Goya's Capricho No.
51, Se Repulen.* ca. 1885
Copie d'après Goya: Capricho no. 51, Se Repulen
Pencil, 6¼ x 8⅞″ (15.7 x 22.6 cm)
Inscribed lower left: *après Goya C'est un si grand
inconvenient d'avoir les ongles trop longs que cela est
défendu même dans la sorcellerie*
Collection The Art Institute of Chicago, Gift of Mr.
and Mrs. James W. Alsdorf (1965.1184)

70 *The Gay: Adoration of the Shepherds.* 1886
La Gai: L'Adoration des bergers
Charcoal and conté crayon, 30 x 26⅜″ (76 x 67 cm)
Signed lower left: *J. Ensor*; signed and dated lower
right: *James Ensor 1886*
Collection Musées Royaux des Beaux-Arts de Belgique,
Brussels

71 *Artist Decomposed.* 1886
L'Artiste décomposé
Colored pencil, 4⅞ x 3¼″ (12.4 x 8.2 cm)
Signed and dated lower right: *J. Ensor 1886*
Collection Musées Nationaux, Paris

72 *The Sad and Broken: Satan and His Fantastic
Legions Tormenting the Crucified Christ.* 1886
*La Triste et brisée: Satan et les légions fantastiques
tourmentant le Crucifié*
Charcoal and conté crayon, 23⅜ x 29⅛″ (61 x 76 cm)
Signed, dated and inscribed lower right:
ENSOR 1886 OSTENDE
Collection Musées Royaux des Beaux-Arts de Belgique,
Brussels

* *Christ Driving the Money Changers from the
Temple.* 1886
Le Christ chassant les marchands du temple
Pencil, 9⅛ x 6⅞″ (23 x 17.5 cm)
Signed and dated lower left: *Ensor 86*
Private Collection

73 *Copy after Rowlandson.* 1886
Copie d'après Rowlandson
Pen and ink and conté crayon, 8⅞ x 16¾″ (22.5 x 17 cm)
Signed and inscribed left of center: *Ensor copie*;
dated: *1886*
Collection Koninklijk Museum voor Schone Kunsten,
Antwerp

74 *The Devils Dzittzs and Hihahox, Under Orders of
Crazou Riding a Furious Cat, Lead Christ to Hell.*
1886
*Les Diables Dzittzs et Hihahox, commandés par
Crazou, montant un chat furieux, conduisent le
Christ aux enfers*
Conté crayon, India ink, and white highlights,
6⅞ x 8⅞″ (17.3 x 22.6 cm)
Signed and dated lower right: *ENSOR 1886*; lower
left: *Ensor 86*
Collection Musées Royaux des Beaux-Arts de Belgique,
Brussels

75 *Self-Portrait and Other Figures.* 1886
Autoportrait et autres personnages
Black and red chalk, 8½ x 11⅜″ (21 x 29 cm)
Signed and dated lower right: *Ensor 86*
Collection Stedelijk Museum, Ostend

76 *Portrait of a Man (after the Rembrandt Self-
Portrait of 1639).* 1886
Copie d'après Rembrandt: Autoportrait de 1639
Pen and ink, 8⅞ x 16¾″ (22.5 x 17 cm)
Signed and dated lower right: *Ensor 86*
Collection The Art Institute of Chicago, Gift of
Mr. and Mrs. James W. Alsdorf (1965.1182)

77 *The Alive and Radiant: The Entry into Jerusalem.*
ca. 1886
La Vive et rayonnante: L'Entrée à Jérusalem
Pencil, 9 x 6¾" (22.7 x 17 cm)
Signed lower right: *Ensor*
Private Collection

* *The Artist's Father in Death.* 1887
Mon père mort
Pencil, black crayon and opaque white (charcoal?),
6¾ x 9" (17.1 x 22.8 cm)
Signed and dated lower right: *JAMES ENSOR 87*
Private Collection, New York

78 *The Artist's Father in Death.* 1887
Mon père mort
Conté crayon, 6¾ x 8⅞" (17 x 22.5 cm)
Signed lower right of center: *Ensor*
Collection Koninklijk Museum voor Schone Kunsten, Antwerp

79 *Copy after Turner: Sunrise, Odysseus Ridiculing
Polyphemus.* 1888
*Copie d'après Turner: Nouveau soleil, Odysse
moquant Polyphème*
Conté crayon, 8⅞ x 6¾" (22.5 x 17 cm)
Dated on reverse: *1888*
Collection Koninklijk Museum voor Schone Kunsten, Antwerp

80 *The Elephant's Joke.* 1888
La Blague d'éléphant
Pencil, 6¾ x 8⅞" (17 x 22.5 cm)
Signed and dated lower left: *Ensor 1888*
Collection Stedelijk Museum, Ostend

* *Five Burlesque Figures.* 1888
Cinq figures burlesques
Watercolor, ink, and gouache, 6⅞ x 5" (17.5 x 12.5 cm)
Signed right of center: *Ensor*
Private Collection

81 *Plague Here, Plague There, Plague Everywhere.*
1888
Peste dessous, peste dessus, peste partout
Pencil and sanguine, 8⅝ x 11⅞" (22 x 30 cm)
Signed and dated lower left: *J. Ensor 1888;* inscribed
across top: *PESTE DESSOUS PESTE DESSUS
PESTE PARTOUT*
(A print of the same composition is dated 1904, T.127)
Collection Koninklijk Museum voor Schone Kunsten, Antwerp

82 *Demons Teasing Me.* 1888
Demons me turlupinant
Pencil and black chalk, 8⅝ x 11¾" (21.8 x 29.8 cm)
Signed lower center: *Ensor 1888*
(Related to the 1895 etching, T.92 (Pl. 108) and poster
and cover for *La Plume,* December 1898)
Collection The Art Institute of Chicago, The Ada
Turnbull Hertle Fund (1967.528)

83 *Skeleton Playing Flute.* 1888
Squelette jouant de la flûte
Pencil on prepared panel, 8½ x 6½" (21.5 x 16.5 cm)
Signed lower right: *Ensor;* dated on reverse: *1888*
Private Collection

47 *The Strike in Ostend.* 1888
La Grève
Colored pencil with watercolor, 13⅜ x 26¾"
(34 x 67.5 cm)
Signed and dated lower right: *James Ensor 1888*
Collection Koninklijk Museum voor Schone Kunsten,
Antwerp

84 *Belgium in the XIX Century.* ca. 1889
Belgique au XIX siècle
Pencil on prepared panel, 6⅜ x 8½" (16.1 x 21.5 cm)
Signed lower right: *Ensor;* inscribed across top:
BELGIQUE XIX SIECLE; across center: *QUE
VOULEZ VOUS? N'ETES VOUS PAS CONTENTS/
UN PEU DE PATI . . . NCE PAS DE VIOLENCE/ JE
VOIS BIEN QU . . . CHOSE MAIS JE NE SAIS POUR
QUELLE CAUSE/ JE NE DISTINGUE PAS TRES
BIEN;* left of center: *SERVICE PERSONNEL/
INSTRUCTION OBLIGATOIRE/SUFFRAGE
UNIVERSEL*
(Related to the 1889 print, T.81)
Collection Bibliothèque Royale Albert Iᵉʳ, Brussels

85 *Roman Triumph.* ca. 1889
Triomphe romain
Pencil on prepared panel, 14⅝ x 18⅛" (37.1 x 46 cm)
Signed lower left: *J. Ensor*
(Related to the 1889 print, T.78)
Collection Bibliothèque Royale Albert Iᵉʳ, Brussels

* *Skeleton Warming Himself.* ca. 1889
Squelette se chauffant
Pencil, 11⅞ x 8⅝" (30.2 x 22 cm)
Signed lower center: *Ensor*
(Study for a painting of 1889)
Collection Koninklijk Museum voor Schone Kunsten,
Antwerp

86 *Self-Portrait.* 1890
Autoportrait
Charcoal, 28¾ x 21⅝" (73 x 55 cm)
Signed and dated on reverse: *James Ensor 1884*
Collection Musées Royaux des Beaux-Arts de Belgique,
Brussels

* *Soldier.* ca. 1890
Soldat
Black chalk, 17⅝ x 5⅛" (19.4 x 13 cm)
Signed lower left: *Ensor*
Collection Stedelijk Prentenkabinet, Antwerp

* *Garden of Love.* 1895
Jardin d'amour
Watercolor and mixed media, 5½ x 4¼" (14 x 10.8 cm)
Signed and dated lower right: *James Ensor 1895*
Collection Mr. and Mrs. James W. Alsdorf

87 *Street in Ostend.* 1895
Rue à Ostende
Pencil with touches of colored chalk, 9 x 12⅜"
(22.8 x 31.5 cm)
Signed and dated lower left: *Ensor 1895*
Collection Stedelijk Prentenkabinet, Antwerp

88 *Dangerous Cooks.* 1896
Les Cuisiniers dangereux
Colored chalk, 9½ x 13″ (24 x 33 cm)
Signed and dated lower left: *Ensor 1896;* inscribed upper center: *Les Cuisiniers Dangereux,* upper right: *100*
Collection Museum Plantin-Moretus, Antwerp

89 *Project for a Chapel Dedicated to SS. Peter and Paul.* 1897
Esquisse pour un chapel consacré à SS. Pierre et Paul
Pencil heightened with Chinese white, 11⅞ x 9½″
(30 x 24 cm)
Signed and dated lower right: *J. Ensor 1897*
Private Collection

90 *Beach at Ostend.* ca. 1898-99
La Plage à Ostende
Pencil, 8⅞ x 11⅝″ (22.5 x 29.5 cm)
Signed lower center: *Ensor*
(Study for the 1899 print, T.115, Pl. 112)
Collection The Art Institute of Chicago, Gift of George A. Poole, Jr., and The Print and Drawing Club (1969.22)

48 *Portrait of the Artist's Niece in Chinese Costume.* 1899
La Nièce de l'artiste au costume chinois
Watercolor over pencil, retouched in pen and ink,
25⅛ x 19⅝″ (63.8 x 49.7 cm)
Signed and dated lower right: *J. Ensor 99*
Collection The Art Institute of Chicago, The Joseph and Helen Regenstein Collection (1972.426)

91 *Skeletons Playing Billiards.* 1903
Squelettes jouant au billard
Pencil and colored crayon, 5 x 6⅞″ (12.5 x 17.5 cm)
Signed lower right: *ENSOR*
Collection Stedelijk Museum, Ostend

* *Caressing Priapus (Dancers and Musicians).* 1909
Priape caressant (danseurs et musicians)
Red chalk, 12¼ x 7¼″ (31 x 18.5 cm)
Signed and dated lower center: *Ensor 1909*
Collection Stedelijk Museum, Ostend

* *The Artist's Mother in Death.* 1915
Ma mère morte
Conté crayon, 8¾ x 12¼″ (22.3 x 31.2 cm)
Signed, dated and inscribed lower left: *mercredi 10 mars 1915 ma mère morte*
Collection Koninklijk Museum voor Schone Kunsten, Antwerp

92 *Nymph Embracing Herm.* ca. 1920
Nymphe embrassant l'herme
Colored pencil,
Signed lower right: *J. Ensor*
Collection Bibliothèque Royale Albert Iᵉʳ, Brussels

93 *My Hands in 1928.* 1928
Mes mains en 1928
Pencil and colored pencil, 8⅞ x 12¼″ (22.5 x 31 cm)
Dated and signed lower right: *1928 James Ensor;* inscribed above signature: *mes mains en 1928*
Collection Stedelijk Museum, Ostend

* *The Tongues.* ca. 1928
Les Langues
Watercolor, 14¼ x 19⅜″ (36 x 50 cm)
Signed lower center: *J. Ensor*
Private Collection

94a *Sketchbook.* 1929 and later
94b *Cahier de Croquis*
58 sheets and leaves with drawings of Ensor's paintings, each sheet 6⅞ x 8⅝″ (17.4 x 21.7 cm)
Includes a sketch of the watercolor *Portrait of the Artist's Niece in Chinese Costume* (Pl. 90), one of the few early works copied by Ensor. According to an inscription on the inside cover, the sketchbook was presented to Ensor in 1929
Collection The Art Institute of Chicago, The Harriott A. Fox Fund

* *The Artist's Studio.* 1930
Ma Chambre préférée
Colored pencil on pencil, 11 x 8″ (28 x 20.3 cm)
Signed and dated lower right: *James Ensor 31 XII 1930;* inscribed above signature across bottom: *Hommage à Mlle. Blanche Hertoge mon atelier*
Lent by Allan Frumkin Gallery, New York

PRINTS

"T" numbers refer to Auguste Taevernier, *James Ensor: Illustrated Catalogue of his Engravings, Their Critical Description and Inventory of the Plates* (Brussels, 1973). All information in the following checklist is based on material in Taevernier.

* *Christ Mocked.* 1886
Le Christ insulté
T.1 Etching, 9⅛ x 6⅛″ (23 x 15.5 cm)
First state of two
Not signed in plate
Signed and dated in pencil lower left: *Ensor 86*
Private Collection

* *Self-Portrait.* 1886
L'Artiste par lui-même
T.4 Etching, 4 x 2¾″ (10 x 7 cm)
Second state of two
Signed in plate lower left: *Ensor*
Signed and dated in pencil lower right: *James Ensor 1896*
Collection The Art Institute of Chicago,
Gift of Dr. and Mrs. Myron Melamed, in memory of Mr. and Mrs. Israel Melamed (1968.478)

95 *Christ Calming the Tempest.* 1886
Le Christ apaisant la tempête
T.5 Drypoint and etching, 6 x 9⅛″ (15.3 x 23 cm)
Third state of three
Signed in plate lower left: *Ensor;* signed lower right: *J. Ensor*
Signed and dated in pencil lower right: *James Ensor 1886*
Private collection Mr. and Mrs. Herman D. Shickman

* *Iston, Pouffamatus, Cracozie and Transmouffe,*
Famous Persian Physicians, Examining the Stool of
King Darius after the Battle of Arbela. 1886
Iston, Pouffamatus, Cracozie et Transmouffe,
célèbres médecins persans, examinant les selles du
roi Darius, après la bataille d'Arbelles

T.6 Etching, 9⅜ x 7″ (23.7 x 17.8 cm)
Second state of three
Signed and dated in plate lower left: *J. Ensor 86*
Signed in pencil lower right: *James Ensor*
Private Collection

* *The Cathedral.* 1886
La Cathédrale

T.7 Etching, 9¼ x 7″ (23.6 x 17.7 cm)
First of two plates, first state of three
Signed in plate on hat of figure bottom center: *Ensor*
Inscribed, signed, and dated in brown ink lower right:
à mon ami Demolder James Ensor 1891
Collection The Art Institute of Chicago, Joseph Brooks
Fair Fund (1953.268)

96 *The Cathedral.* 1886
La Cathédrale

T.7 Etching, 9⅞ x 7½″ (23.6 x 17.7 cm)
First of two plates, second state of three, blue ink
Signed in plate on hat of figure bottom center: *Ensor*;
signed and dated upper right: *Ensor 1886*
Collection The Minneapolis Institute of Arts, Bequest
of Putnam Dana McMillan

* *The Cathedral.* 1886
La Cathédrale

T.7 Etching, 9¼ x 7″ (23.6 x 17.7 cm)
First of two plates, third state of three, hand colored
Signed in plate on hat of figure bottom center: *Ensor*;
signed and dated upper right: *Ensor 1886*
Signed and dated in pencil lower right: *James Ensor*
1886
Collection The Art Institute of Chicago, Joseph R.
Shapiro Collection (1966.93)

* *The Infernal Cortege.* 1886
Cortège Infernal

T.10 Etching, 8¼ x 10¼″ (21 x 25.8 cm)
Second state of two
Signed and dated in plate bottom left of center: *Ensor*
86 or 87
Signed upper right: *Ensor*
Collection The Art Institute of Chicago, Gift of B. E.
Bensinger Fund (1960.718)

97 *Ernest Rousseau.* 1887

T.11 Drypoint, 9 x 6⅝″ (22.8 x 16.8 cm)
Fourth state of four
Signed and dated in plate lower right: *Ensor 87*
Signed and dated in pencil lower right: *James Ensor 1887*
Private Collection Mr. and Mrs. Herman D. Shickman

98 *The Pisser.* 1887
Le Pisseur

T.12 Etching, 5¾ x 4⅛″ (14.5 x 10.5 cm)
Only state
Inscribed in plate upper right: *ENSOR EST UN FOU,*
MERDE, MALADIES SECRETE
Signed in pencil lower right: *James Ensor*
Collection Philadelphia Museum of Art, Print Club
Permanent Collection

* *Grand View of Mariakerke.* 1887
Grand Vue de Mariakerke

T.13 Etching, 8¼ x 10¼″ (21 x 25.9 cm)
Second state of two
Signed in plate lower left: *Ensor*
Signed and dated in pencil lower right: *James Ensor 1887*
Collection The Art Institute of Chicago, Gift of the
Print and Drawing Club (1967.44)

* *Rue du Bon-Secours, Brussels.* 1887
Rue du Bon-Secours à Bruxelles

T.17 Drypoint, 5⅛ x 3½″ (13 x 9 cm)
Only state
Inscribed in plate below center: *ENSOR*
Signed in pencil lower right: *James Ensor*
Private Collection Mr. and Mrs. Herman D. Shickman

* *Combat of the Rascals Désir and Rissolé.* 1888
Le Combat des pouilleux Désir et Rissolé

T.19 Drypoint, 9 x 11″ (22.9 x 28 cm)
Second state of three
Signed and dated in plate lower left: *Ensor 88*; lower
center: *Ensor 1888*
Signed in pencil lower right: *James Ensor*
Collection The Art Institute of Chicago, Gift of the
Print and Drawing Club (1955.1061)

* *The Street Lamp.* 1888
Réverbère

T.21 Etching, 3½ x 2½″ (9 x 6.2 cm)
Second state of two
Signed in plate upper right: *ENSOR*
Signed and dated in pencil lower right: *James Ensor 1887* (sic)
Collection Louise S. Richards

* *Haunted Furniture.* 1888
Le Meuble hanté

T.22 Etching, 5⅜ x 3½″ (13.5 x 8.8 cm)
Third state of three
Signed in plate lower left: *Ensor*
Signed and dated in pencil lower right: *James Ensor 1888*
Private Collection

* *Devils Thrashing Angels and Archangels.* 1888
Diables rossant anges et archanges

T.23 Etching, 9⅞ x 11½″ (25 x 29.3 cm)
Only state, hand colored
Signed and dated in plate lower right: *Ensor 88*
Signed in pencil within composition lower right: *Ensor*;
signed and dated in pencil lower right: *James Ensor*
1888
Collection The Art Institute of Chicago, Olivia Shaler
Swan Fund (1971.629)

* Devils Thrashing Angels and Archangels. 1888
Diables rossant anges et archanges
T.23 Etching, 9⅞ x 11½" (25 x 29.3 cm)
Only state
Signed and dated in plate lower right: *Ensor 88*
Signed in pencil lower right: *James Ensor*
Collection The Art Institute of Chicago, Gift of the
Print and Drawing Purchase Fund (1955.1075)

99 Town Hall of Audenaerde. 1888
Hôtel de Ville d'Audenaerde
T.28 Etching, 5⅞ x 4½" (15 x 11.3 cm)
Second state of three
Inscribed, signed, and dated in plate lower right:
AUDENAERDE J. ENSOR 1888
Signed and dated in pencil lower right: *James Ensor 88*
Collection The Minneapolis Institute of Arts, The Ladd
Collection, Gift of H. V. Jones

* Capture of a Foreign City. 1888
Prise d'une ville étrange
T.33 Etching, 6⅞ x 9¼" (17.3 x 23.3 cm)
Third state of four
Signed in plate lower right: *Ensor*
Signed in pencil lower right: *James Ensor*
Collection The Museum of Modern Art, New York

100 My Portrait in 1960. 1888
Mon portrait en 1960
T.34 Etching, 2¾ x 4¾" (6.4 x 11.4 cm)
Second state of two, hand colored
Signed and dated in plate lower right: *Ensor 88*
Inscribed in pencil lower left: *mon portrait en 1960;*
signed and dated in pencil lower right: *James Ensor 1888*
Collection Philadelphia Museum of Art, purchased with
funds given by Derald H. Ruttenberg and Robert A. Hauslohner

* My Portrait in 1960. 1888
Mon portrait en 1960
T.34 Etching, 2¼ x 4½" (6.4 x 11.4 cm)
Second state of two
Signed and dated in plate lower right: *Ensor 88*
Signed in pencil lower right: *James Ensor*
Collection The Art Institute of Chicago, The Charles
Deering Collection (1968.181)

* My Father in Death. 1888
Mon père mort
T.35 Drypoint, 3⅝ x 5½" (9.2 x 13.1 cm)
Third state of three
Signed in plate lower left: *Ensor*
Inscribed in pencil lower left: *Mon père mort pointe
sèche;* signed and dated in pencil lower right: *James Ensor 1888*
Collection The Art Institute of Chicago, Anonymous
gift (1967.233)

* The Terrible Archer. 1888
L'Archer terrible
T.36 Etching, 7 x 9½" (17.7 x 23.8 cm)
Second state of two
Signed in plate lower right: *Ensor*
Signed and dated in pencil lower right: *James Ensor 1888*
Collection The Art Institute of Chicago, Gift of the
Print and Drawing Club (1946.1042)

* The Cataclysms. 1888
Les Cataclysmes
T.37 Etching, 7 x 9½" (17.8 x 23.7 cm)
Only state
Signed in plate lower right: *Ensor*
Inscribed in pencil lower left: *Les Cataclysmes;* signed
and dated in pencil lower right: *James Ensor 1888*
Collection The Art Institute of Chicago, Joseph Brooks
Fair Fund (1943.1021)

* The Assassination. 1888
L'Assassinat
T.38 Etching, 7 x 9½" (17.8 x 23.8 cm)
Only state
Signed in plate lower right: *J. Ensor*
Inscribed in pencil lower left: *L assassinat;* signed and
dated in pencil lower right: *James Ensor 1888*
Collection Yale University Art Gallery, New Haven,
Gift of James N. Elesh

* Extraordinary Musicians. 1888
Musiciens fantastiques
T.43 Etching, 7 x 4⅞" (17.8 x 12.3 cm)
First state of two
Signed in plate lower left: *Ensor*
Signed and dated in pencil lower right: *James Ensor 1888*
Collection The Art Institute of Chicago, Gift of the
Print and Drawing Club (1946.1066)

* The Main Dock, Ostend. 1888
Le Grand Basin, Ostend
T.45 Etching, 7⅛ x 9⅜" (17.9 x 23.8 cm)
Second state of three
Signed and dated in plate lower right: *Ensor 88*
Signed in pencil lower right: *James Ensor*
Collection The Art Institute of Chicago, Gift of the
Print and Drawing Club (1967.693)

101 Peculiar Insects. 1888
Insectes singuliers
T.46 Drypoint, 4½ x 6⅛" (11.4 x 15.4 cm)
Fifth state of five
Signed and dated in plate upper left: *Ensor 1888;* lower
right: *Ensor 88*
Signed and dated lower right: *James Ensor 1888*
Private Collection Mr. and Mrs. Herman D. Shickman

102 Storm at the Edge of the Wood. 1888
Coup de vent à la lisière d'un bois
T.47 Etching, 6⅝ x 9⅜" (16.6 x 23.8 cm)
Second state of two
Signed and dated in plate lower left: *Ensor 88*
Signed in pencil lower right: *James Ensor*
Collection The Art Institute of Chicago, Print and
Drawing Purchase Fund (1960.337)

103 Boats Aground. 1888
Barques échouées
T.49 Etching, 7 x 9⅜" (17.6 x 23.7 cm)
Second state of three
Signed and dated in plate lower right: *Ensor 88*
Collection The Art Institute of Chicago, Gift of Dennis
Adrian (1963.538)

* *Wizards in a Squall.* 1888
Sorciers dans la bourrasque

T.52 Etching, 7⅛ x 9⅜" (17.9 x 23.8 cm)
Second state of two, hand colored
Signed and dated in plate lower right: *Ensor 1888*
Inscribed in pencil lower left: *Sorciers dans la bourrasque*; signed and dated in pencil lower right: *James Ensor 1888*
Collection The Art Institute of Chicago, Gift of Dennis Adrian (1963.537)

* *Wizards in a Squall.* 1888
Sorciers dans la bourrasque

T.52 Etching and drypoint, 7⅛ x 9⅜" (17.9 x 23.8 cm)
Second state of two
Signed in plate lower right: *Ensor*
Signed and dated in pencil lower right: *James Ensor 1888*
Collection The Art Institute of Chicago, Gift of the Print and Drawing Club (1946.264)

* *The Gendarmes.* 1888
Les Gendarmes

T.55 Etching, 7⅛ x 9⅜" (17.9 x 23.8 cm)
Sixth state of six
Signed in plate lower left of center: *Ensor*
Signed in pencil lower right: *James Ensor*
Collection The Art Institute of Chicago, Gift of the Print and Drawing Club (1946.1044)

* *The Stars in the Cemetery.* 1888
Les Etoiles au cimitière

T.56 Etching, 5¼ x 6⅞" (13.2 x 17.3 cm)
Only state
No signature or date
Collection The Museum of Modern Art, New York, Gift of Abby Aldrich Rockefeller

* *Lust.* 1888
La Luxure

This print was later inserted in the album *The Seven Deadly Sins,* 1904
T.59 Etching, 3⅝ x 5⅛" (9.2 x 13.1 cm)
Second state of two, hand colored
Signed in plate lower left: *ENSOR*; lower right: *Ensor*
Inscribed in red pencil lower left: *Luxure*; signed in red pencil lower right: *J. Ensor*
Collection The Art Institute of Chicago, Gift of Joseph R. Shapiro and William McCallin McKee and Stanley Fields Funds (1958.374)

104 *Lust.* 1888
La Luxure

This print was later inserted in the album *The Seven Deadly Sins,* 1904
T.59 Etching, 3⅞ x 5½" (9.2 x 13.1 cm)
Second state of two
Signed in plate lower left: *ENSOR*; lower right: *Ensor*
Inscribed in pencil lower left: *La luxure*; signed and dated in pencil lower right: *James Ensor 1888*
Collection The Cleveland Museum of Art, Purchase from the J. H. Wade Fund

* *The Garden of Love.* 1888
Jardin d'Amour

T.61 Etching, 4⅜ x 2⅞" (11.2 x 7.3 cm)
Third state of three, hand colored
Signed in plate lower center: *Ensor*
Signed and dated in pencil lower right: *James Ensor 1888*
Collection The Art Institute of Chicago, Gift of the Print and Drawing Club (1954.112)

* *Steam Boats.* 1888
Bateaux à vapeur

T.64 Etching, 2⅞ x 4⅜" (7.3 x 11.2 cm)
Third state of three
Signed in plate lower right of center: *ENSOR*
Signed in pencil lower right: *James Ensor*
Collection James N. Elesh

105 *The Skaters.* 1889
Les Patineurs

T.65 Etching, 6⅞ x 9⅛" (17.5 x 23.2 cm)
First state of two
Signed and dated in plate lower right: *Ensor 1889*
Collection The Art Institute of Chicago, Gift of the Print and Drawing Club (1952.257)

106 *My Portrait as a Skeleton.* 1889
Mon portrait squelettisé

T.67 Etching, 4⅝ x 3" (11.6 x 7.5 cm)
Third state of three
Signed in plate lower left: *ENSOR*
Signed in pencil lower right: *James Ensor*
Collection Fogg Art Museum, Harvard University, Cambridge, Massachusetts

* *The Thunderstorm.* 1889
L'Orage

T.70 Etching, 3 x 4⅝" (7.5 x 11.6 cm)
Second state of three
Signed in plate lower right: *ENSOR*
Signed and dated in pencil lower right: *James Ensor 1889*
Collection The Art Institute of Chicago, Gift of the Print and Drawing Club (1952.256)

* *Village Fair at the Windmill.* 1889
La Kermesse au moulin

T.72 Etching, 5⅜ x 6⅞" (13.5 x 17.4 cm)
Only state
Signed in plate upper left: *Ensor*
Inscribed in pencil lower left: *La fête au moulin*; inscribed, signed, and dated lower right: *un bon souvenir à notre bon ami/ et, tous mes souhaites de bonheur et de joie James Ensor Ostende novembre (? erased) 1929*
Collection The Art Institute of Chicago, Gift of the Print and Drawing Club (1960.336)

* *The Ghost.* 1889
Le Fantôme

T.73 Etching, 3 x 4⅝" (7.6 x 11.6 cm)
Fourth state of four
Signed in plate lower right: *Ensor*
Inscribed in pencil lower left: *Le genie des cataclysmes*; signed and dated lower right: *James Ensor 1889*
Collection The Art Institute of Chicago, Gift of the Print and Drawing Club (1946.263)

* *The Pool of the Poplars.* 1889
La Mare aux peupliers
T.74 Etching, 6⅛ x 9¼" (15.5 x 23.3 cm)
Only state
Signed and dated in plate upper right: *Ensor 1889*
Signed in pencil lower right: *James Ensor*
Private collection Mr. and Mrs. Herman D. Shickman

* *Rustic Bridge.* 1889
Pont rustique
T.76 Etching, 3 x 4⅝" (7.5 x 11.7 cm)
Second state of two
Signed in plate upper left: *ENSOR*
Signed in pencil lower right: *Ensor 1889*
Collection James N. Elesh

* *Doctrinal Nourishment.* 1889
Alimentation doctrinaire
T.79 Etching, 7⅛ x 9¾" (18 x 23.8 cm)
First of two plates, fourth or fifth state, hand colored
Signed in plate center left: *ENSOR*
Inscribed in plate upper left: *BELGIQUE EN 1889
ALIMENTATION DOCTRINAIRE*; center left:
INSTRUCTION OBLIGATOIRE; center right:
SERVICE PERSONNEL/SUFFRAGE UNIVERSEL . . .
Signed in yellow paint upper right: *Ensor*
Private collection Mr. and Mrs. Herman D. Shickman

* *Music in the Vlaanderenstraat, Ostend.* 1890
La Musique rue de Flandre, Ostende
T.83 Etching, 4⅝ x 3" (11.6 x 7.5 cm)
Third state of three
Signed and dated in plate upper right: *Ensor 1890*
Collection Philadelphia Museum of Art

* *Windmill at Slykens.* 1891
Moulin à Slykens
T.84 Etching, 2¾ x 4⅜" (7 x 11.2 cm)
Only state
Signed in plate upper left: *ENSOR*
Signed in pencil lower right: *James Ensor 89* (sic)
Collection James N. Elesh

107 *The Multiplication of the Fishes.* 1891
La Multiplication des poissons
T.85 Etching, 6⅞ x 9⅛" (17.4 x 23.2 cm)
Only state
Inscribed in plate upper right: *FANFARES DOC-
TRINAIRES/TOUJOURS REUSSI/ALIMENTATION
DOCTRINAIRES*; signed and dated in plate lower left
of center: *Ensor 1891*
Signed in pencil lower right: *James Ensor*
Collection The Art Institute of Chicago, Gift of the
Print and Drawing Club (1946.255)

* *The Good Judges.* 1894
Les Bons juges
T.88 Etching, 7⅛ x 9⅜" (18 x 23.9 cm)
First state of two
Signed in plate lower left: *ENSOR*
Signed and dated in pencil lower right: *James Ensor
1894*; inscribed lower left: *Les bons juges*
Collection The Art Institute of Chicago, Gift of Dennis
Adrian (1963.540)

* *The Devils Dzittzs and Hihahox, Under Orders of
Crazou Riding a Furious Cat, Lead Christ to Hell.*
*Les Diables Dzittzs et Hihahox, commandés par
Crazou, montant un chat furieux, conduisent
le Christ aux enfers*
T.90 Etching, 5¼ x 6¾" (13.3 x 17.2 cm)
Only state
Signed and dated in plate lower left: *Ensor 95*
Signed and dated in pencil lower right: *James Ensor 1895*
Collection The Art Institute of Chicago, Gift of the
Estate of Peter H. Deitsch (1971.377)

49 *Demons Teasing Me.* 1895
Démons me turlupinant
T.92 Etching, 4½ x 6⅛" (11.4 x 15.4 cm)
Only state, hand colored
Signed and dated in plate above center: *J. Ensor 1895*
Inscribed in pencil lower right: *de James Ensor à M.
Weismaker (?)*
Collection The Art Institute of Chicago, The Joseph R.
Shapiro Collection (1964.88)

50 *Christ Tormented by Demons.* 1895
Le Christ tourmenté par les démons
T.94 Etching, 6¾ x 9¼" (17.2 x 23.5 cm)
Only state, hand colored
Signed and dated in plate lower left: *JAMES ENSOR 1895*
Inscribed in pencil lower left: *Le Christ tourmenté par
les démons/ épreuve colorée pour mon ami A.
Croquez/ James Ensor*; signed in pencil lower right: *James Ensor*
Collection The Art Institute of Chicago, Gift of Dr.
Eugene Solow (1975.499)

* *Fridolin and Gragapanca of Yperdamme.* 1895
Fridolin et Gragapanca d'Yperdamme
T.95 Etching, 3¾ x 5⅜" (9.6 x 13.5 cm)
Only state
Inscribed in plate across top: *Fridolin et Gragapanca
d'Yperdamme*; right of center: *LIBRE CRITIQUE*;
signed and dated lower right: *J. ENSOR 95*
Signed and dated in pencil lower right: *James Ensor 1895*
Collection The Art Institute of Chicago, Departmental
Purchase Fund (1967.21)

* *Battle of the Golden Spurs.* 1895
Bataille des éperons d'or
T.96 Etching, 6¾ x 9⅜" (17.3 x 23.7 cm)
Only state
Signed in plate lower center: *J. Ensor*
Signed in pencil lower right: *James Ensor*
Collection Barbara M. Elesh

* *The Bad Doctors.* 1895
Les mauvais médecins
T.97 Etching, 6¾ x 9¾" (17.2 x 24.6 cm)
Only state
Inscribed in plate across top: *Les mauvais médecins*;
across bottom: *femme x crev . . . à 7 heures Recu mille
francs Expedier Z Rien recu j'ai laissé l'éponge dans le
ventre peritonite se déclarer*
Signed and dated in pencil lower right: *James Ensor 1895*
Collection The Art Institute of Chicago, Gift of the
Print and Drawing Club (1946.254)

* *King Pest.* 1895
Le Roi peste

T.100 Etching, 3¾ x 4½" (9.6 x 11.5 cm)
Only state, hand colored
Signed and dated in plate lower left of center:
J. Ensor 95
Inscribed, signed, and dated in pencil lower left: *Le roi peste*; lower right: *James Ensor 1895*
Collection The Art Institute of Chicago, Gift of the Print and Drawing Club (1954.113)

* *The Old . . . Rascals.* 1895
Les Vieux . . . polissons

T.101 Etching, 3¾ x 5⅜" (9.6 x 13.6 cm)
Only state
Signed and dated in plate lower right: *J. Ensor 95*
Signed and dated in pencil lower right: *James Ensor 1895*
Collection The Museum of Modern Art, New York, Gift of Mr. and Mrs. Walter Bareiss

* *Christ and the Beggars.* 1895
Le Christ aux mendiants

T.102 Etching, 3½ x 5⅛" (8.8 x 13.1 cm)
Second state of two
Signed in plate lower left: *Ensor 95*
Signed in pencil lower right: *James Ensor*
Collection The Art Institute of Chicago, Gift of Mrs. Everett Kovler (1967.24)

* *Death Chasing the Flock of Mortals.* 1896
La Mort poursuivant le troupeau des humains

T.104 Etching, 9¼ x 6⅞" (23.5 x 17.5 cm)
Second state of three
Signed in plate lower left: *Ja. Ensor*
Signed in pencil lower right: *James Ensor*
Collection James N. Elesh

* *The Cathedral.* 1896
La Cathédrale

T.105 Etching, 9½ x 7" (24 x 17.8 cm)
Second of two plates, only state
Signed and dated in plate upper right: *Ensor 1886* (sic); on hat of figure bottom center: *Ensor*
Private Collection

* *Menu for Charles Vos.* 1896
Menu pour Charles Vos

T.110 Etching, 6¼ x 4¼" (15.7 x 10.9 cm)
Only state, hand colored
Signed in plate lower right: *Ensor*
Inscribed in pencil lower left: *Menu Charles Vos*; signed and dated lower right: *James Ensor 1896*
Collection The Art Institute of Chicago, John H. Wrenn Memorial Collection (1957.320)

* *Napoleon's Farewell.* 1897
Les Adieux de Napoléon

T.111 Etching, 4⅞ x 7½" (12.2 x 18.9 cm)
Second state of two, hand colored
Signed and dated in plate lower left: *Ensor 97*
Signed and dated in pencil lower right: *James Ensor 1897*
Collection The Art Institute of Chicago, Mr. and Mrs. Henry C. Woods Fund (1969.391)

* *Napoleon's Farewell.* 1897
Les Adieux de Napoléon

T.111 Etching, 4⅞ x 7½" (12.2 x 18.9 cm)
Second state of two
Signed and dated in plate lower left: *Ensor 97*
Signed and dated in pencil lower right: *James Ensor 1897*
Collection The Art Institute of Chicago, Print and Drawing Purchase Fund No. 1 (1965.186)

108 *Hop-Frog's Revenge.* 1898
La Vengeance de Hop-Frog

T.112 Etching, 13¾ x 9½" (35 x 24.2 cm)
Second state of two, hand colored
Signed and dated in plate lower center: *ENSOR 98*
Signed and dated in pencil lower right: *James Ensor 1898*
Collection The Art Institute of Chicago, The John H. Wrenn Memorial Collection (1947.683)

* *Hop-Frog's Revenge.* 1898
La Vengeance de Hop-Frog

T.112 Etching, 13¾ x 9½" (35 x 24.2 cm)
Second state of two
Signed and dated in plate lower center: *ENSOR 98*
Inscribed in pencil lower left: *La Vengence de Hop-Frog*; signed in pencil lower right: *James Ensor 1898*
Collection Barbara M. Elesh

* *The Entry of Christ into Brussels.* 1898
L'Entrée du Christ à Bruxelles

T.114 Etching, 9¾ x 14" (24.8 x 35.5 cm)
First state of three, this example contains the corrections for the third state
Inscribed in plate lower left below center: *VIVE JESUS ET LES REFORMES*; upper right: *COLMANS MUSTART / VIVE DENBLON (?) / GOUVEMENT FLAMAND / LES VIVISECTEURS BELGES INSENSIBLES / LES XX / VIVE LA SOCIALE*; center right: *FANFARES DOCTRINAIRES TOUJOUR REUSSI / LES CHARCHUTIERS DE JERUSALEM / SALUT JESUS ROI DE BRUXELLES / PHALANGE WAGNER FRACASSANT / LA SAMARIE RECONNAISSANTE*; lower right of center: *VIVE ANSEELE ET JESUS*; signed lower right: *J. Ensor*
Private Collection

109 *The Entry of Christ into Brussels.* 1898
L'Entrée du Christ à Bruxelles

T.114 Etching, 9¾ x 14" (24.8 x 35.5 cm)
Third state of three
Inscribed in plate lower left below center: *VIVE JESUS ET LES REFORMES*; upper right: *COLMANS MUSTART / VIVE DENBLON (?) / GOUVEMENT FLAMAND / LES VIVISECTEURS BELGES INSENSIBLES / LES XX / VIVE LA SOCIALE*; center right: *FANFARES DOCTRINAIRES TOUJOUR REUSSI / LES CHARCHUTIERS DE JERUSALEM / SALUT JESUS ROI DE BRUXELLES / PHALANGE WAGNER FRACASSANT / LA SAMARIE RECONNAISSANTE*; lower right of center: *VIVE ANSEELE ET JESUS*; signed lower right: *J. Ensor*
Inscribed, signed, and dated in pencil lower right: *Hommage à Monsieur (name erased) / le plus crane des ministères à cerveau / en souvenir de sa visite à Ostende chez / le peintre des masques / James Ensor 2 août 1933*
Collection The Art Institute of Chicago, Bequest of Joseph Winterbotham (1954.340)

The Entry of Christ into Brussels. 1898
L'Entrée du Christ à Bruxelles

T.114 Etching, 9¾ x 14″ (24.8 x 35.5 cm)
Third state of three, hand colored
Inscribed in plate lower left below center: *VIVE JESUS ET LES REFORMES*; upper right: *COLMANS MUSTART / VIVE DENBLON (?) / GOUVEMENT FLAMAND / LES VIVISECTEURS BELGES INSENSIBLES / LES XX / VIVE LA SOCIALE*; center right: *FANFARES DOCTRINAIRES TOUJOUR REUSSI / LES CHARCHUTIERS DE JERUSALEM / SALUT JESUS ROI DE BRUXELLES / PHALANGE WAGNER FRACASSANT / LA SAMARIE RECONNAISSANTE*; lower right of center: *VIVE ANSEELE ET JESUS*; signed lower right: *J. Ensor*
Inscribed, signed, and dated in pencil lower left: *L'Entrée du Christ à Bruxelles en 1889*; signed and dated in pencil, lower right: *James Ensor 1898*
Collection The Art Institute of Chicago, Departmental Purchase Fund (1955.1107)

110 *The Baths at Ostend.* 1899
Les Bains à Ostende

T.115 Etching, 8⅜ x 10⅝″ (21.3 x 26.8 cm)
Second state of two, hand colored
Signed and dated in plate: *Ensor 1899*
Inscribed in pencil lower left: *Les bains d'Ostende*; signed lower right: *James Ensor*
Collection The Art Institute of Chicago, Bequest of Curt Valentin (1955.607)

* *Queen Parysatis.* 1899
La Reine Parysatis

T.116 Etching, 6¾ x 4¾″ (17.1 x 12.1 cm)
Second state of two
Signed in plate lower center: *Ensor*
Signed and dated in pencil lower right: *James Ensor 1900* (sic)
Collection The Museum of Modern Art, New York, Gift of Mr. and Mrs. Walter Bareiss

* *Sloth.* 1902
La Paresse

Part of the series *The Seven Deadly Sins,* album published 1904
T.119 Etching, 3¾ x 5⅜″ (9.6 x 13.6 cm)
First state of two
Signed in plate lower right: *Ensor*
Signed in pencil lower right: *James Ensor*
Collection The Cleveland Museum of Art, Purchase from the J. H. Wade Fund

* *Sloth.* 1902
La Paresse

Part of the series *The Seven Deadly Sins,* album published 1904
T.119 Etching, 3¾ x 5⅜″ (9.6 x 13.6 cm)
Second state of two, hand colored
Signed in plate lower right: *Ensor*
Inscribed in red pencil lower left: *Paresse*; signed in red pencil lower right: *J. Ensor*
Collection The Art Institute of Chicago, Gift of Joseph R. Shapiro and William McCallin McKee and Stanley Fields Funds (1958.378)

* *Anger.* 1904
La Colère

Part of the series *The Seven Deadly Sins,* album published 1904
T.121 Etching, 3¾ x 5¾″ (9.5 x 14.6 cm)
Second state of two, hand colored
Signed in plate lower right: *Ensor*
Inscribed in red pencil lower left: *Colère*; signed in red pencil lower right: *J. Ensor*
Collection The Art Institute of Chicago, Gift of Joseph R. Shapiro and William McCallin McKee and Stanley Fields Funds (1958.377)

* *Anger.* 1904
La Colère

Part of the series *The Seven Deadly Sins,* album published 1904
T.121 Etching, 3¾ x 5¾″ (9.5 x 14.6 cm)
Second state of two, hand colored
Signed and dated in plate lower right: *Ensor 1904*
Signed and dated in watercolor lower right: *Ensor 1904*
Collection The Cleveland Museum of Art, Purchase from the J. H. Wade Fund

* *Pride.* 1904
L'Orgueil

Part of the series *The Seven Deadly Sins,* album published 1904
T.122 Etching, 3⅝ x 5¾″ (9.3 x 14.6 cm)
Third state of four, hand colored
Signed in plate lower right: *Ensor*
Inscribed in red pencil lower left: *orgueil*; signed in red pencil lower right: *J. Ensor*
Collection The Art Institute of Chicago, Gift of Joseph R. Shapiro and William McCallin McKee and Stanley Fields Funds (1958.376)

* *Pride.* 1904
L'Orgueil

Part of the series *The Seven Deadly Sins,* album published 1904
T.122 Etching, 3⅝ x 5¾″ (9.3 x 14.6 cm)
Fourth state of four
Signed in plate lower right: *Ensor*
Inscribed in pencil lower left: *L'orgueil*; signed and dated lower right: *James Ensor 1904*
Collection The Cleveland Museum of Art, Purchase from the J. H. Wade Fund

* *Avarice.* 1904
L'Avarice

Part of the series *The Seven Deadly Sins,* album published 1904
T.123 Etching, 3¾ x 5¾″ (9.5 x 14.5 cm)
Second state of two, hand colored
Signed in plate lower left: *Ensor*
Inscribed in red pencil lower left: *avarice*; signed in red pencil lower right: *J. Ensor*
Collection The Art Institute of Chicago, Gift of Joseph R. Shapiro and William McCallin McKee and Stanley Fields Funds (1958.373)

* *Avarice*. 1904
L'Avarice

Part of the series *The Seven Deadly Sins*, album
published 1904
T.123 Etching, 3¾ x 5¾″ (9.5 x 14.5 cm)
Second state of two
Signed in plate lower left: *Ensor*
Inscribed in pencil lower left: *L'avarice*; signed and
dated in pencil lower right: *James Ensor 1904*
Collection The Cleveland Museum of Art, Purchased
from the J. H. Wade Fund

* *Gluttony*. 1904
La Gourmandise

Part of the series *The Seven Deadly Sins*, album
published 1904
T.124 Etching, 3⅝ x 5¾″ (9.1 x 14.5 cm)
Second state of two, hand colored
Signed in plate lower right: *Ensor*
Inscribed in red pencil lower left: *gourmandise*; signed
in red pencil lower right: *J. Ensor*
Collection The Art Institute of Chicago, Gift of Joseph
R. Shapiro and William McCallin McKee and Stanley
Fields Funds (1958.376)

111 *Gluttony*. 1904
La Gourmandise

Part of the series *The Seven Deadly Sins*, album
published 1904
T.124 Etching, 3⅝ x 5¾″ (9.1 x 14.5 cm)
Second state of two
Signed in plate lower right: *Ensor*
Inscribed in pencil lower left: *La gourmandise*; signed
and dated in pencil lower right: *James Ensor 1904*
Collection The Cleveland Museum of Art, Purchase
from the J. H. Wade Fund

* *Envy*. 1904
L'Envie

Part of the series *The Seven Deadly Sins*, album
published 1904
T.125 Etching, 3¾ x 5⅞″ (9.4 x 14.8 cm)
Third state of three, hand colored
Signed in plate upper right: *Ensor*
Inscribed in red pencil lower left: *Envie*; signed in red
pencil lower right: *J. Ensor*
Collection The Art Institute of Chicago, Gift of Joseph
R. Shapiro and William McCallin McKee and Stanley
Fields Funds (1958.374)

* *Envy*. 1904
L'Envie

Part of the series *The Seven Deadly Sins*, album
published 1904
T.125 Etching, 3¾ x 5⅞″ (9.4 x 14.8 cm)
Third state of three
Signed in plate upper right: *Ensor*
Signed and dated in pencil lower right: *James Ensor 1904*
Collection The Cleveland Museum of Art, Purchase
from the J. H. Wade Fund

* *The Deadly Sins Dominated by Death*. 1904
Les Péchés capitaux dominés par la mort

Part of the series *The Seven Deadly Sins*, album
published 1904
T.126 Etching, 3⅜ x 5¼″ (8.4 x 13.4 cm)
Only state, hand colored
Signed in plate lower right: *Ensor*
Inscribed in red pencil lower left: *Les péchés capitaux*;
signed in red pencil lower right: *J. Ensor*
Collection The Art Institute of Chicago, Gift of Joseph
R. Shapiro and William McCallin McKee and Stanley
Fields Funds (1958.371)

* *The Deadly Sins Dominated by Death*. 1904
Les Péchés capitaux dominés par la mort

Part of the series *The Seven Deadly Sins*, album
published 1904
T.126 Etching, 3⅜ x 5¼″ (8.4 x 13.4 cm)
Only state
Signed in plate lower right: *Ensor*
Inscribed in pencil lower left: *Péchés capitaux dominés
par la mort*; signed and dated lower right: *James
Ensor 1904*
Collection The Cleveland Museum of Art, Purchase
from the J. H. Wade Fund

* *Perplexed Masks*. 1904
Masques intrigués

Part of the series *The Seven Deadly Sins*, album
published 1904
T.128 Etching, 2⅞ x 4½″ (7.4 x 11.4 cm)
Only state, hand colored
Signed in plate lower left: *Ensor*
Inscribed in red pencil lower left: *orgueil*; signed in red
pencil lower right: *J. Ensor*
Collection The Art Institute of Chicago, Gift of Joseph
R. Shapiro and William McCallin McKee and Stanley
Fields Funds (1958.372)

112 *Poster for* La Plume. 1898
Affiche de La Plume

T.141 Colored lithograph, 20⅞ x 14⅝″ (53 x 37.2 cm)
Only state
Signed on the stone lower left: *ENSOR*
Collection The Art Institute of Chicago, Gift of Arthur
F. Aldis (1914.561)

113 *Poster for the Carnival at Ostend*. 1931
Affiche pour Le Carnivale d'Ostende

T.142 Colored lithograph, 18½ x 12⅞″ (47 x 32.5 cm)
Only state
Inscribed on the stone around center: *FEVRIER
FEVRUARI 14-15-22 CARNAVAL MARS MAART 15
OSTENDE 1931*; signed on the stone lower center:
ENSOR
Inscribed across bottom: *Pour Blanche Hertoge la
muse médusée au • studio• Ostende souvenir de mon
ami le peintre des masques James Ensor*
Collection Dr. J. Maniewski

1. *Self-Portrait*
Autoportrait. 1879

2. *After the Storm*
 Après la tempête. 1880

color good. slightly too soon add'l years

far too blue. houses @ far st. actually
warm grey

4. *Sketch for Bourgeois Salon*
 Esquisse pour le salon bourgeois. 1880

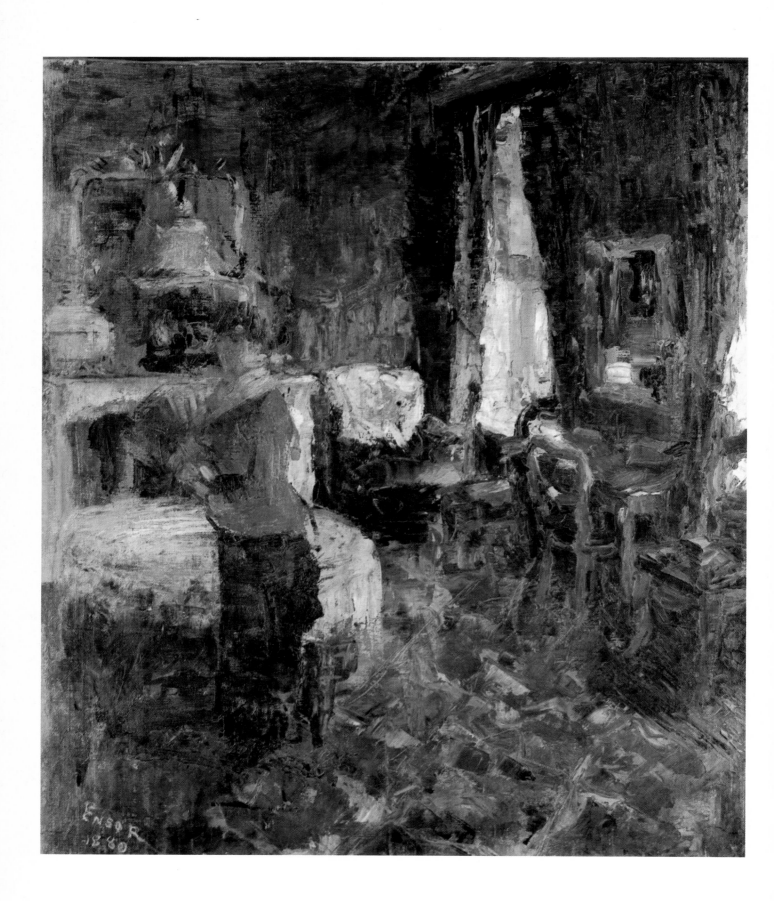

5. *Still Life with Blue Bottle*
 Nature morte au flacon bleu. 1880

not exh. Chicago

not exh. chicago

6. *Woman on a Breakwater*
 La Femme au brise-lames. 1880

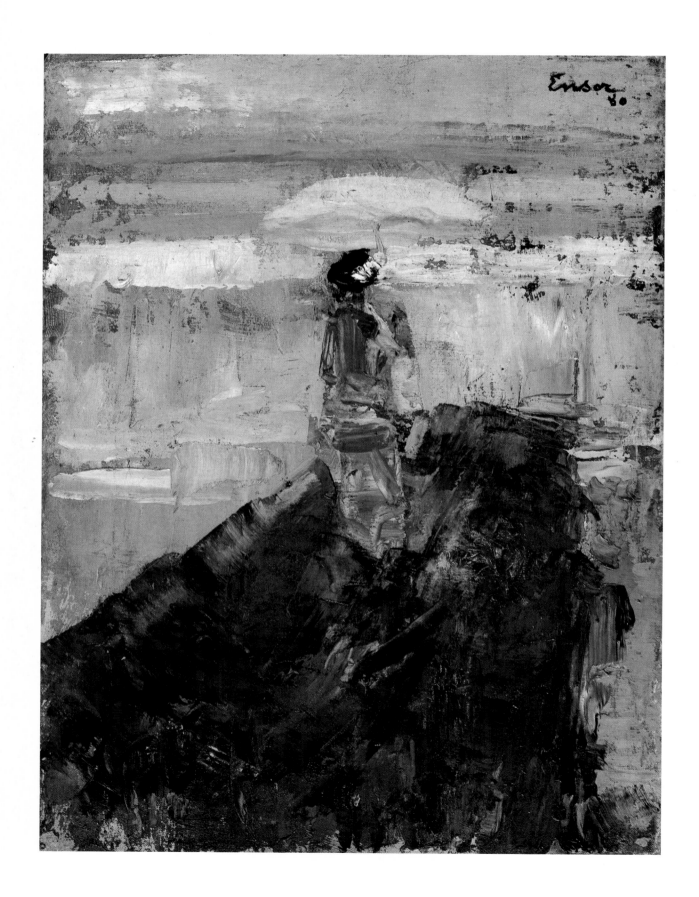

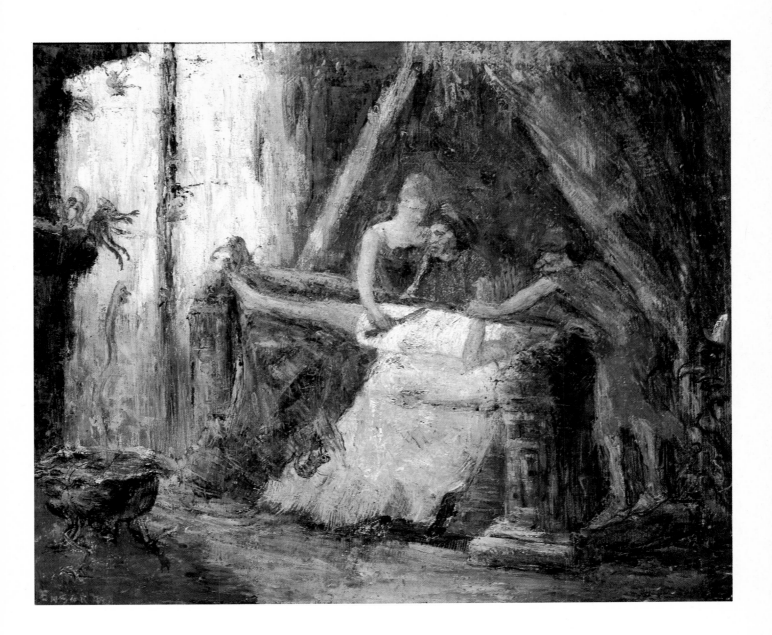

7. *Judith and Holofernes*
Judith et Holopherne. ca. 1880 with later additions

much too red.

8. *Russian Music*
 Musique russe. 1881

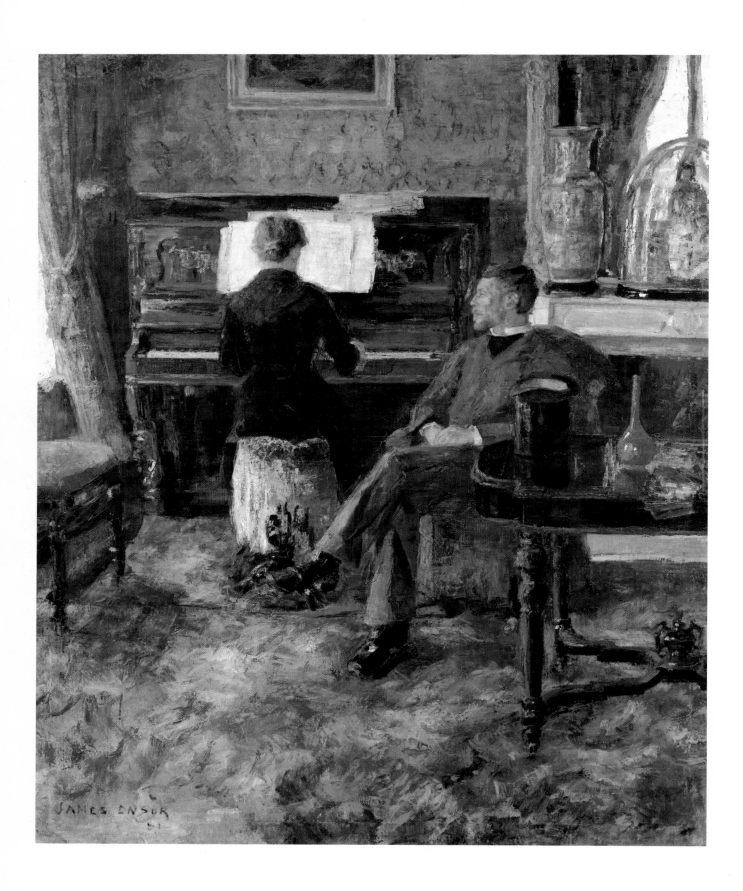

9. *The Breakwater*
Le Brise-lames. 1882

10. *Woman in Distress*
 Femme en détresse. 1882

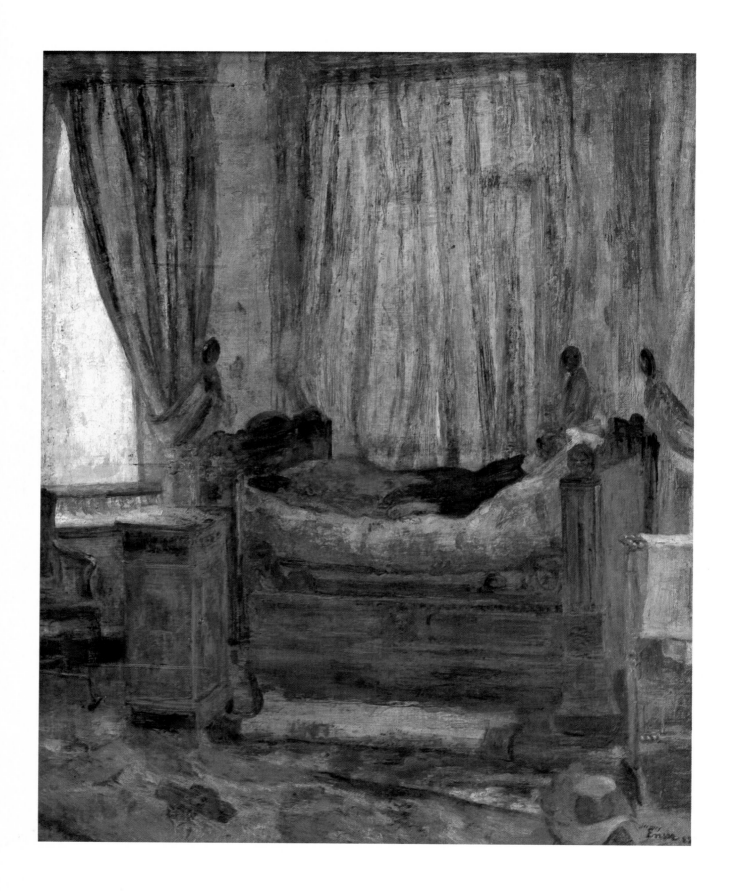

11. *Still Life*
Nature morte. ca. 1882

12. *The Drunkards*
 Les Pochards. 1883

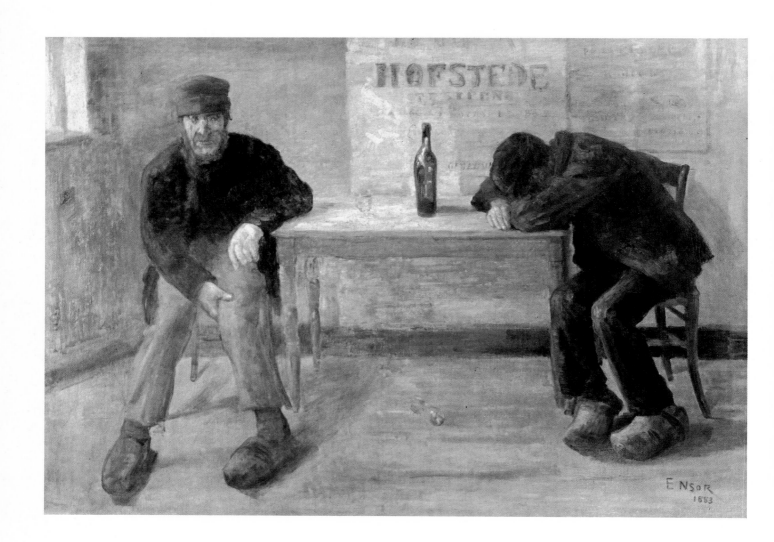

13. *The Rower*
Le Rameur. 1883

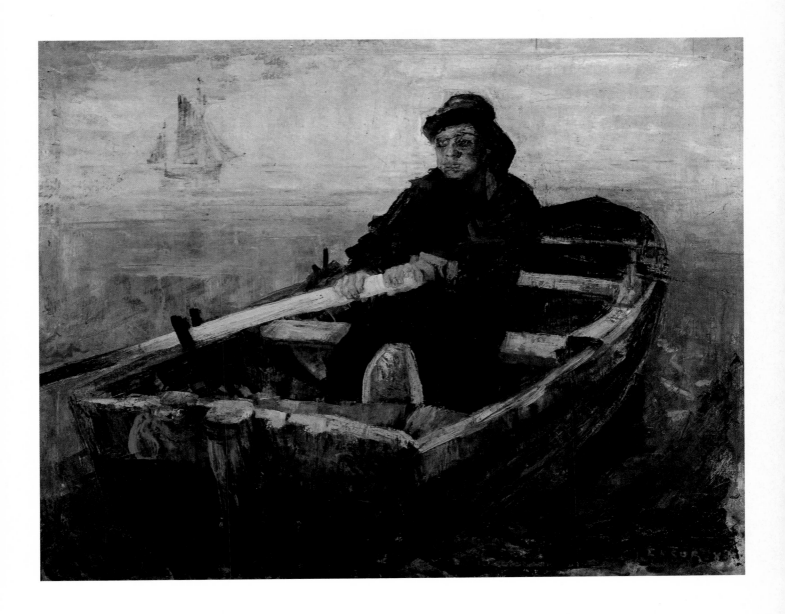

14. *Scandalized Masks*
 Les Masques scandalisés. 1883

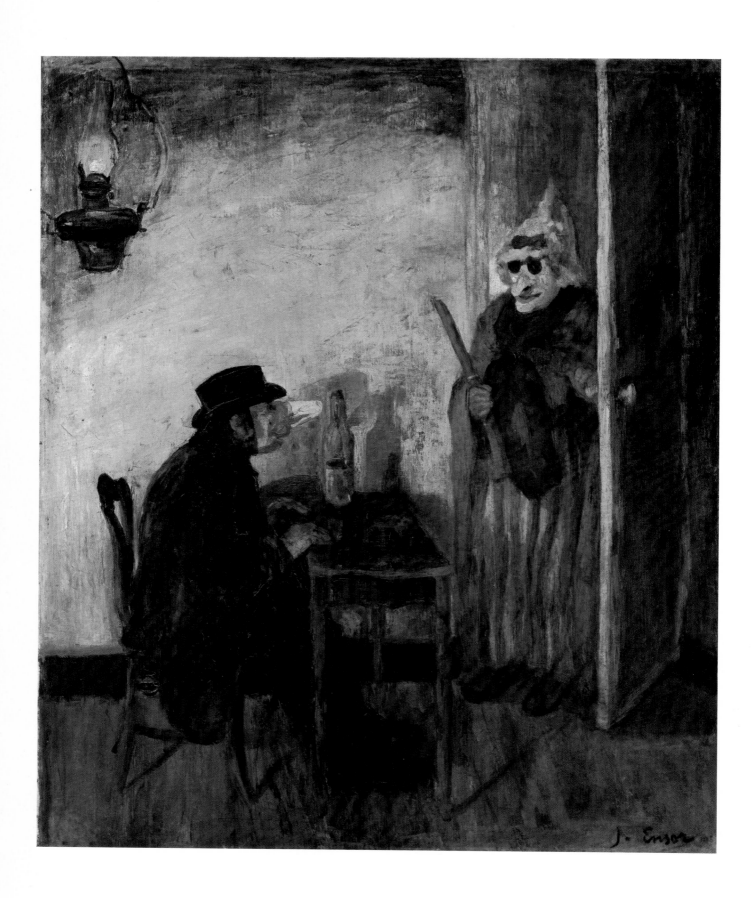

15. *Self-Portrait in a Flowered Hat*
Ensor au chapeau fleuri. 1883/ff.

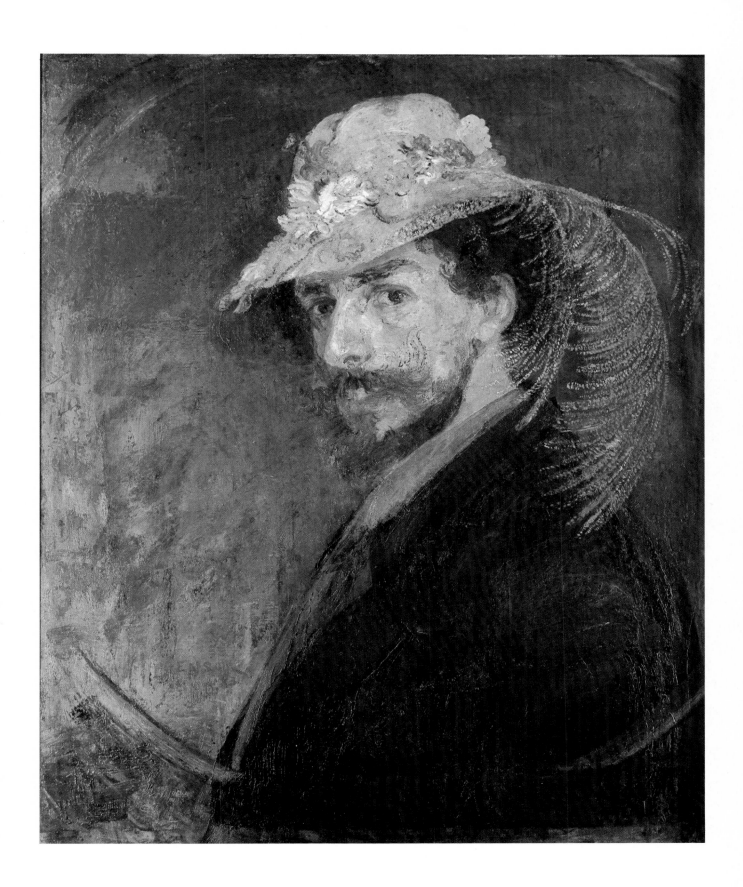

16. *Ship with Yellow Sail*
 Bateau à voile jaune. 1883

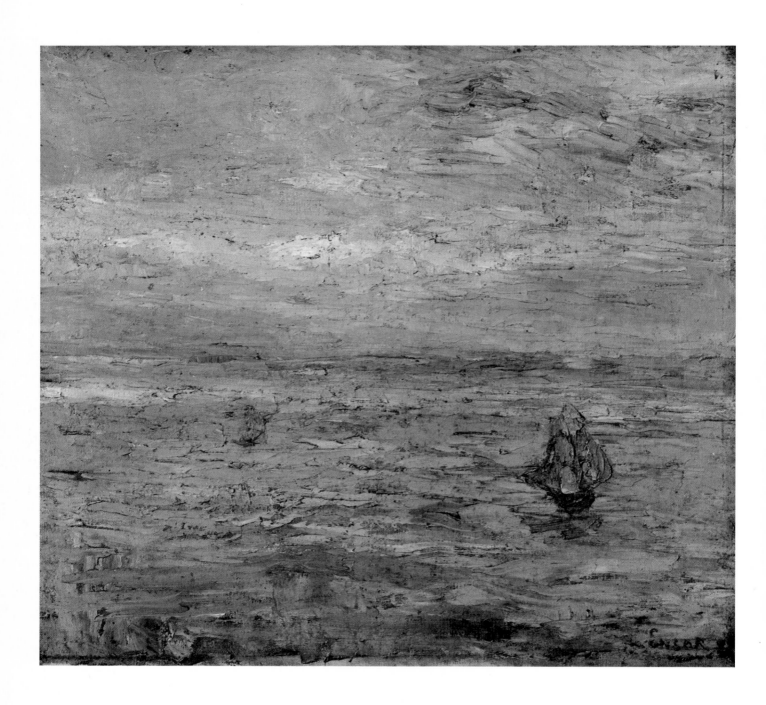

17. *Vase of Flowers*
Vase et fleurs. 1883

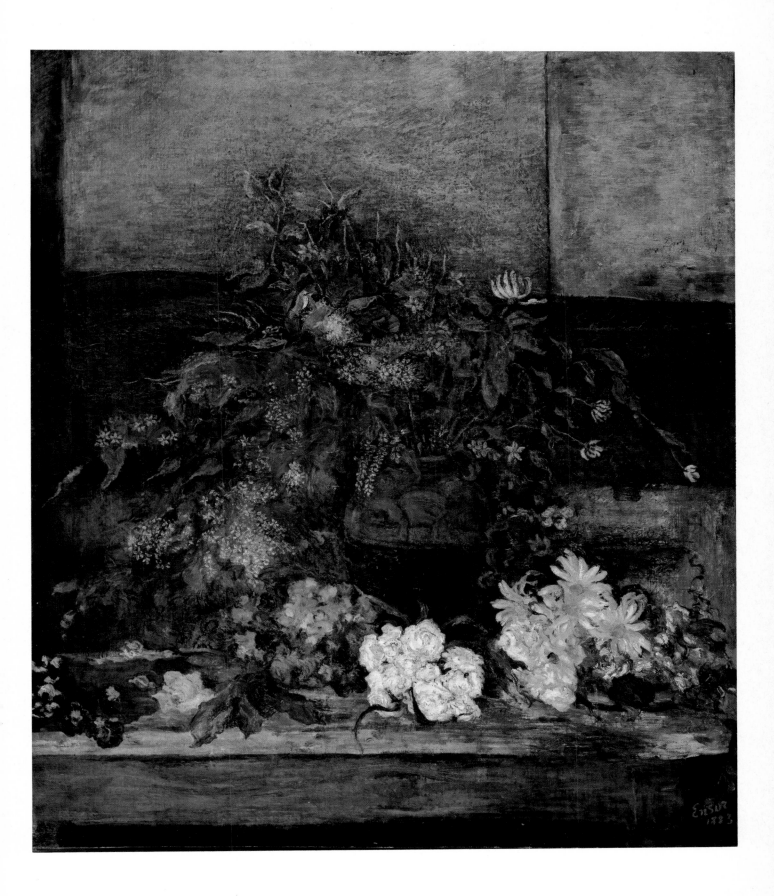

18. *Girl with Doll*
 Jeune fille et poupée. 1884 / *f f*

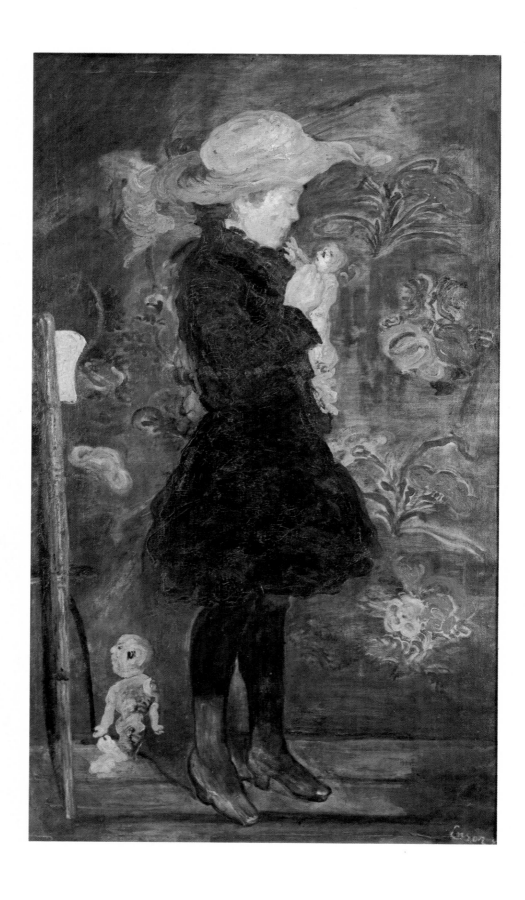

19. *Town Hall, Brussels*
Hôtel de ville, Bruxelles. 1885

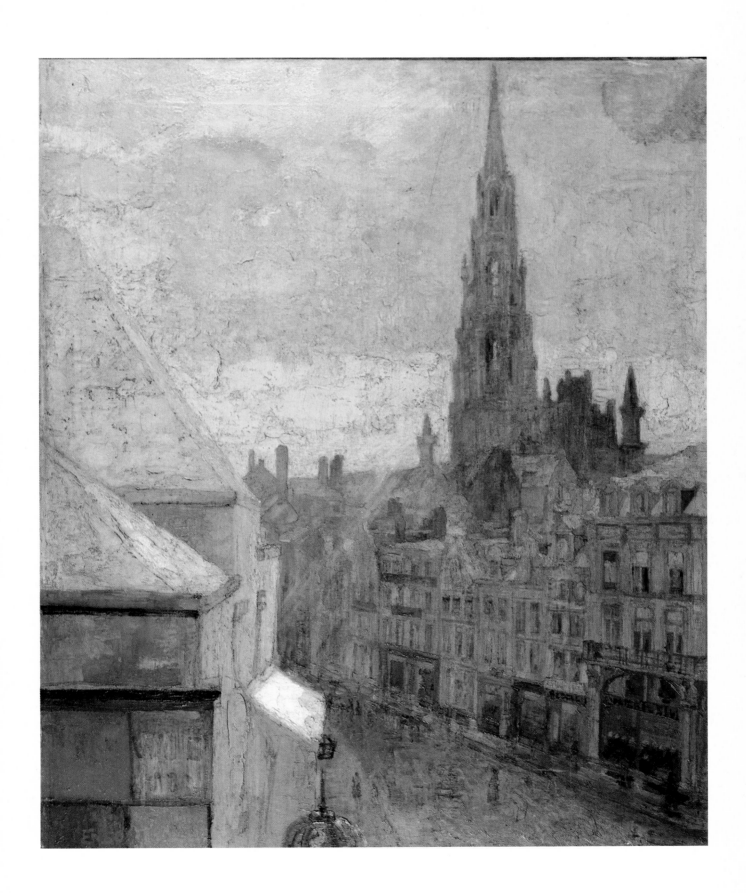

20. *Rooftops of Ostend*
 Les Toits d'Ostende. 1885

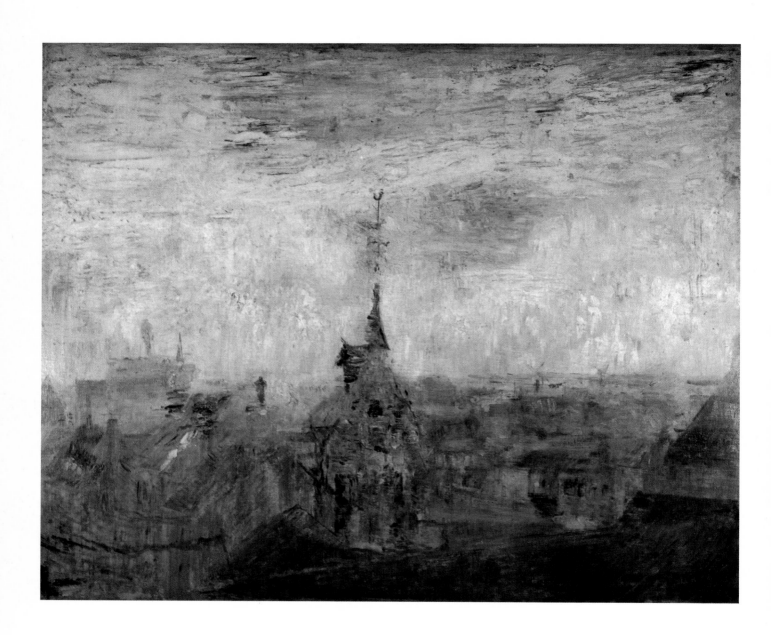

21. *Skeleton Studying Chinoiseries*
 Squelette regardant les chinoiseries. 1885 / *fr.*

skull added later (superimposed)

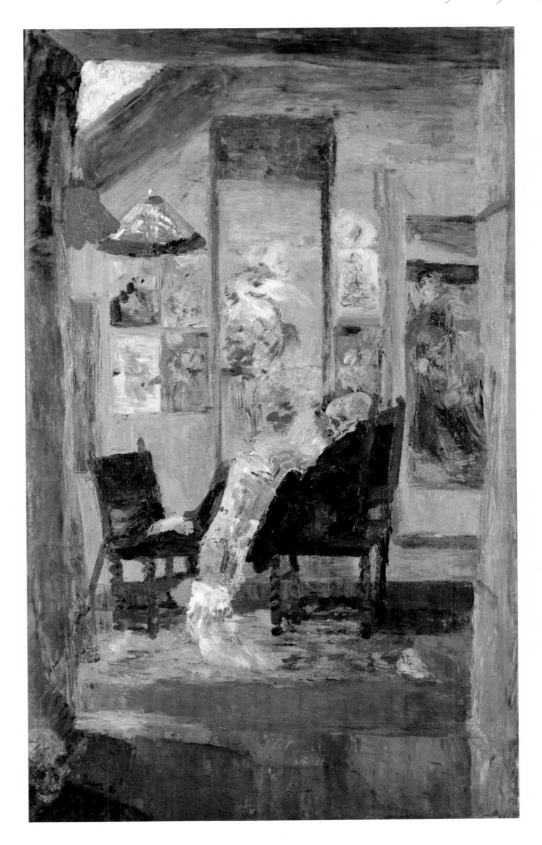

22. *Adam and Eve Expelled from Paradise*
 Adam et Eve chassés du paradis. 1887

23. *Fireworks*
Feu d'artifice. 1887

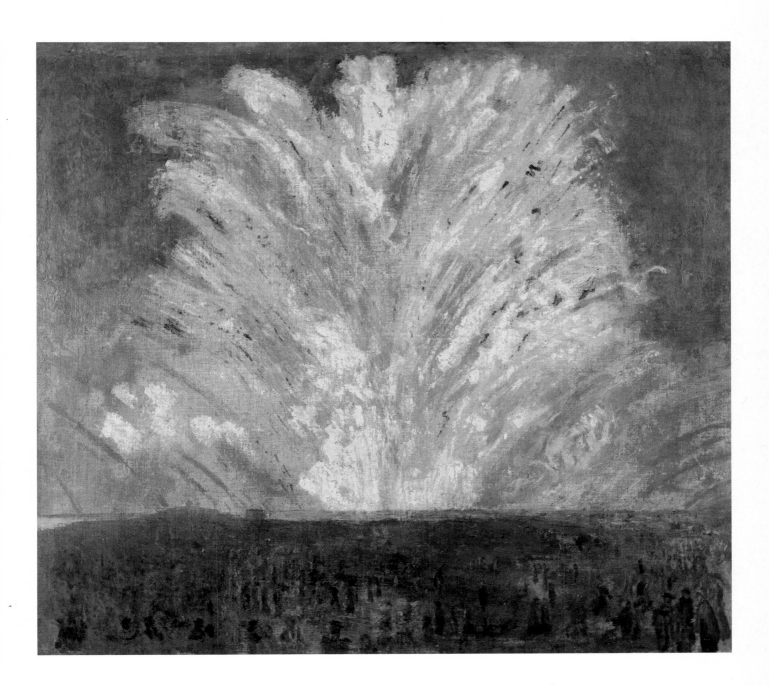

24. *Tribulations of St. Anthony*
 Les Tribulations de Saint Antoine. 1887

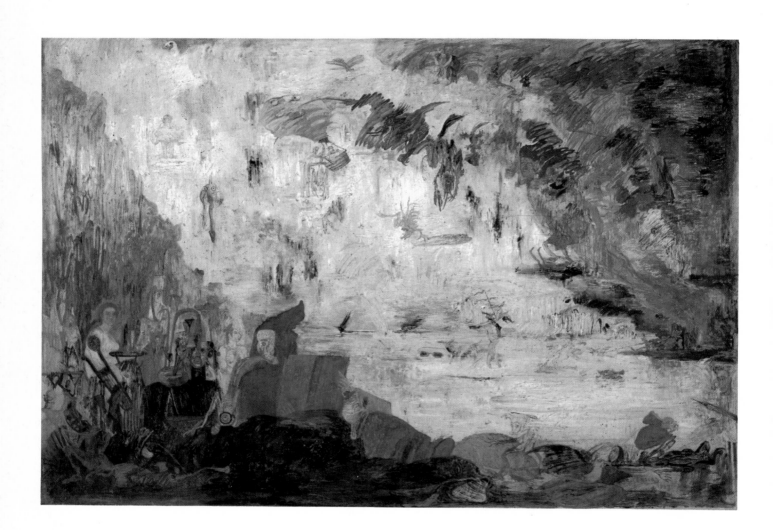

25. *The Entry of Christ into Brussels*
L'Entrée du Christ à Bruxelles. 1888

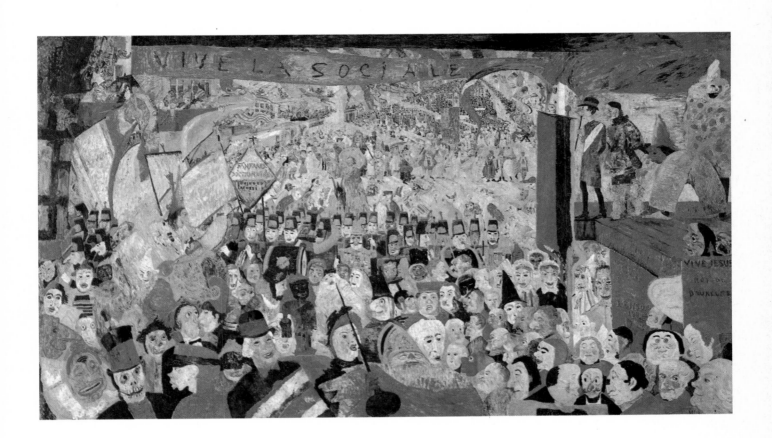

26. *Still Life with Fish and Shells*
 Nature morte aux poissons et coquillages. 1888

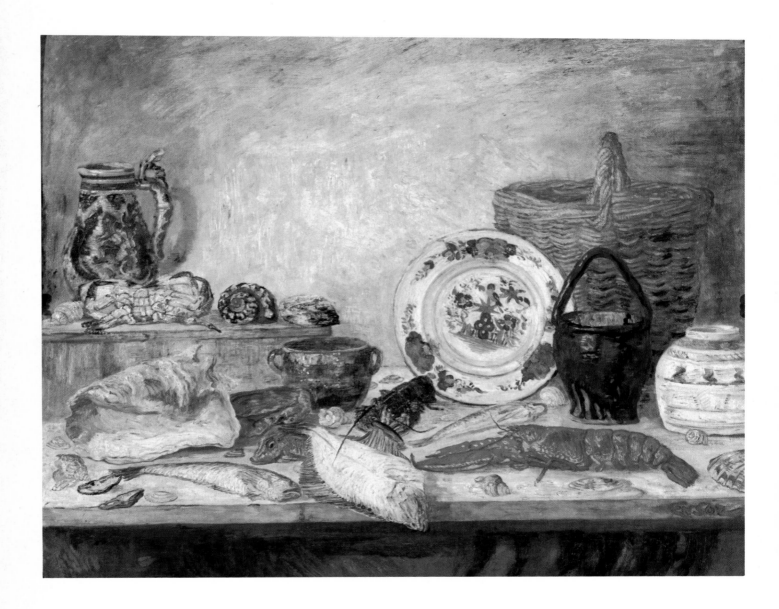

27. *Tower of Lisseweghe*
La Tour de Lisseweghe. 1888

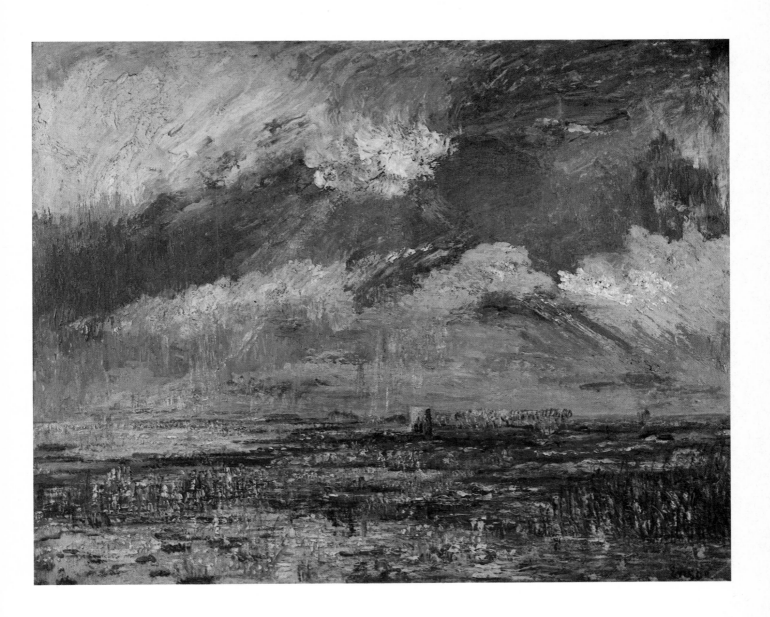

28. *Attributes of the Studio*
 Les Attributs de l'atelier. 1889

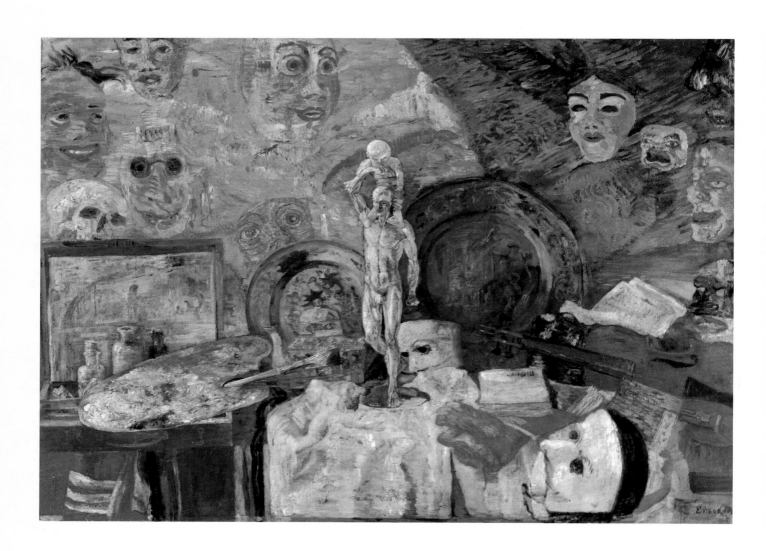

29. *Portrait of Old Woman with Masks*
 Portrait d'une vieille aux masques. 1889

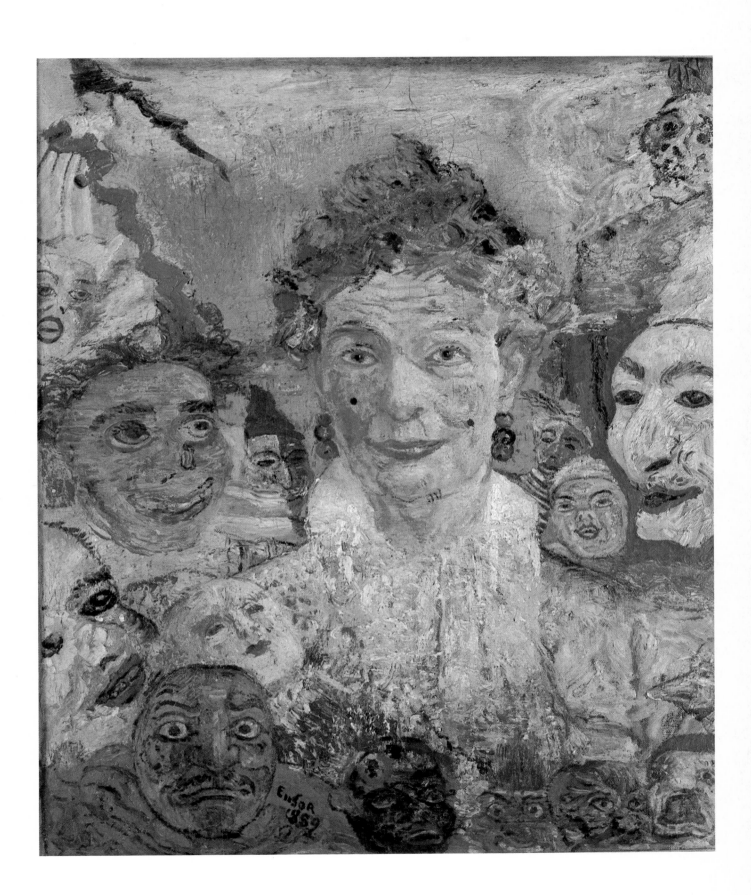

30. *Still Life with Flowers and Butterflies*
 Nature morte aux fleurs et papillons. 1889

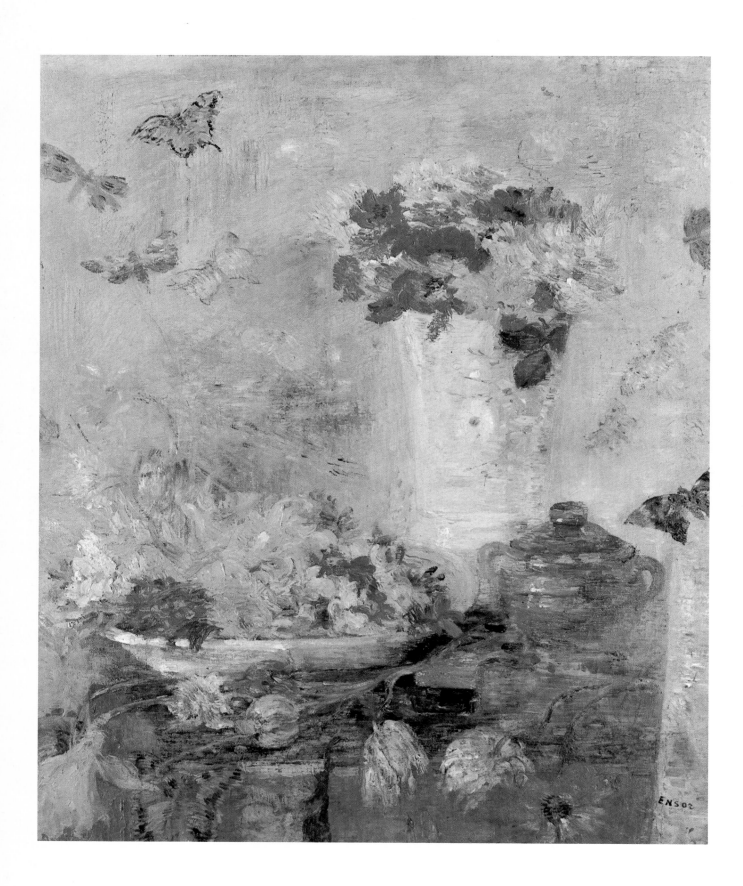

31. *Still Life with Blue Pitcher*
Nature morte à la cruche bleue. 1890-91

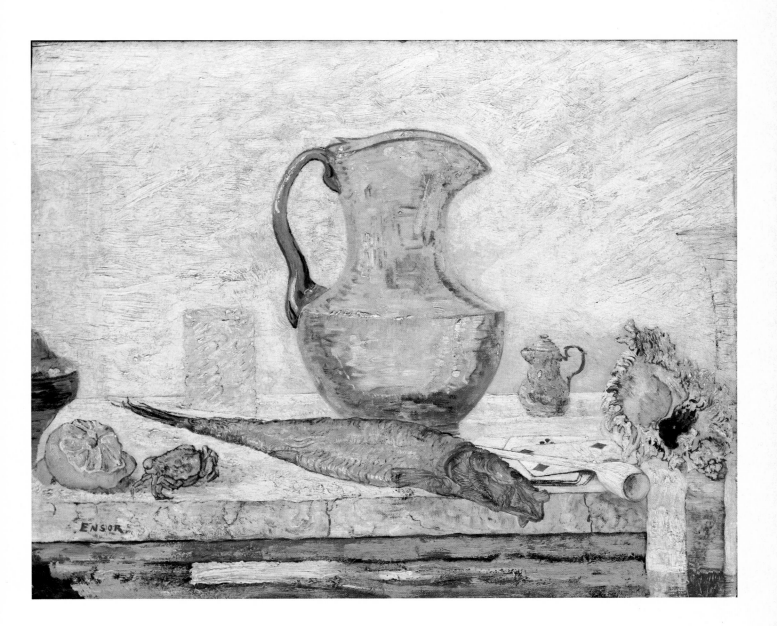

32. *At the Conservatory*
 Au conservatoire.

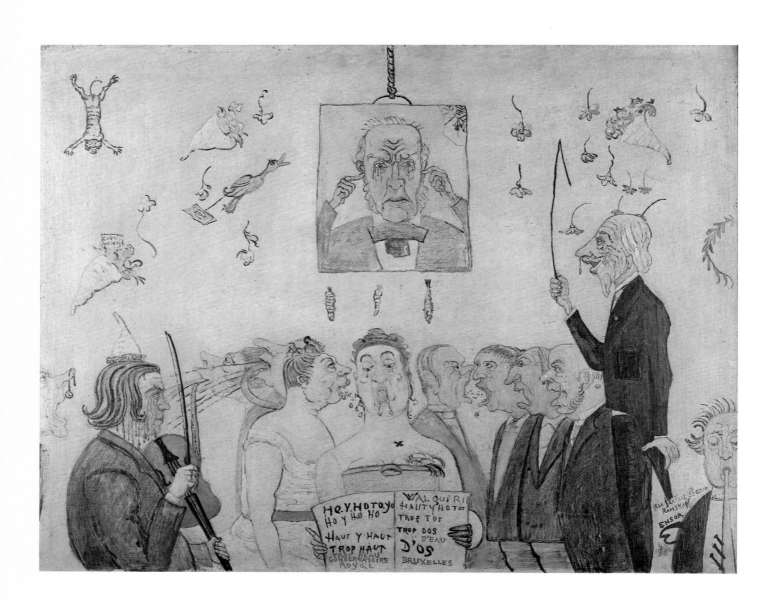

33. *The Good Judges*
Les Bons juges. 1891

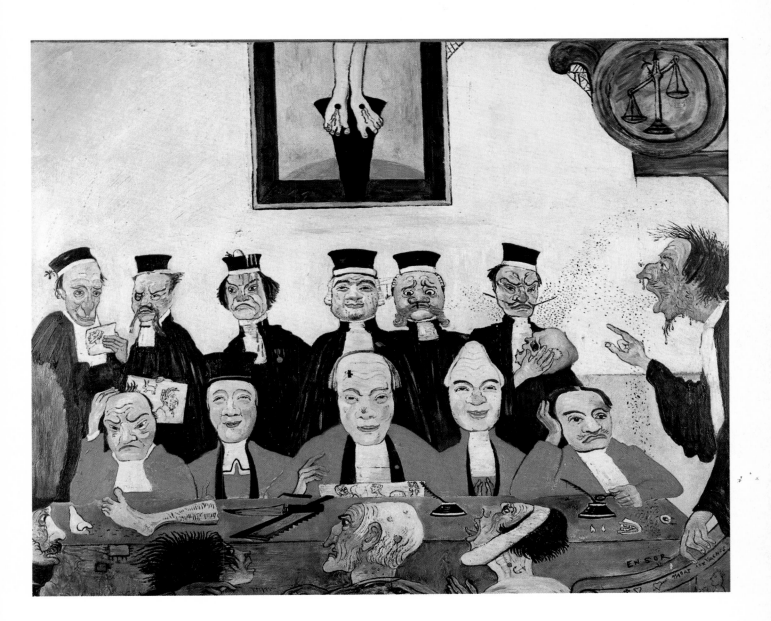

34. *Man of Sorrows*
 L'Homme des douleurs. 1891

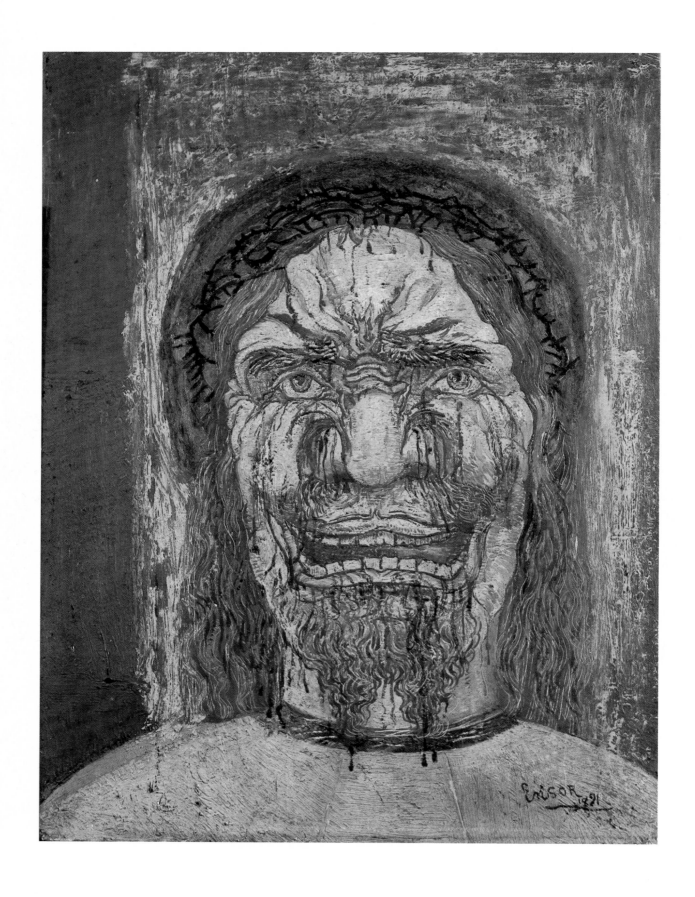

35. *Skeletons Fighting for the Body of a Hanged Man*
Squelettes se disputant un pendu. 1891

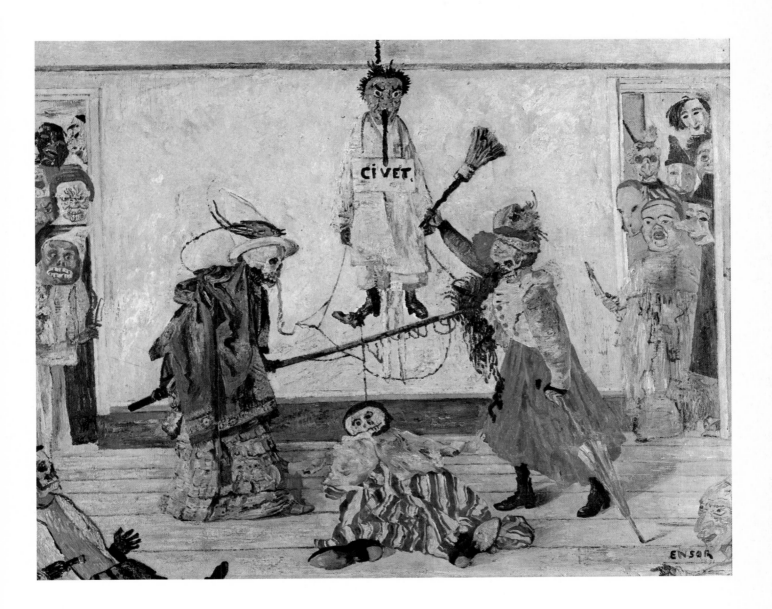

36. *The Consoling Virgin*
 La Vièrge consolatrice. 1892

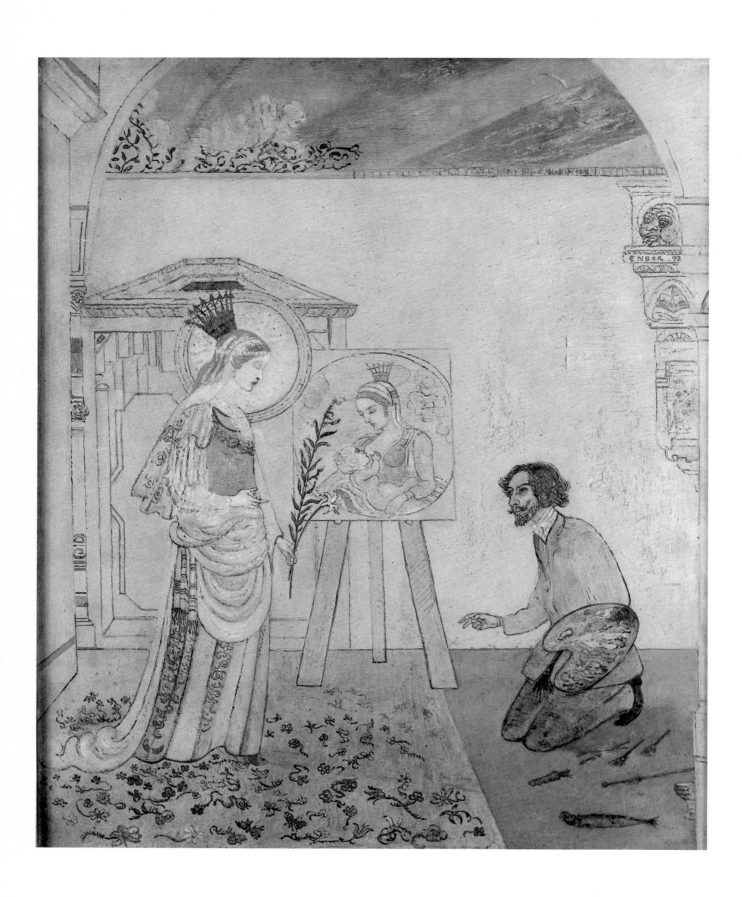

37. *The Gendarmes*
Les Gendarmes. 1892

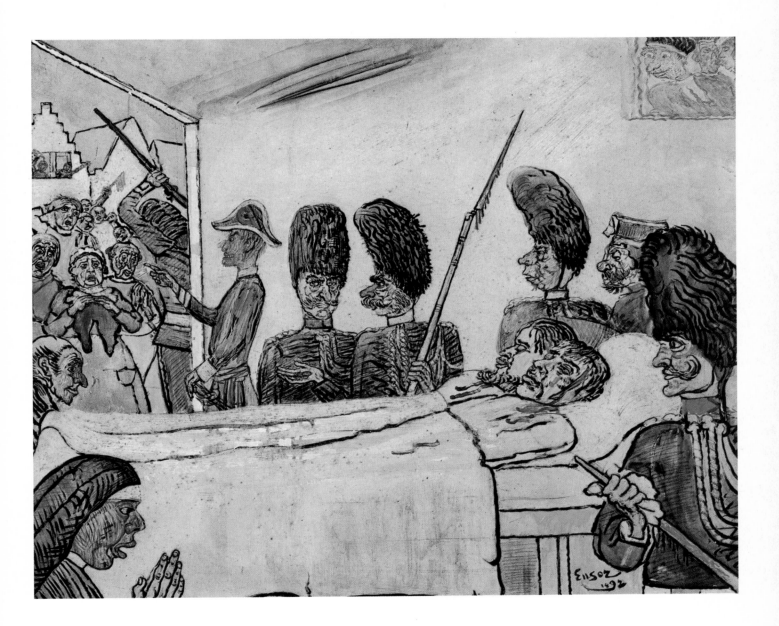

38. *Still Life with Ray*
 La Raie. 1892

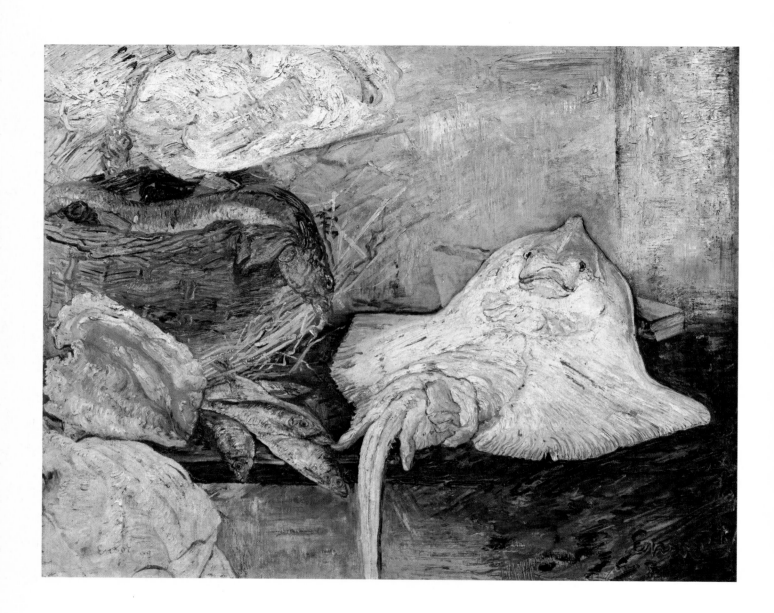

39. *Pierrot and Skeleton in Yellow Robe*
Pierrot et squelette en jaune. 1893

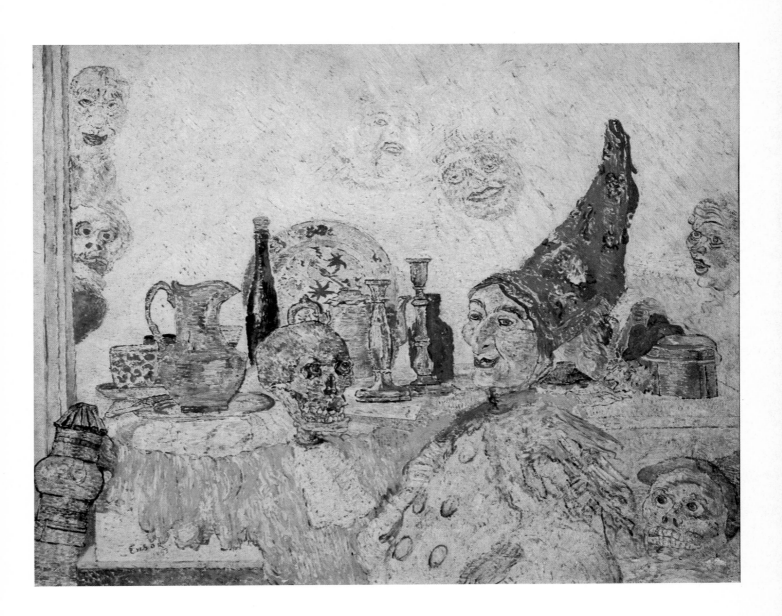

40. *Still Life with Fish and Shells*
 Nature morte aux poissons et coquillages. 1895

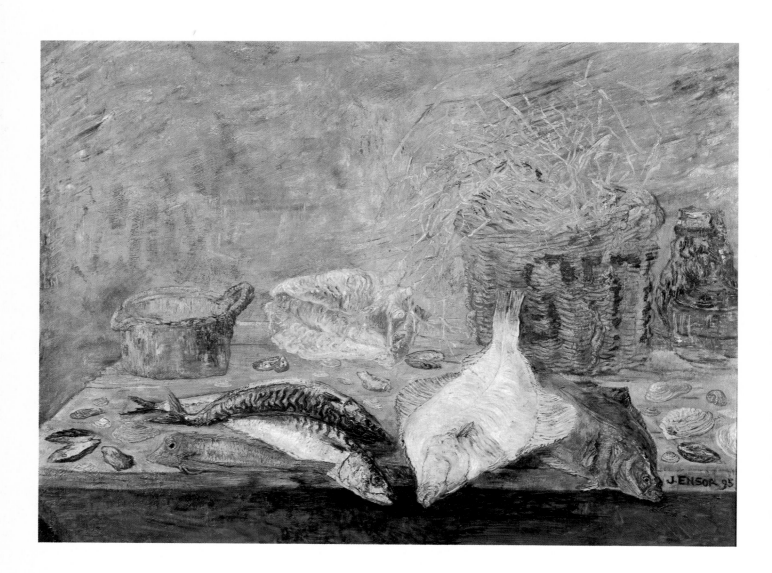

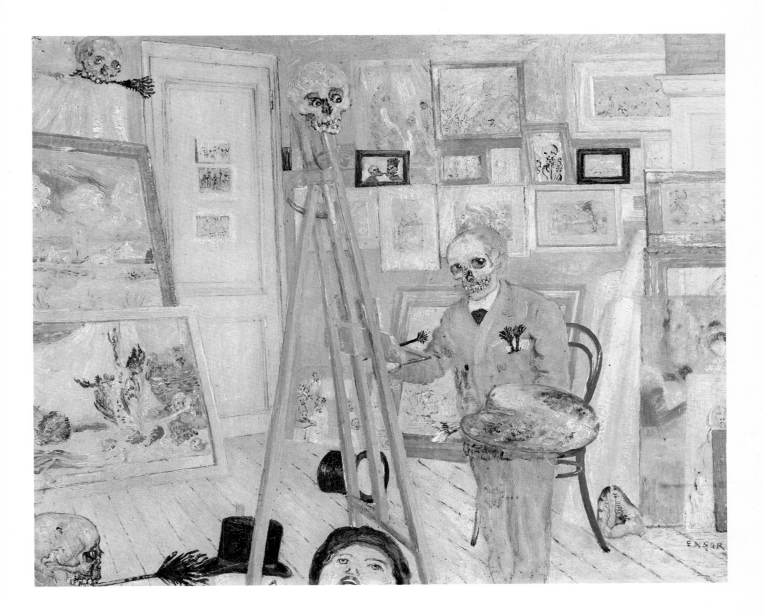

41. *Skeleton Painter in His Atelier*
 Le Peintre squelettisé dans l'atelier. 1896 (?)

42. *Masks and Death*
 Les Masques et la mort. 1897

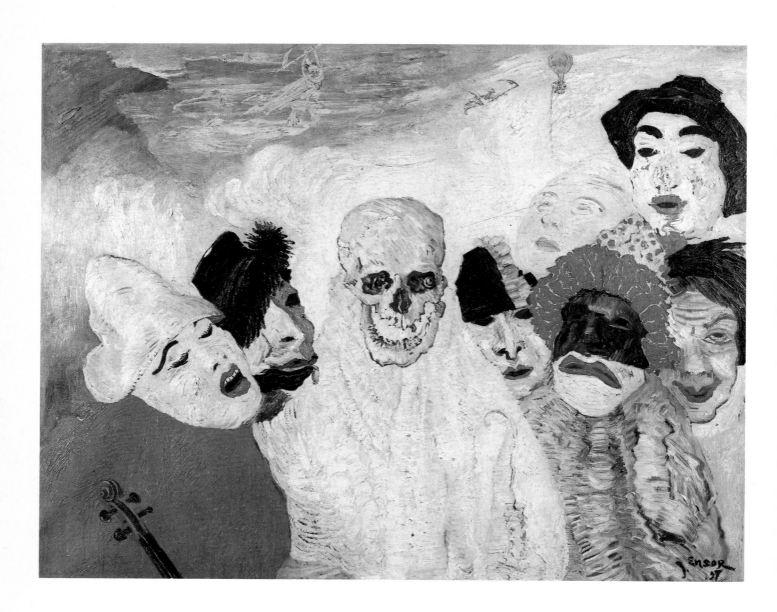

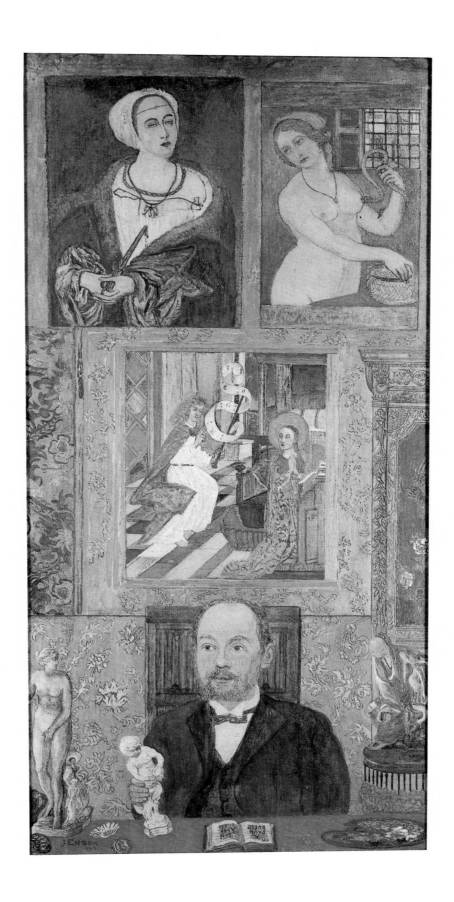

43. *The Antiquarian*
L'Antiquaire. 1902

44. *Flowers in the Sunlight*
 Fleurs à la lumière du soleil. 1905

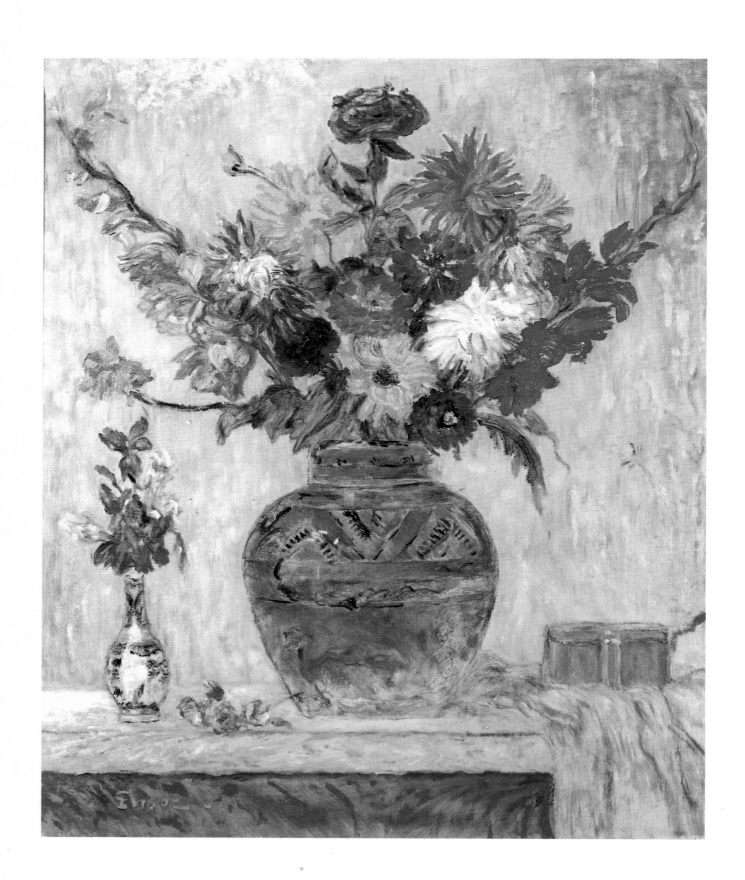

slightly too orange a tint too flat

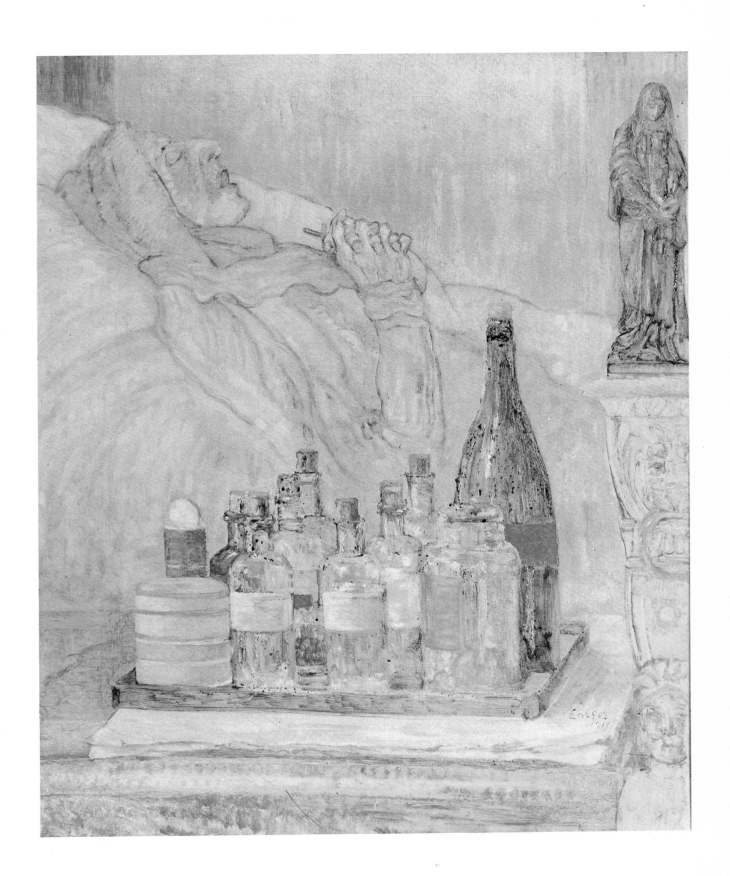

46. *Finding of Moses*
 La Découverte de Moïse. 1924

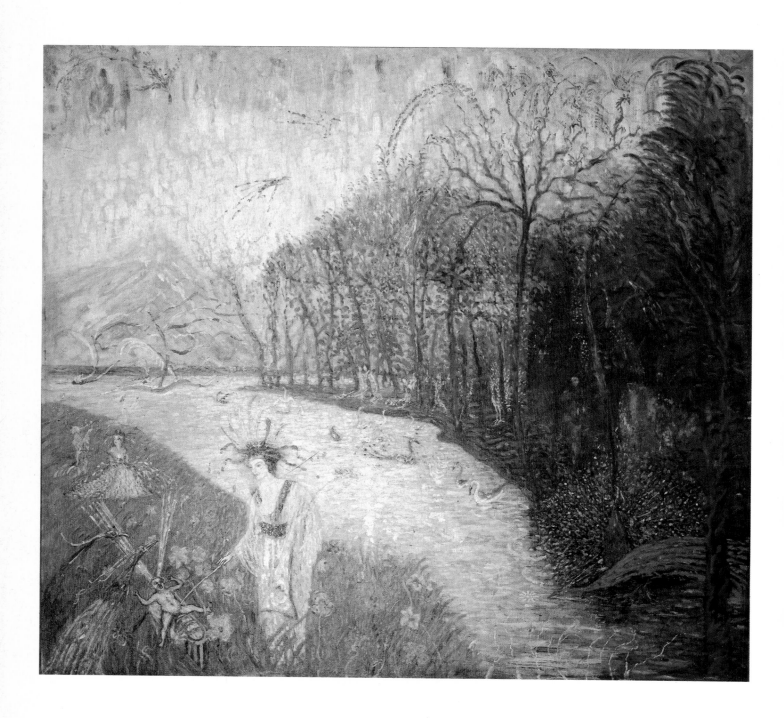

47. *The Strike in Ostend*
Le Grève. 1888

48. *Portrait of the Artist's Niece in Chinese Costume*
La Nièce de l'artiste au costume chinois. 1899

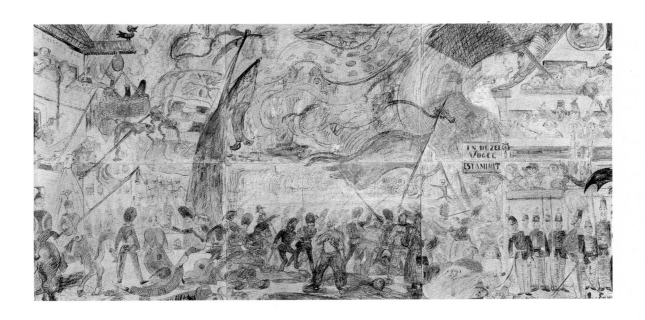

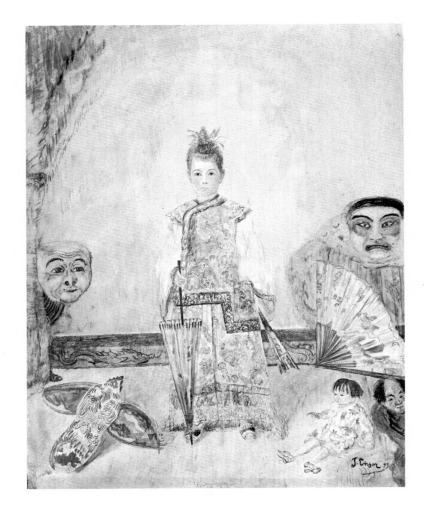

49. *Demons Teasing Me*
 Démons me turlupinant. 1895

50. *Christ Tormented by Demons*
 Le Christ tourmenté par les démons. 1895

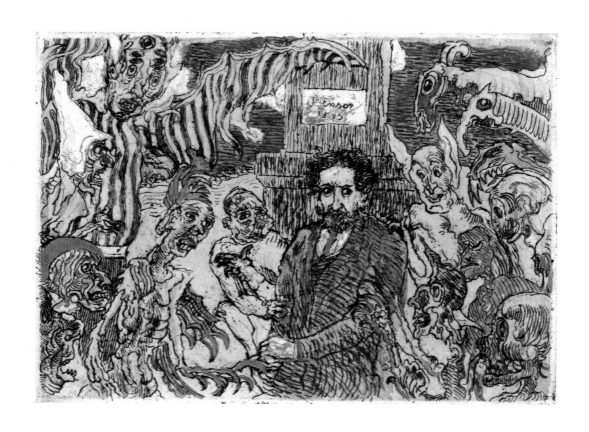

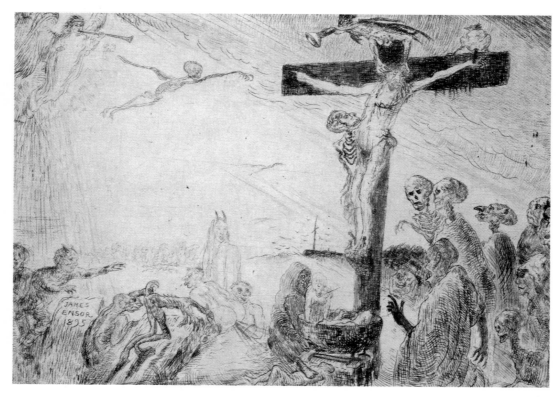

51. *Academic Study of a Male Nude*
Etude d'académie. 1878

52. *Biblical Scene*
Scène biblique. 1878

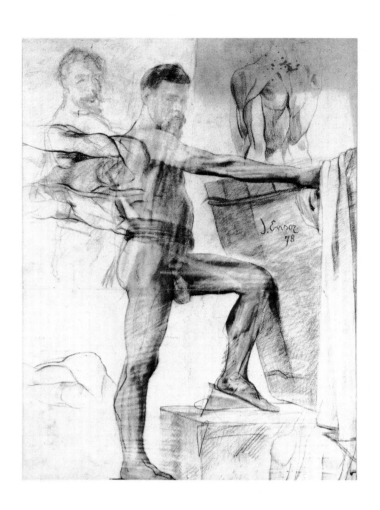

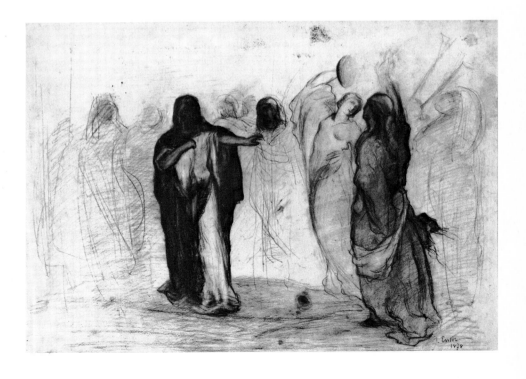

53. *Death of Jezebel*
 La Mort de Jézabel. 1880

54. *Young Man in a Derby Hat*
 Jeune homme au chapeau melon (garçon à la barrière). 1880

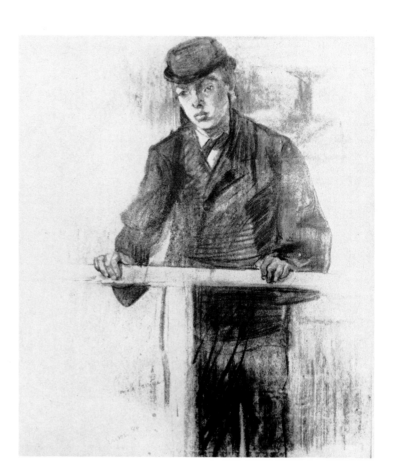

55. *The Artist's Sister and Stove*
 La Soeur de l'artiste et un poêle. 1880-82

56. *White Horse and Figures*
 Cheval blanc et personnages. 1880-82

57. *Still Life with Clock*
 Cheminée et pendule. ca. 1880-82

58. *Vase with Flowers*
 Vase et fleurs.

59. *Portrait of His Sister*
 La Soeur de l'artiste. 1881

60. *Théo Hannon*
 Théo Hannon. 1882

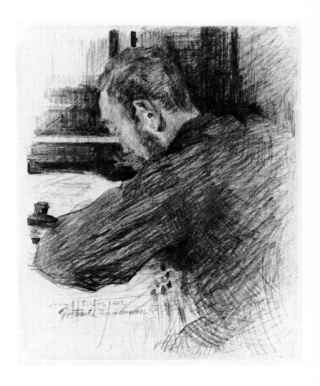

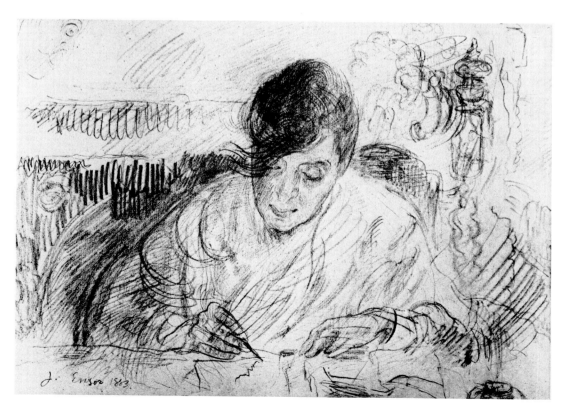

65. *Copy after Delacroix: Lion*
 Copie d'après Delacroix: Lion. 1885

66. *Copy after Rembrandt: Death of Mary Magdalen*
 Copie d'après Rembrandt: Mort de Madeleine. 1885

67. *Copy after Rembrandt: Street near Canal*
 Copie d'après Rembrandt: Rue près d'un canal. 1885.

68. *Masks and Grotesque Figures*
 Masques et marmousets. 1885

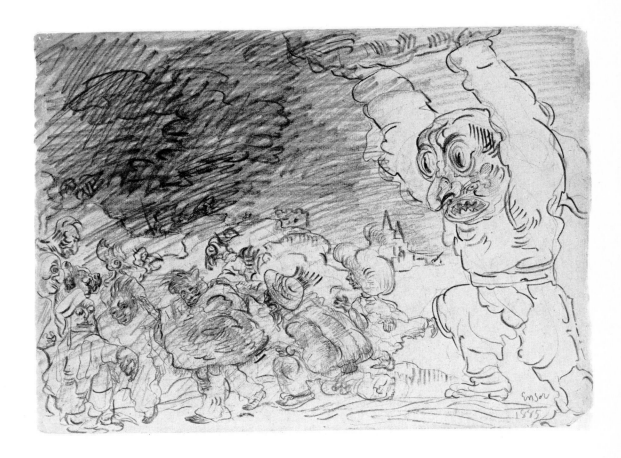

69. *Personnages of Goya after Goya's Capricho No. 51, Se Repulen*
Copie d'après Goya: Capricho no. 51, Se Repulen. ca. 1885

70. *The Gay: Adoration of the Shepherds*
La Gai: L'Adoration des bergers. 1886

71. *Artist Decomposed*
 L'Artiste décomposé. 1886

72. *The Sad and Broken: Satan and His Fantastic Legions*
 Tormenting the Crucified Christ.
 Le Triste et brisée: Satan et les légions fantastiques
 tourmentant le Crucifié. 1886

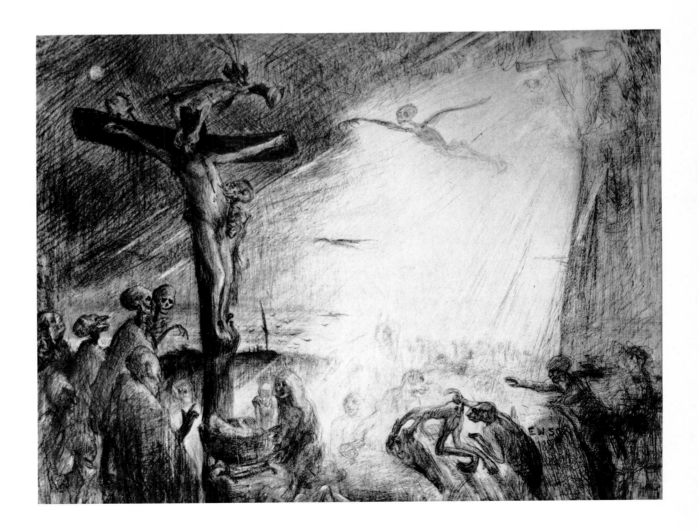

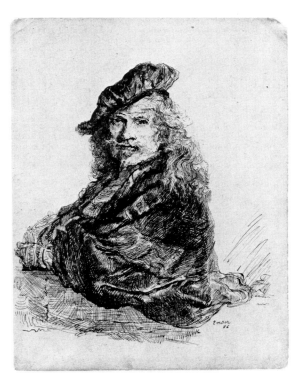

77. *The Alive and Radiant: The Entry into Jerusalem*
 La Vive et rayonnante: L'Entrée à Jérusalem

78. *The Artist's Father in Death*
 Mon père mort. 1887

79. *Copy after Turner: Sunrise, Odysseus Ridiculing Polyphemus*
Copie d'après Turner: Nouveau soleil, Odysse moquant
Polyphème. 1888

80. *The Elephant's Joke*
La Blague d'éléphant. 1888

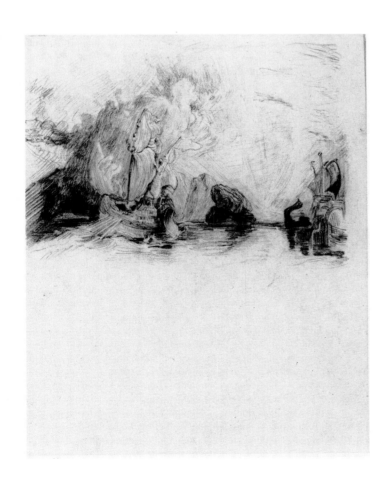

81. *Plague Here, Plague There, Plague Everywhere*
Peste dessous, peste dessus, peste partout. 1888

82. *Demons Teasing Me*
Démons me turlupinant. 1888

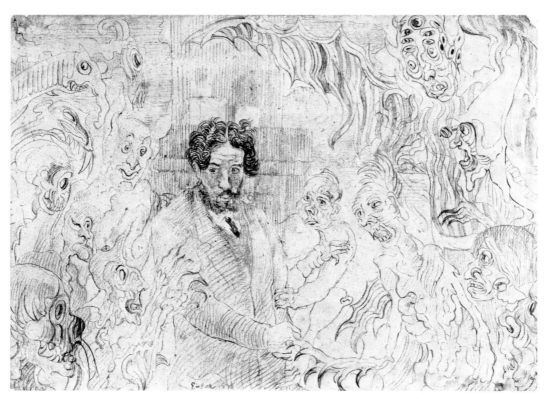

83. *Skeleton Playing Flute*
 Squelette jouant de la flûte. 1888

84. *Belgium in the XIX Century*
 Belgique au XIX siècle. ca. 1889

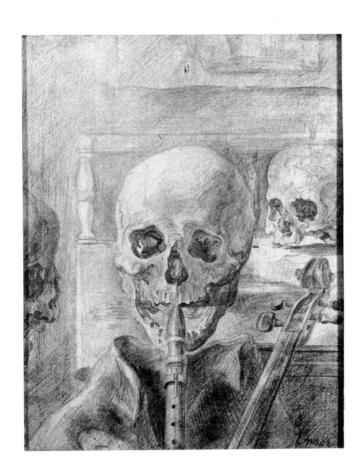

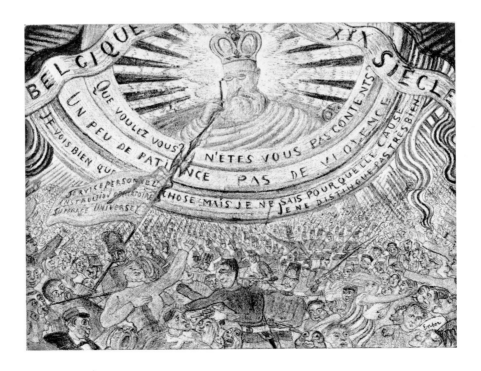

85. *Roman Triumph*
 Triomphe romain. ca. 1889

86. *Self-Portrait*
 Autoportrait. 1890

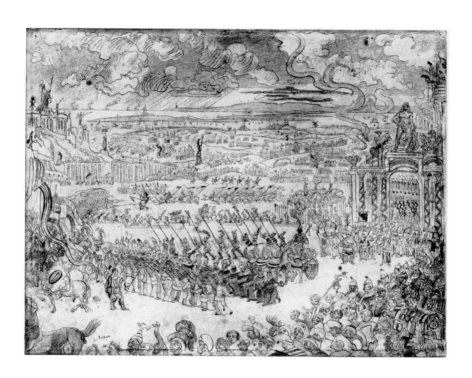

87. *Street in Ostend*
 Rue à Ostende. 1895

88. *Dangerous Cooks*
 Les Cuisiniers dangereux. 1896

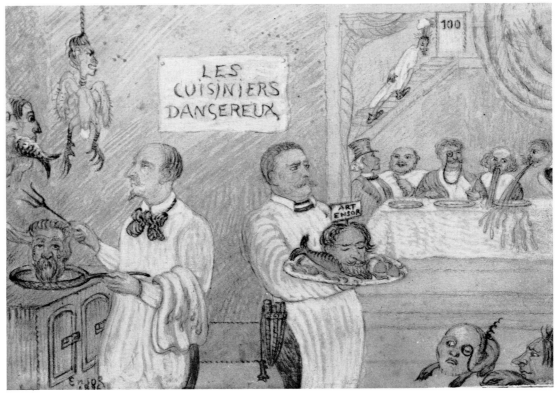

89. *Project for a Chapel Dedicated to SS. Peter and Paul*
 Esquisse pour un chapel consacré à SS. Pierre et Paul. 1897

90. *Beach at Ostend*
 La Plage à Ostende. ca. 1898-99

91. *Skeletons Playing Billiards*
 Squelettes jouant au billard. 1903

92. *Nymph Embracing Herm*
 Nymphe embrassant l'herme. ca. 1920

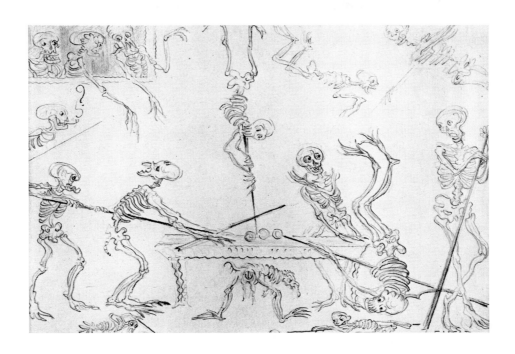

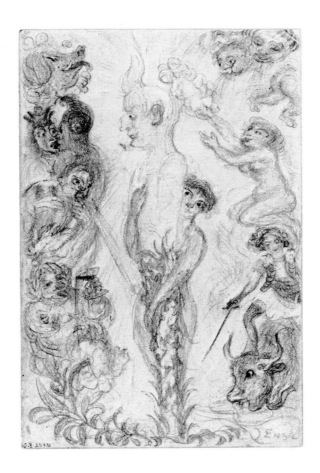

93. *My Hands in 1928*
 Mes mains en 1928. 1928

94a and b. *Sketchbook*
 Cahier de croquis. 1929 and later

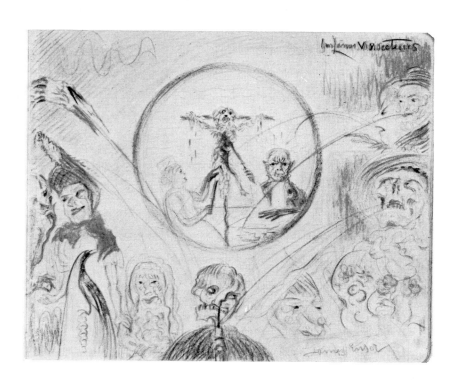

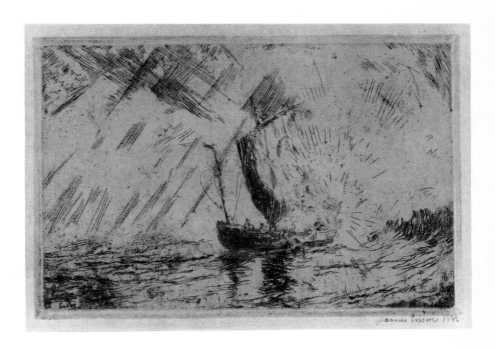

96. *The Cathedral*
 La Cathédrale. 1886

97. *Ernest Rousseau.* 1887

98. *The Pisser*
 Le Pisseur. 1887

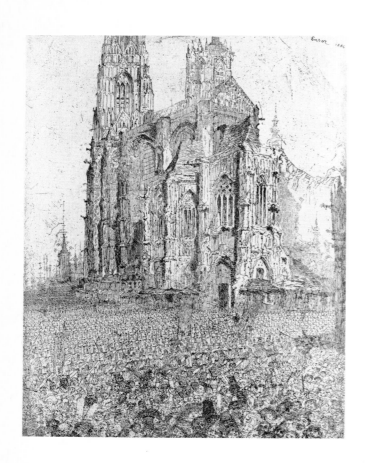

99. *Town Hall of Audenaerde*
 Hôtel de Ville d'Audenaerde. 1888

100. *My Portrait in 1960*
 Mon portrait en 1960. 1888

101. *Peculiar Insects*
 Insectes singuliers. 1888

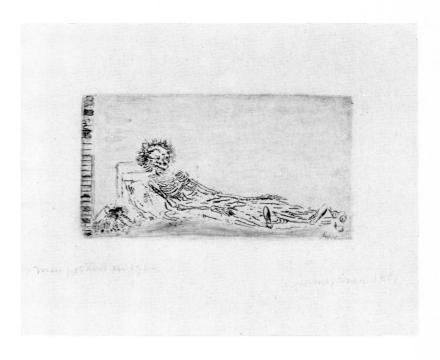

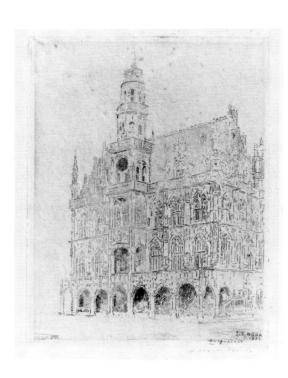

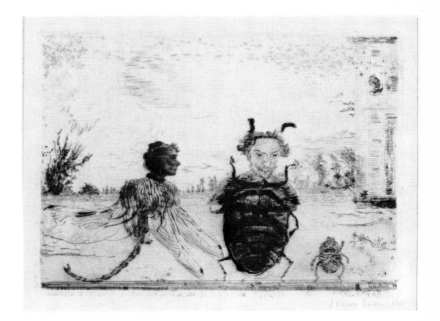

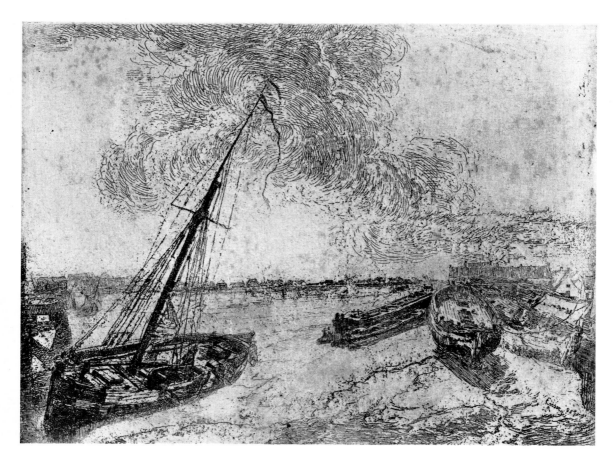

102. *Storm at the Edge of the Wood*
 Coup de vent à la lisière d'un bois. 1888

103. *Boats Aground*
 Barques échouées. 1888

104. *Lust*
 La Luxure. 1888

105. *The Skaters*
 Les Patineurs. 1889

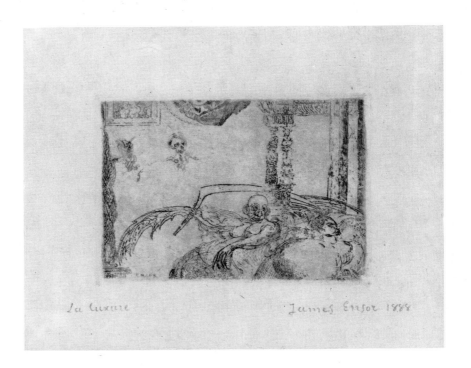

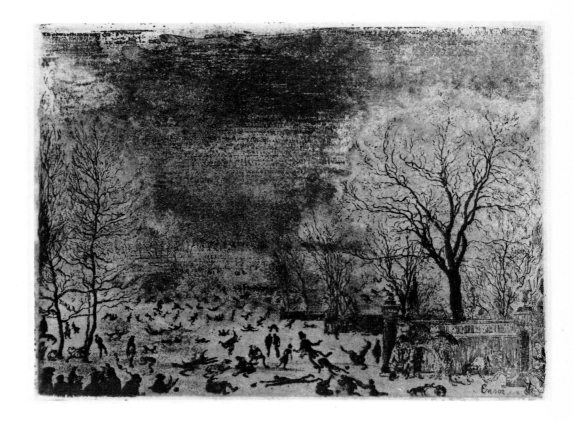

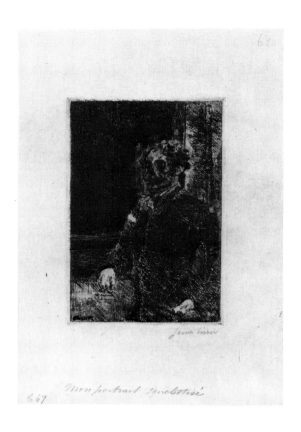

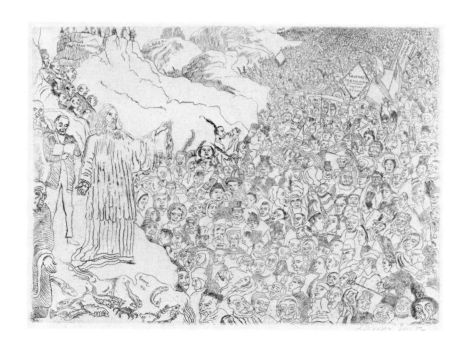

108. *Hop-Frog's Revenge*
La Vengeance de Hop-Frog. 1898

109. *The Entry of Christ into Brussels*
L'Entrée du Christ à Bruxelles. 1898

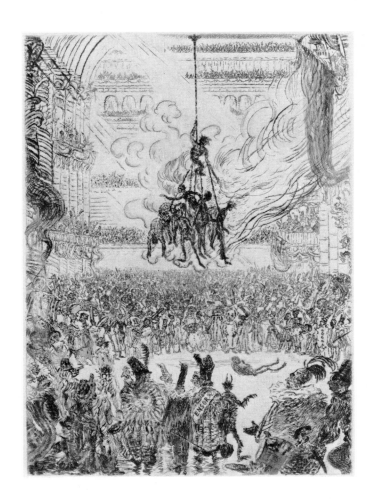

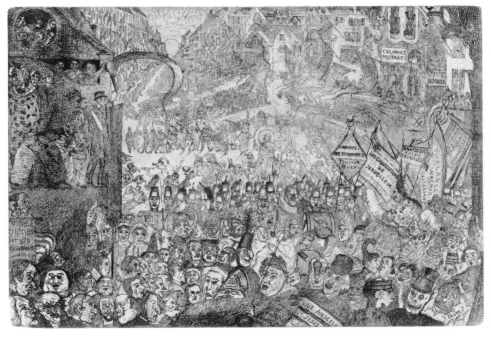

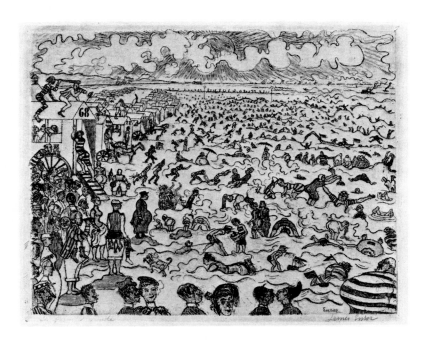

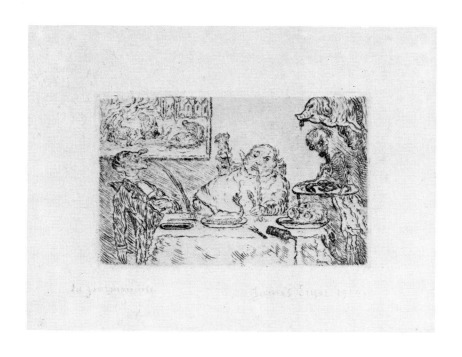

112. *Poster for* La Plume
Affiche de La Plume. 1898

113. *Poster for the Carnival at Ostend*
Affiche pour Le Carnivale d'Ostende. 1931